MW00630290

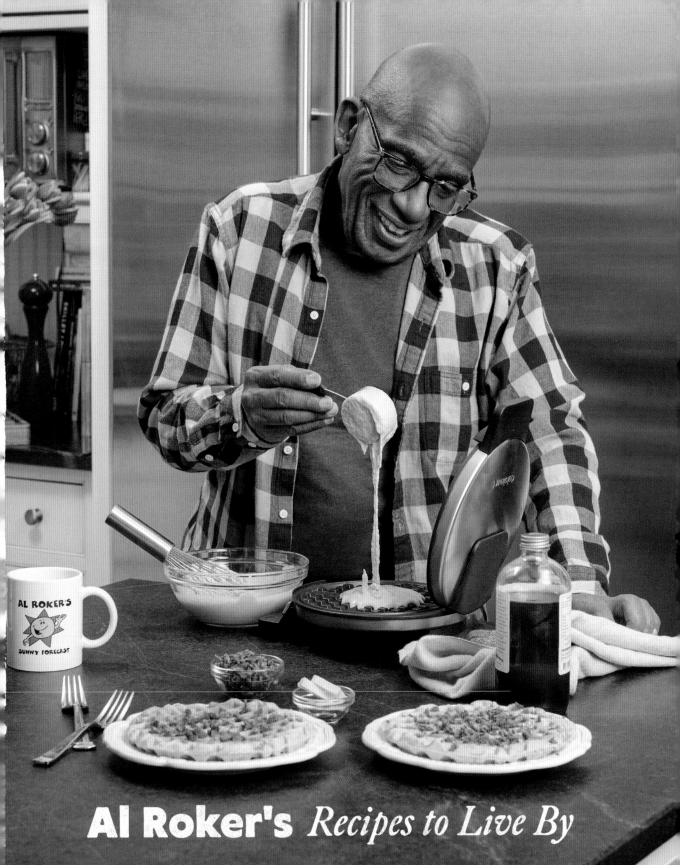

Al Roker's *Recipes to Live By*

Al Roker's
Recipes to Live By

Easy, Memory-Making
Family Dishes
for Every Occasion

Al Roker
with Courtney Roker Laga

LEGACY
LIT

NEW YORK / BOSTON / LONDON

Copyright © 2024 by Al Roker Entertainment, Inc.

Food styling and recipe development by Courtney Roker Laga

Cover design by Dana Li. Cover photo and art copyright © by Amy Roth.
Cover copyright © 2024 by Hachette Book Group, Inc.

Hachette Book Group supports the right to free expression and the
value of copyright. The purpose of copyright is to encourage writers and
artists to produce the creative works that enrich our culture.

The scanning, uploading, and distribution of this book without
permission is a theft of the author's intellectual property. If you would like permission
to use material from the book (other than for review purposes), please contact
permissions@hbgusa.com. Thank you for your support of the author's rights.

Legacy Lit
Hachette Book Group
1290 Avenue of the Americas
New York, NY 10104
LegacyLitBooks.com
Instagram.com/LegacyLitBooks

First Edition: October 2024

Legacy Lit is an imprint of Grand Central Publishing. The Legacy Lit name
and logo are trademarks of Hachette Book Group, Inc.

The publisher is not responsible for websites (or their content) that
are not owned by the publisher.

Legacy Lit books may be purchased in bulk for business, educational, or
promotional use. For information, please contact your local bookseller or the Hachette
Book Group Special Markets Department at special.markets@hbgusa.com.

Food and lifestyle photos © by Amy Roth; family photos courtesy of the Roker family

Library of Congress Cataloging-in-Publication Data
Names: Roker, Al, 1954- author. | 1 Laga, Courtney Roker, aut
Title: Al Roker's recipes to live by : easy, memory-making family dishes
for every time of day and every occasion / Al Roker with Courtney Roker Laga.
Description: First edition. | New York : Legacy Lit, 2024. | Includes in
Identifiers: LCCN 2024008738 | ISBN 9781538740699 (hardback) |
ISBN 9781538740705 (ebook)
Subjects:
Classification: LCC TX833.5 .R64 2024 | DDC 641.5/12—dc23/eng/20240304
LC record available at https://lccn.loc.gov/2024008738

ISBNs: 978-1-5387-4069-9 (paper over board), 978-1-5387-4070-5 (ebook)

Printed in China

RRD-APS

10 9 8 7 6 5 4 3 2 1

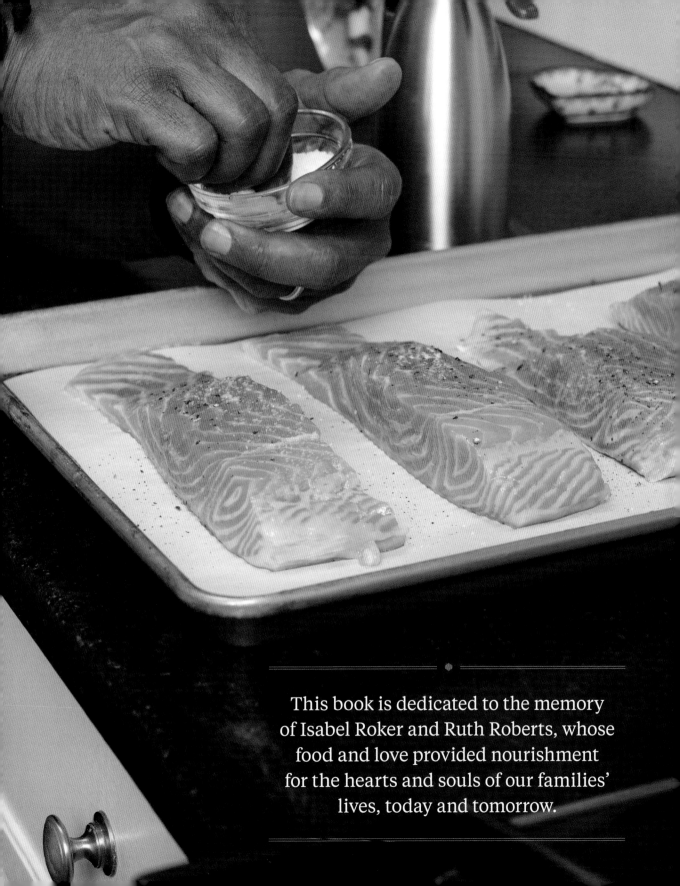

This book is dedicated to the memory of Isabel Roker and Ruth Roberts, whose food and love provided nourishment for the hearts and souls of our families' lives, today and tomorrow.

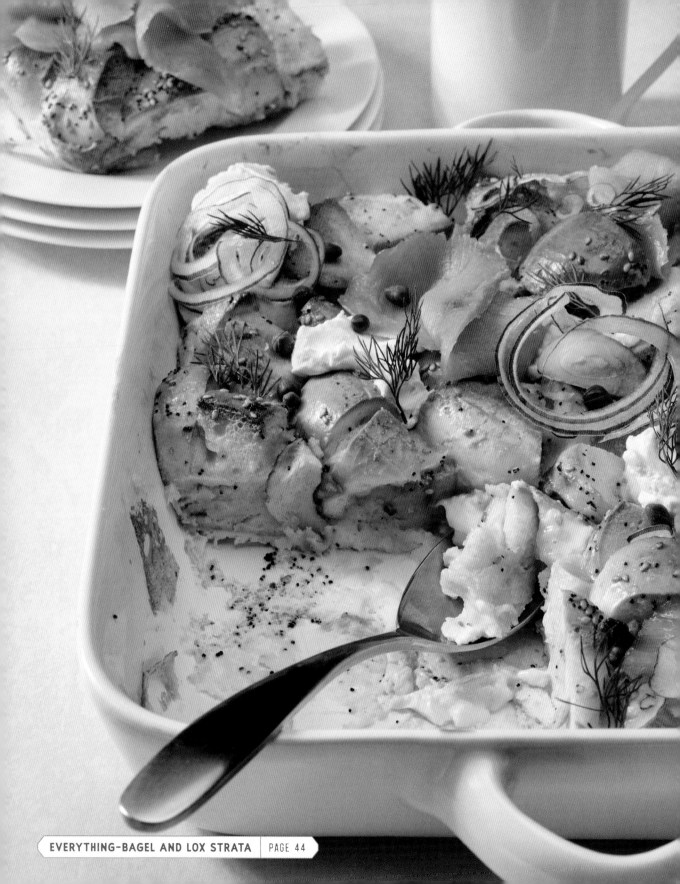

CONTENTS

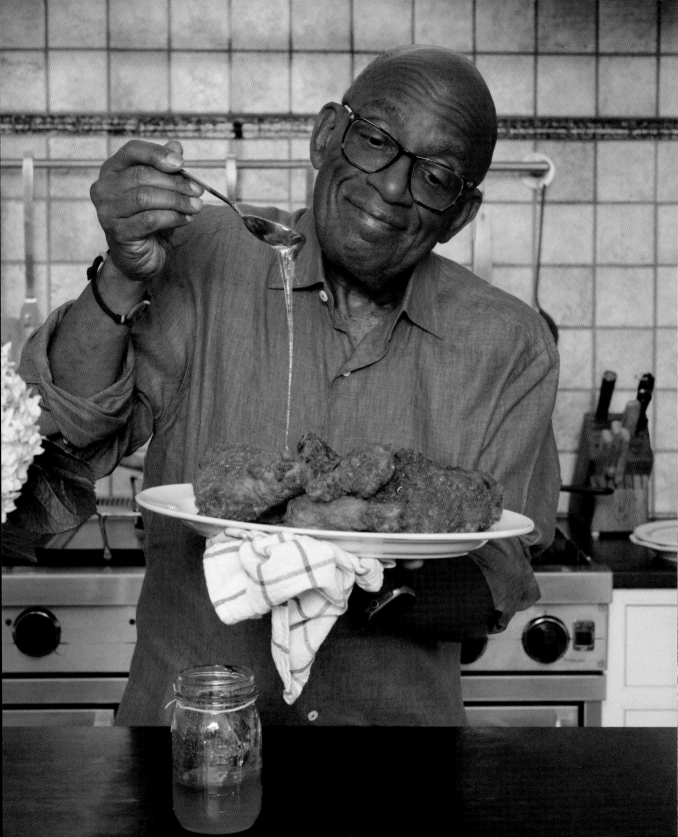

Most of you probably know me because I've told you it's going to rain or warned you that a severe storm is coming your way.

Sharing news about the weather is a big part of my life, but it's only one part of my story. Food is the narrative that has shaped so much of who I am, and it's the source of my warmest memories. All it takes is the simple smell of a sweet potato or chicken roasting and I go back in time. There I am, the slightly pudgy Albert Roker Jr., with the big Coke-bottle glasses. I'm about eight years old, standing next to my mother as she gets to work preparing dinner for her brood in a modest kitchen in Queens, New York. I can hear my brothers and sisters making a ruckus in the living room, but it's quiet in the kitchen as my mom bustles around, taking ingredients out of the refrigerator. She pulls out a wooden cutting board and a knife from the drawer and starts chopping vegetables while I watch. There's a rhythm to her work, and an effortlessness.

I'm still awed by how she could transform a simple pile of ingredients into one of the Roker clan's favorite meals—chicken cacciatore or maybe shrimp and grits. I also marvel at how my mom managed to feed so many of us day after day. The core Roker clan, made up of me, my dad, and my brothers and sisters, was challenging enough, but there were also many days when extra chairs were pulled up to the table, when one of us brought home a friend (or two or three) or when an aunt or uncle dropped by. No matter how many mouths there were to feed, Mom always made it work.

My mother's tools were modest. She had the most basic appliances, some simple pots and pans, and a decent knife or two. She did not have a six-burner stove, an oversized refrigerator, French casserole dishes, or professional-grade knives. I remember asking her, "Why don't we get a dishwasher like the family down the street?" She turned and stared at me. "Why would I get a dishwasher when I have all you kids? *You all* are my dishwasher."

My mom wasn't focused on becoming the next Julia Child. Her cooking was a surefire means of gathering us together. That's what mattered. Years later, when I had a family of my own, I understood why preparing food was so important to her. Food begets memories.

Whenever I made pancakes for breakfast or short ribs for a more elaborate dinner, our kitchen became the family gathering place. The kids walked by to grab snacks, or maybe sat on a stool and chatted with me for a while, or worked on homework, or sometimes just passed through to ask for money. These were the moments I tried to etch into my mind. Nick filling me in about a swim meet after I had made him a sandwich. Leila talking about how she hoped to live in Paris someday and how she couldn't wait to eat in a real French bistro. Courtney helping me with dinner, as her skills for cooking showed up early on. My wife, Deborah, grabbing a quick bite before running off for an interview.

> Food is the narrative that has shaped so much of who I am, and it's the source of my warmest memories.

These memories are different from the big ones—weddings, birthdays, anniversaries, graduations—that go with celebratory dinners and elaborate cakes. They are easily cemented into our memories (iPhone cameras and about 900 pictures also help). But everyday events are important too—maybe even more important. If I wanted to be fully present and make precious memories of daily life with my family, all I needed to do was head to the kitchen.

Now my kids cook too. Courtney went on to culinary school. Nick is the king of sandwiches, and Leila makes a killer lemon meringue pie and has showed me the pleasure of eating "bowls."

But what warms my heart the most is watching my children, who loved their grandmother's cooking, embrace the recipes she carefully crafted in that little kitchen in Queens. To see them dig into oxtail stew or grab a big scoop of macaroni salad is my past finding a place in my present. Those cherished moments around the dinner table of my childhood have been reignited in my own home with my own children. To know that these recipes will make their way into the kitchens of yet another generation is magical, and I wonder if my mom knew this, as she gracefully prepared meal after meal.

At Courtney's wedding rehearsal dinner

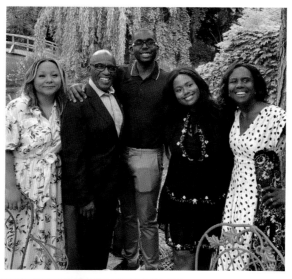

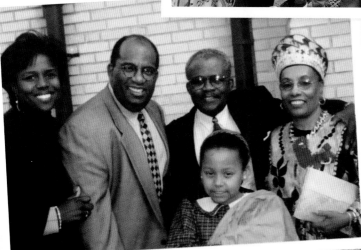

With Deborah, Courtney, and
my parents, Al Sr. and Isabel,
in Queens, New York

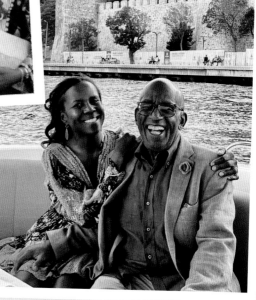

Vacationing with Deborah in Istanbul

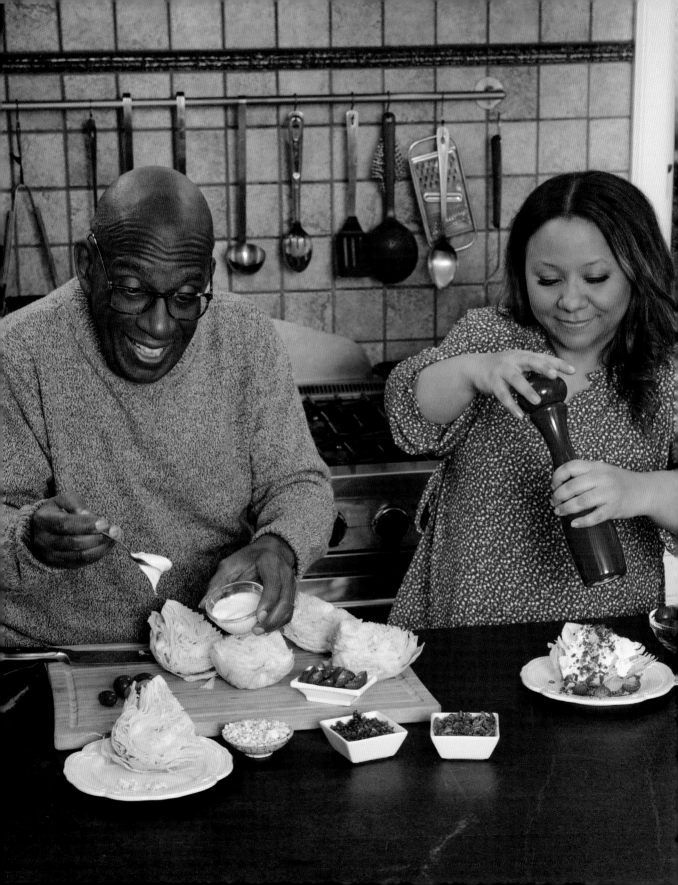

There was a time when I didn't know what kind of future I would have with food. I was a chubby kid, and I definitely liked to eat, but the scales tipped too far (literally). I struggled with obesity for years, occasionally dropping a bunch of pounds but always gaining them back (and sometimes more). I used to joke that Deborah and I had a "mixed-weight marriage." Deborah is lean, she runs, lifts weights, and is one of the fittest people I know. It was painful for her to see me not taking care of myself. Finally, when my father was dying, and I was at my heaviest (about 340 pounds), he made me vow to lose weight so I could still be around to see my kids grow up. In 2002, I made the decision to have gastric bypass surgery. It isn't a cure-all, but the surgery was the tool I needed to finally lose weight. When my mother was sick and I was shuttling back and forth to see her in Queens, I fell off my routine and gained back 40 pounds. That was another wake-up call and a reminder that taking care of your body isn't an on-and-off thing; it's something you have to do every day.

> This collection is a peek into the Roker family recipe box.

At present, my relationship with food is better than it has ever been. I exercise regularly. I walk every day, getting at least 10,000 steps. I work out with a trainer and live a much more active lifestyle than I did before. I don't do "diet foods"—whatever those are. I eat lots of protein and vegetables, although I eat indulgent foods too. I savor them, eating them slowly and making sure to enjoy every single wonderful bite. There are times when the weight starts to creep back, and occasionally I'll jump on a keto diet for a bit to get down a few pounds. I am grateful that I've made these changes, grateful that I will be around for my wife, children, and grandchildren...and that I have a future full of food to look forward to.

This collection is a peek into the Roker family recipe box. Some of the dishes were inspired by my parents, and I've been eating them since I was old enough to sit up. My mother is of Jamaican heritage, and my father's family hailed from the Bahamas. Their rich cultures are responsible for my love of ginger and the island dish peas and rice. Classic soul food like collard greens, cornbread, and baked mac and cheese were served often at our dinner table when I was growing up, and they're still being passed around at my table today.

This cookbook isn't just about my past, though, it's about the recipes my wife, children, and I have added to the collection. My first-born, Courtney, a professionally trained chef, was responsible for transforming the vague instructions that lived in my head or were scrawled out on random pieces of paper into proper recipes that even a beginner can confidently cook.

The Roker recipe file has something for every food-related situation imaginable. Weeknight dinners like pan-seared chicken thighs and barbecued bacon-wrapped shrimp. Dishes to make you proud at potlucks. And when you want to impress your future-in-laws, a romantic interest, or the dear friend you haven't seen in ages, the wine-braised short ribs I learned from a famous New York City chef or the perfectly roasted chicken that's become a national legend will never let you down. You'll also find simple desserts with an extra little zing, like strawberry shortcakes embellished with whipped cream and lemon curd, as well as spirited and non-spirited drinks to transform your living room into your very own cocktail/mocktail lounge.

This book is a compilation of all the joy-inducing food that lands on my table, my tried-and-true dishes, and my greatest kitchen accomplishments. So pull up a chair, dig in, and pass the Tuscan polenta.

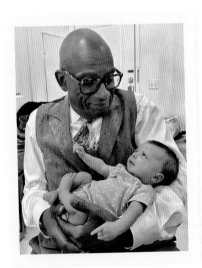

Around the Roker table, the future looks bright and delicious. One of my daughters is married, and my first grandchild, Sky, has arrived. I can't wait to see what culinary traditions she grabs onto. Will she smear apple butter on everything like her mother did when she was young? What will be her favorite kind of pie? Which new recipes will she bring into our fold as she grows up?

Food is an ever-evolving story with new traditions and rituals—our lives are measured in recipes. I hope that as you continue to hold tight to your own family favorites, you'll find a few dishes in this book that will become a part of your story.

A
BREAKFAST
STATE OF MIND

BREAKFAST IS MORE THAN A MEAL, IT'S A SIMPLE RITUAL that sets you up for the rest of your day. My father, Albert Roker Sr., drove a bus for the Metropolitan Transit Authority in New York City, and he always got up early enough to prepare a hot breakfast before heading out the door. Forcing myself out of a comfortable bed an hour earlier than I wanted to meant starting my day with scrambled eggs, crispy bacon, buttery toast, and my father's undivided attention. It wasn't easy to get one-on-one time in a busy household with two working parents, and I treasured those early morning solitary meals—being with my father in the peace and calm before the day jumped to life. Our breakfast conversations weren't necessarily groundbreaking. Between sips of coffee (for him) and orange juice (for me), we talked about what I was studying in school or maybe how the Yankees were shaping up for the upcoming season. After he took a final sip of coffee, I'd take our dishes to the sink. My father would grab his lunch, tell me to have a good day, and be out the door just as the rest of the Roker clan was rousing (noisily).

My brothers and sisters would come bounding into the kitchen, bringing a happy chaos with them. Hair needed to be combed, shoes tied, homework placed in backpacks . . . and we all needed to be fed (except me, but only *technically*, in my opinion) before being sent off to school. My bonus breakfast couldn't have been more different from the first. Mom stood at the stove stirring oatmeal, trying to keep us kids in order. She slid bowls of sticky oatmeal to each of us with a look that said, *Do not say a word about what's in your bowl. Just eat so we can all get out of here on time.* My siblings and I wolfed down our oatmeal, chatting and goofing around, or purposefully getting on each other's nerves. Then en masse, we grabbed our book bags, slipped on our coats, and took our bag lunches as we were shuttled out the door to school. I left the house with a full stomach (eating two meals will do that) and a happy heart.

My son, Nick, would have had to get up at 3:45 a.m. for us to eat breakfast together. (I'm sure I would have been a one-breakfast kid if my dad had to get up that early.) Occasionally I'll cross paths with my wife, Deborah, on days she's slated to be on *Good Morning America*, but usually the kitchen is my domain in the predawn hours. In the couple of years right before

Nick left for college, when Deborah and I were soon to be "empty nesters," I wanted to take the opportunity to make Nick a hot breakfast, just like my dad made for me. We wouldn't be able to eat together, but I wanted him to know I was thinking of him. I managed to slip this small act of cooking into my routine quite easily by making pancake batter the night before. Then, around 4:00 a.m., while I had my daily call with my meteorologist to update me on the weather, I'd fire up the griddle. Or sometimes I'd do a quick scrambled egg or pull some already-cooked bacon from the fridge and put it on a plate for him in the warming drawer of our oven. Knowing my son would wake up to a hot breakfast gave me comfort because I was connecting with him through the simple act of preparing a meal.

While I love breakfast and all of its options, both salty and sweet, I stick to coffee during the week. After getting dressed, choosing a tie, and deciding whether or not it's going to be a pocket-watch day, I pour myself a cup of my signature cold brew. I swear this stuff empowers me to do almost anything! Then, when the weekend hits, it's *Breakfast game on, everyone!*

Now I'm not about to tell you to get up at the crack of dawn to make yourself and your family homemade waffles topped with butter you churned yourself and maple syrup you tapped from a tree in your backyard. I know what kind of chaos a simple weekday morning can bring to even the steadiest of souls. What I *do* suggest is that you take some time—even just a few minutes—to sit down and nourish yourself and your family before you are flung out into the wilds of work and other obligations. Breakfast is a state of mind as much as it is a meal. Whether your morning starts with pancakes, a quick sausage-spinach egg "muffin" you've pulled out of the freezer, a simple cup of coffee just to get you going, or a luxurious shakshuka, it's the practice of making breakfast each day that matters.

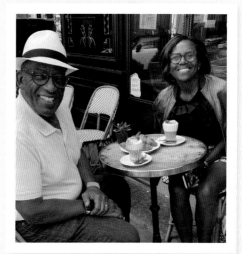

Enjoying breakfast with Deborah at a Parisian café

FRIED-EGG BLT

2 tablespoons mayonnaise

2 teaspoons lemon juice

1 teaspoon Dijon mustard

4 slices uncured bacon

1 tablespoon unsalted butter

1 large egg

2 slices sourdough bread, toasted

2 leaves Bibb lettuce

2 slices beefsteak or other large ripe tomato

Freshly ground black pepper

This is one of the world's greatest sandwiches re-dressed for breakfast…New York City style. It's your classic BLT but with the addition of a fried egg, inspired by everyone's favorite bodega sandwich, the bacon, egg, and cheese (aka the BEC). Walk into any corner deli and follow that bacon aroma straight to the grill. Within a couple of minutes, you'll be handed a foil-wrapped packet containing a no-frills sandwich that is perfection shoved into a roll. It is hubris to try to recreate the iconic BEC—it cannot be done (although many have tried)! Instead, I'm injecting a little bit of that BEC magic by adding an egg to the equally delicious BLT, creating one ultra-delectable super sandwich.

Combine the mayonnaise, lemon juice, and Dijon mustard in a small bowl and set aside.

Cook the bacon in a medium skillet over medium heat, turning halfway through, for about 5 minutes, until crisp. Transfer it to a paper towel–lined plate to drain.

Melt the butter in a small nonstick skillet over medium-low heat. Add the egg and cook for about 2 minutes. Gently flip the egg and cook for 30 seconds, or until it's done the way you like it. Remove from the heat.

Assemble the sandwich by spreading the mayo mixture on one side of each piece of toast. Layer the lettuce, tomato, and bacon on one slice. Put the fried egg on top of the bacon, season with pepper, and top with the other slice of toast. Cut in half and serve right away.

If you are not a fan of mayo, you can substitute your favorite spread, such as pesto, hummus, or guacamole.

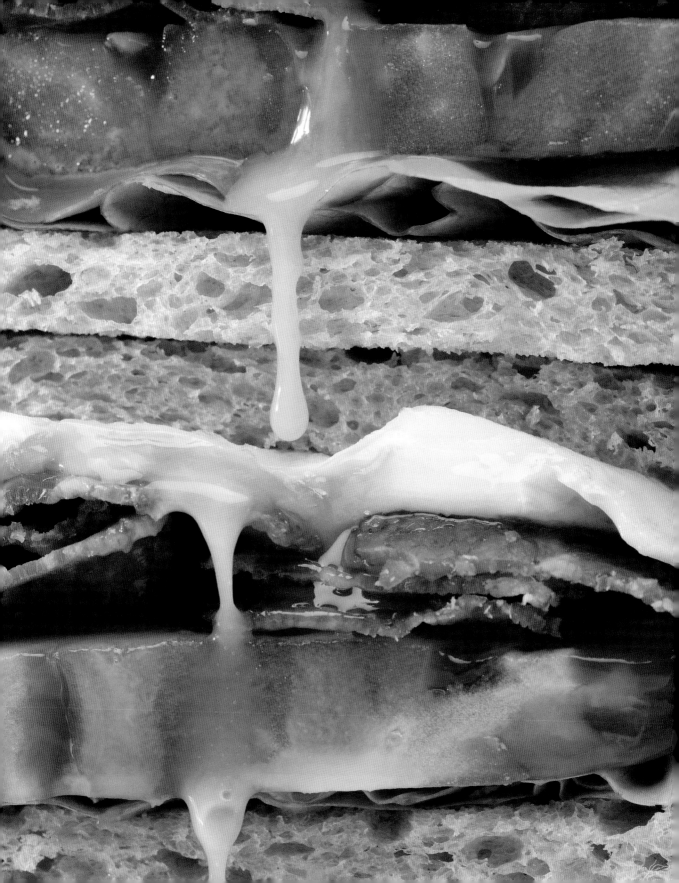

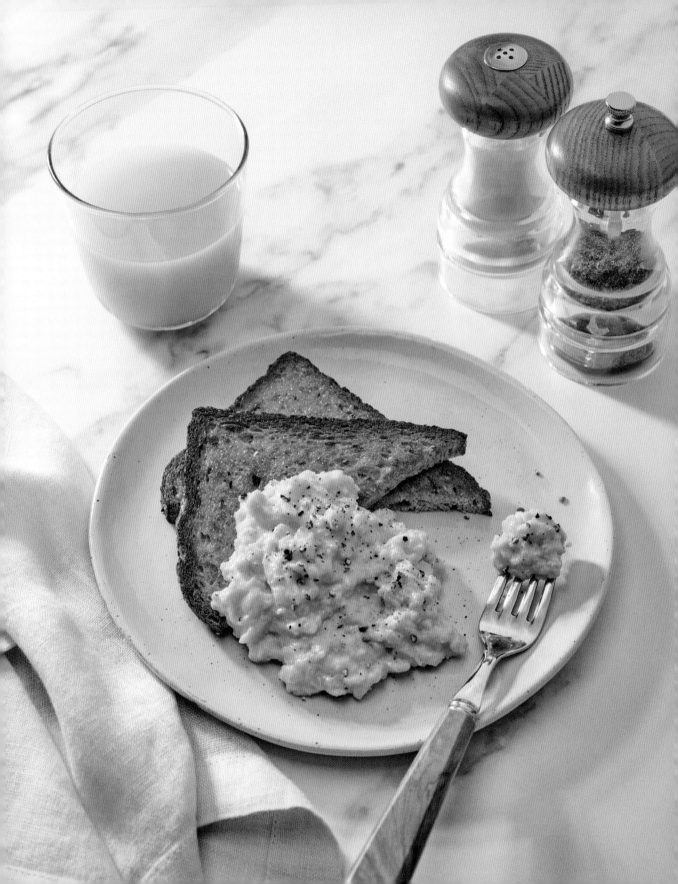

AHA-MOMENT SCRAMBLED EGGS

4 large eggs

2 tablespoons heavy cream

1 tablespoon unsalted butter

1 slice American cheese, torn into pieces

2 tablespoons cream cheese, at room temperature

⅛ teaspoon kosher salt

Freshly ground black pepper (optional)

Scrambled eggs are one of the simplest of foods, but many people have strong personal feelings about their preparation. Some folks believe the firm, hard-cooked variety is the only way to go, while others insist that scrambled eggs should be fluffy and moist. (I prefer the latter.) My son, Nick, a budding cook in his own right, falls into a different camp. He believes scrambled eggs reach the apex of deliciousness with the addition of the power duo of American cheese and cream cheese. The first time he slid me a plate of these velvety eggs, I thought, *Aha! Now THIS is the way to scramble an egg!* I've been eating this dressed-up, cheesy version ever since.

Whisk the eggs and cream in a medium bowl until combined.

Melt the butter in a medium nonstick skillet over medium-low heat. Add the egg mixture and let sit undisturbed for about 30 seconds. Using a silicone spatula or spoon, gently push the eggs from the sides of the pan into the middle and cook, stirring, for 3 to 4 minutes for soft-scrambled, or until they are cooked the way you like them.

Remove from the heat and fold the American cheese, cream cheese, and salt into the eggs.

Immediately turn the eggs out of the pan onto a platter. Season with pepper, if desired, and serve right away.

THE McROKER

PREP TIME: **15 MINUTES** • COOK TIME: **20 MINUTES**

BACON

1 pound uncured bacon

PANCAKES

2¼ cups all-purpose flour

2 tablespoons granulated
sugar

1 tablespoon baking powder

½ teaspoon kosher salt

1⅔ cups whole milk

1 large egg

4 tablespoons (½ stick)
unsalted butter, melted and
cooled

¼ cup maple syrup

EGGS

2 tablespoons unsalted butter

8 large eggs, lightly beaten

8 slices American cheese

These are a great option
for a grab-and-go weekday
breakfast. Let the sandwiches
cool, then wrap in foil, place
in a zipper-lock bag, and
freeze for up to 2 weeks. When
ready to reheat, just remove
the foil and microwave for
about 2 minutes.

If you've ever walked into a McDonald's hoping to quash a craving
for bacon, eggs, and pancakes packaged together in the perfect
salty-meets-sweet sandwich, only to find you've missed the breakfast
cutoff, I feel your pain. You can take matters into your own hands
with this delicious all-in-one recipe. Freezing the extras means you'll
have access to the sandwich 24/7, and you'll never have to worry
about hitting the breakfast deadline again.

FOR THE BACON: Preheat the oven to 200°F.

Cook the bacon in a medium skillet over medium heat, turning
halfway through, until crisp, about 5 minutes. Transfer it to a
paper towel–lined plate and keep warm in the oven.

FOR THE PANCAKES: Mix the flour, sugar, baking powder, and salt
in a large bowl.

In a medium bowl, whisk together the milk, egg, butter, and
syrup. Stir the wet ingredients into the dry.

Lightly coat a large griddle or skillet with cooking spray and
heat over medium heat until a few drops of water roll around
for a second before evaporating. Working in batches to make
16 pancakes, pour ¼ cup batter onto the hot pan for each
pancake, spacing them about 1 inch apart. Let cook, undisturbed,
until bubbles rise to the surface and the undersides are browned,
2 to 3 minutes. Flip and cook the other sides for about 1 minute.
Transfer to a baking sheet and keep warm in the oven.

FOR THE EGGS: Melt the butter in a medium nonstick skillet over
medium-low heat. Add the eggs and let sit, undisturbed, for
about 30 seconds. Using a silicone spatula or spoon, gently stir
for about 4 minutes, until soft scrambled.

TO ASSEMBLE: For each sandwich, place a pancake on a plate and
top with a slice of cheese, then a spoonful of scrambled eggs,
and 2 slices of bacon. Top with a second pancake and serve.

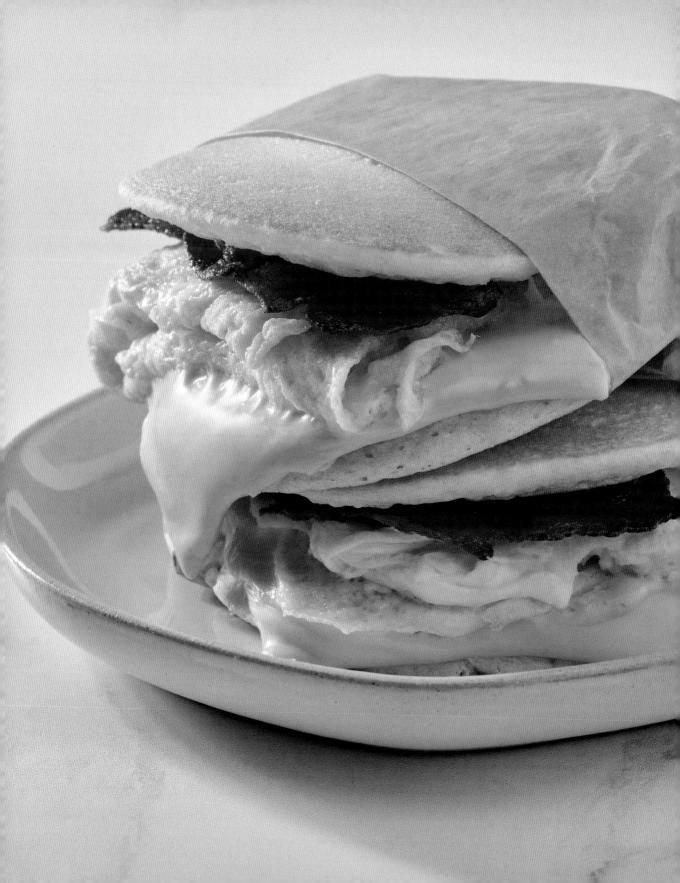

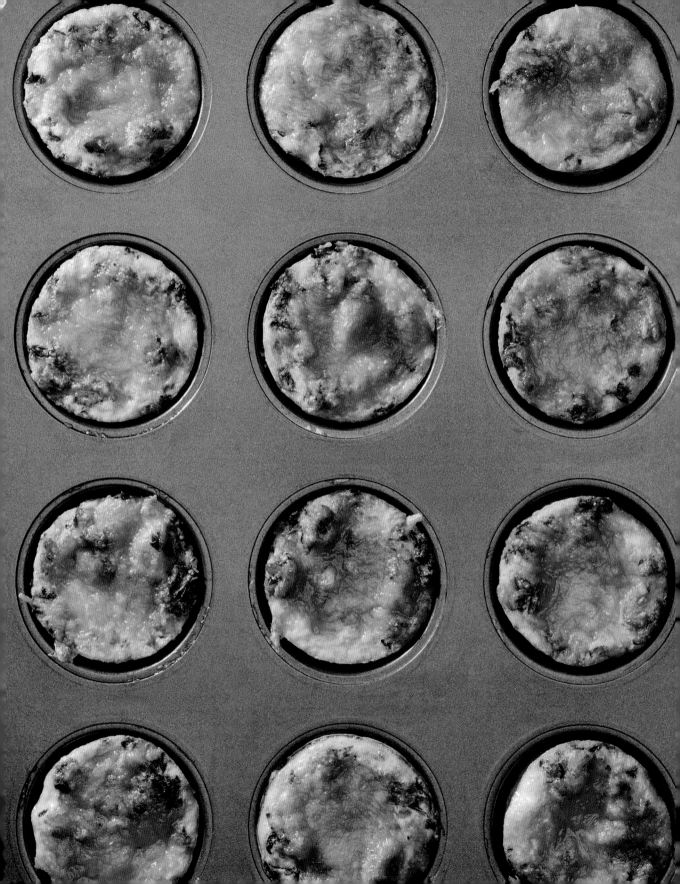

SAUSAGE-AND-SPINACH EGG "MUFFINS"

7 large eggs

¼ cup half-and-half

½ teaspoon kosher salt

1 teaspoon olive oil

1 pound ground pork breakfast sausage

6 ounces baby spinach

1 cup shredded cheddar cheese

I discovered these "muffins" during my keto days. They're essentially a vehicle for sausage and cheese, with a dose of greens for good measure. This is pocket-sized protein—delicious, portable, and easy-to-make. The muffins can be stashed in the freezer and quickly warmed up to crush an oncoming attack of the hangries. (You're welcome.) If I've got an extra-long day ahead of me and I know a cup of coffee isn't going to sustain me, I can pop one of these in the microwave and I've got a nutritious and satisfying breakfast ready to go in the amount of time it takes to tie my tie…then I'm out the door.

Preheat the oven to 375°F. Lightly grease a 12-cup muffin tin.

Whisk together the eggs, half-and-half, and salt in a medium bowl and set aside.

Heat the oil in a large skillet over medium heat. Add the sausage and cook, stirring with a wooden spoon to break it up, until it is crumbled and no longer pink, about 5 minutes. Add the spinach and cook just until wilted, a minute or two.

Spoon ¼ cup of the sausage mixture into the bottom of each muffin cup. Spoon 2 tablespoons of the egg mixture over the sausage and sprinkle some cheese evenly on top. Bake for 12 to 15 minutes, until set. Serve hot or at room temperature.

AVOCADO TOAST

1 ripe Hass avocado, halved and pitted

2 teaspoons olive oil

½ teaspoon grated lemon zest

1 teaspoon lemon juice

⅛ teaspoon kosher salt

⅛ teaspoon freshly ground black pepper

1 garlic clove

2 slices seeded whole-grain bread, toasted

Baby arugula, red pepper flakes, and/or Maldon or other flaky sea salt, for garnish

Smoked salmon, halved cherry tomatoes, and/or baby arugula, for topping (optional)

I pride myself on knowing what's going on in the world of food, but I swear avocado toast came out of nowhere. It didn't exist, and suddenly there it was on the menu of every breakfast joint, casting a shadow over timeless staples like omelets and eggs Benedict. As much as I appreciate a breakfast innovation, I initially shunned this interloper. Its trendiness had no place in my world of breakfast foods. That is, until my daughter Courtney, the professional chef of the family, made one for me. *Oh, so this is what it's all about!* I, Albert Lincoln Roker Jr., have welcomed the avocado toast into my home.

Scoop the avocado flesh into a medium shallow bowl. Add the olive oil, lemon zest and juice, salt, and pepper and stir to combine.

Slice the garlic clove in half and lightly rub each slice of toast with the cut side of the garlic.

Spread the toasts with the avocado mixture. Top with arugula, red pepper flakes, and/or sea salt, and if you like, smoked salmon, and cherry tomatoes and/or baby arugula, then serve.

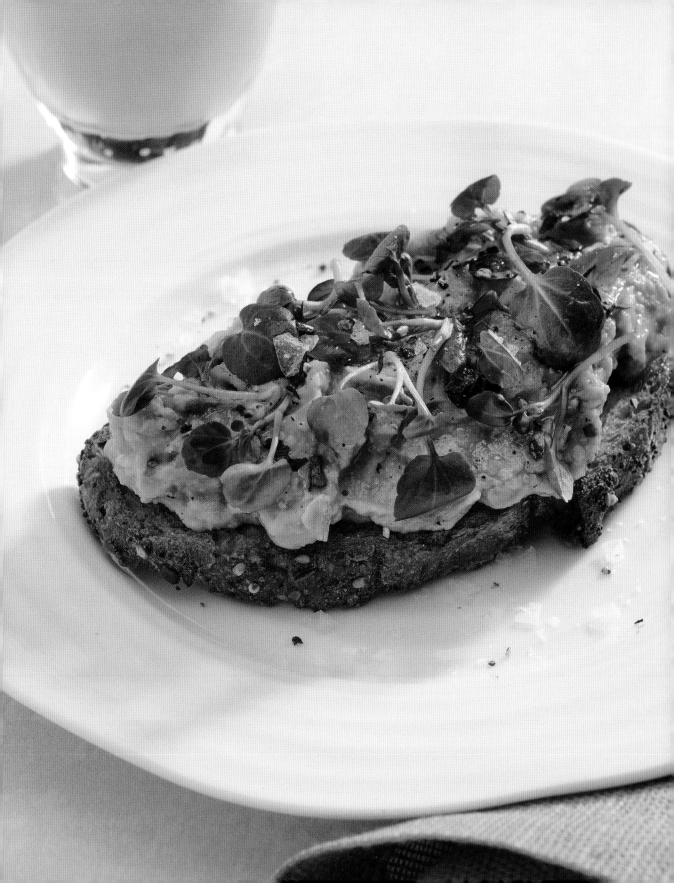

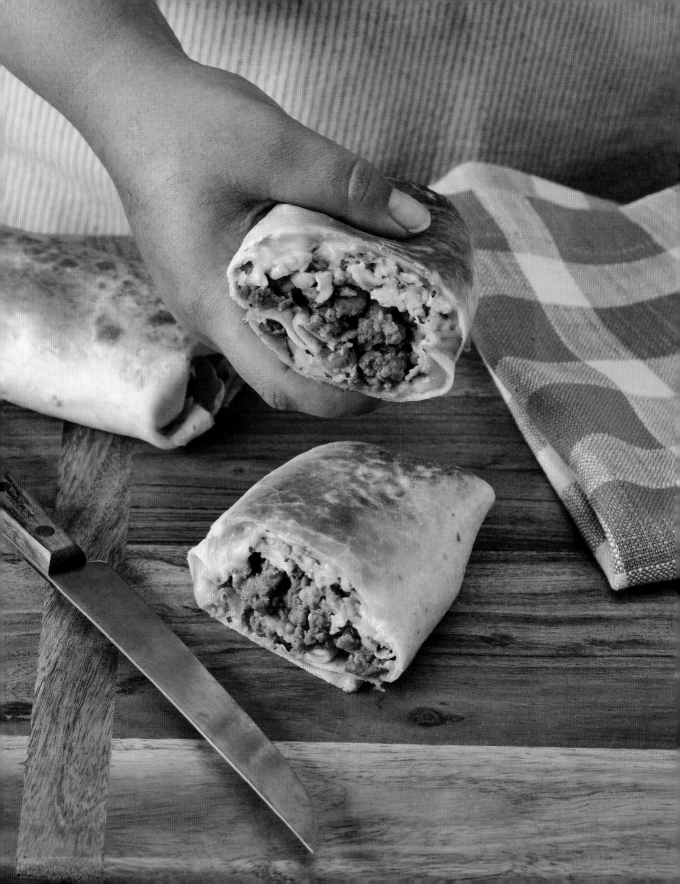

SUNRISE BURRITOS

2 tablespoons canola oil, divided

1 small yellow onion, finely diced

1 small red bell pepper, finely diced

1 teaspoon ground cumin

½ teaspoon kosher salt

8 ounces raw chorizo sausage, casings removed

6 large eggs, lightly beaten

½ cup jarred chunky salsa, plus more for serving (optional)

2 tablespoons chopped fresh cilantro

4 (10-inch) flour tortillas

1 cup shredded Monterey Jack cheese

To make vegetarian burritos, replace the chorizo with 1 (15-ounce) can black beans, rinsed and drained.

I'm not trying to start a war here, but if forced to decide between breakfast tacos and burritos, I'd be Team Burrito. Hear me out. A burrito is like a breakfast cigar, wrapped up tightly to provide manageability. It's also perfectly acceptable to eat a breakfast burrito with a fork and knife! Now take the taco. A taco in the morning is pretty much a guarantee you're going to spill something on your suit. Give a breakfast taco to a kid and you're just asking for a we-missed-the-bus-because-Timmy-was-covered-in-hot-sauce-and-had-to-change situation. Why do this to yourself in the morning when you're at your most vulnerable? Consider yourself warned. Make the burrito.

Heat 1 tablespoon of the oil in a large skillet over medium heat. Add the onion, bell pepper, cumin, and salt and cook, stirring, for 5 minutes, or until the vegetables are tender.

Add the chorizo and cook, stirring occasionally with a wooden spoon to break it up, until crumbled and browned, about 5 minutes. Reduce the heat to medium-low, add the eggs, and continue to cook, stirring with a fork, until they are scrambled and cooked to your liking. Remove the skillet from the heat and stir in the salsa and cilantro.

To assemble the burritos, microwave the tortillas for about 20 seconds, until pliable. Evenly divide the egg mixture among the tortillas, placing a spoonful just below the center, and sprinkle with ¼ cup cheese. Fold the bottom edge of the tortillas over the filling, tuck in the sides, and roll up the burrito.

Heat the remaining 1 tablespoon oil in a large nonstick skillet over medium heat. Add 2 burritos, seam side down, and cook until the bottoms are golden brown, about 2 minutes. Flip the burritos and cook until golden brown on the other side, about 2 minutes. Repeat to cook the remaining 2 burritos.

Serve with additional salsa, if desired.

ANYTHING-FROM-YOUR-GARDEN FRITTATA

8 large eggs

½ cup heavy cream

1 cup shredded white cheddar cheese

⅓ cup chopped fresh chives

2 tablespoons finely chopped fresh basil

2 tablespoons unsalted butter

1 small yellow onion, finely diced

1 small red bell pepper, finely diced

2 garlic cloves, chopped

½ teaspoon kosher salt

1 cup cherry tomatoes, halved

1 medium tomato, preferably heirloom, cut into ¼-inch-thick slices

When vegetables, eggs, cream, and cheese gather lovingly together in one pan, a wholesome breakfast is born, and it is called the garden frittata. As far as I'm concerned, there are two ways to view this veggie-packed breakfast: (A) Summer in your mouth. The fresh basil, ripe tomatoes, and peppers from your garden or the farmers' market make for a light but very satisfying breakfast. (B) A veggie-drawer purge. I'm not going to hold you to this exact recipe if you've got veggies that are long in the tooth! Chop them up and throw them in! Either path leads to breakfast deliciousness, so just go for it.

Preheat the oven to 350°F.

Whisk together the eggs and cream in a large bowl. Add the cheese, chives, and basil and stir to combine.

Melt the butter in a large ovenproof skillet over medium-low heat. Add the onion, bell pepper, garlic, and salt and cook until the onion is soft and translucent, about 5 minutes. Add the cherry tomatoes and cook for about 2 minutes, stirring frequently. Turn off the heat and pour the egg mixture evenly across the pan. Place the heirloom tomato slices on top in an even layer.

Transfer the skillet to the oven and bake for 15 to 20 minutes, until set. Slice into wedges and serve hot or at room temperature.

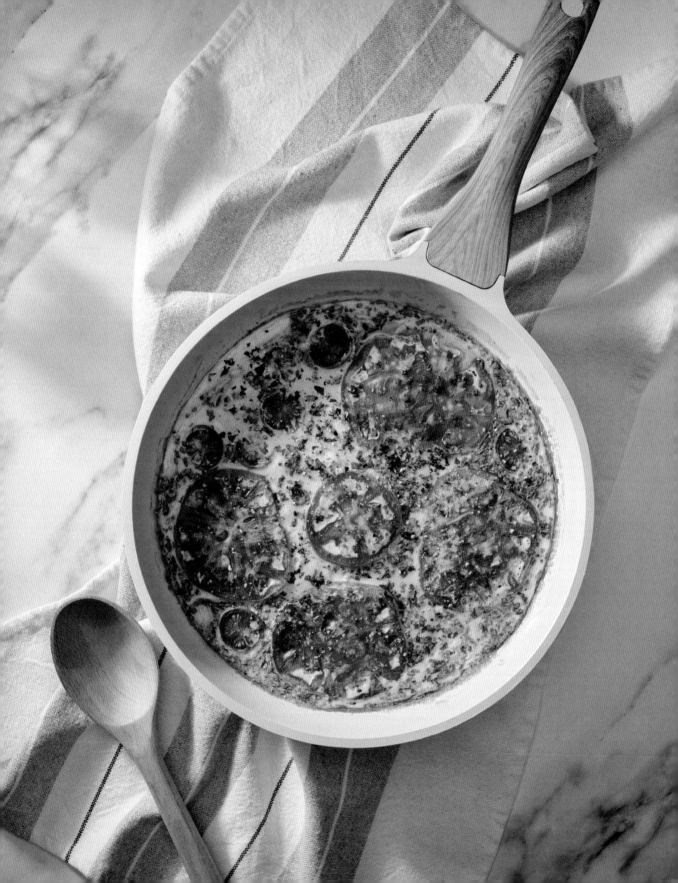

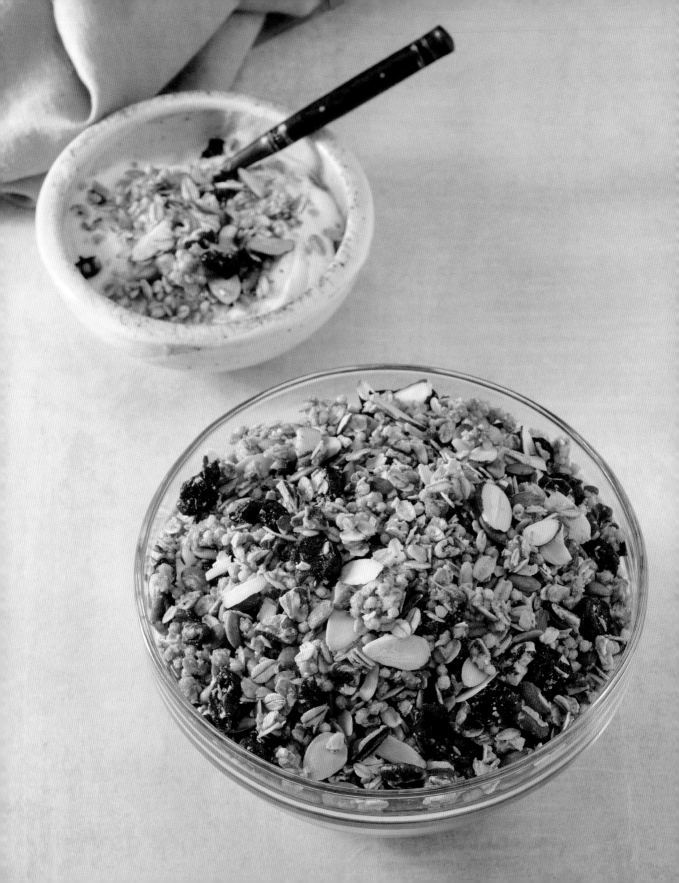

Makes 4 cups

JUST-RIGHT GRANOLA

PREP TIME: **10 MINUTES, PLUS 30 MINUTES TO COOL** • COOK TIME: **30 MINUTES**

2 cups old-fashioned rolled oats

1 cup chopped raw pecans

½ cup sliced raw almonds

¼ cup raw pepitas

½ cup maple syrup

3 tablespoons coconut oil, melted

1 teaspoon kosher salt

1 teaspoon ground cinnamon

¼ teaspoon ground nutmeg

½ cup dried cherries

Raw nuts are ideal for this recipe, but if you've got roasted nuts on hand, by all means use those. Pepitas are pumpkin seeds without the hulls, and you're likely to find them in the nut and seed section of your grocery store.

My rule of thumb is I'm not going to kill myself making something I can easily buy a good version of in the store. I'm honestly puzzled by people who make their own ketchup or marshmallows. Seriously? Why go to all the trouble when these items are readily available for purchase? Granola is my exception to this rule, because making it yourself allows for control over your ingredients. This granola isn't fat laden, overly sweet, or too savory, and it doesn't contain M&M's or miniature peanut butter cups. (The minute you add candy to your granola it ceases to be granola, so stop fooling yourself.) The combo of oats, nuts, and pepitas strikes just the right balance, and the dried cherries chime in, providing their own wow moment, no candy necessary.

Preheat the oven to 350°F. Line a baking sheet with parchment paper.

Combine the oats, pecans, almonds, and pepitas in a large bowl. Pour in the maple syrup, coconut oil, salt, cinnamon, and nutmeg and mix until the oats and nuts are coated.

Transfer the granola to the prepared baking sheet, spreading it out in an even layer. Bake until golden brown, about 30 minutes, stirring halfway through.

Allow the granola to cool for at least 30 minutes, then stir in the dried cherries. Once it's cool and dry, serve or store in an airtight container at room temperature for up to a week.

BACON WAFFLES

PREP TIME: **20 MINUTES** • COOK TIME: **40 MINUTES**

8 ounces uncured bacon

2 cups all-purpose flour

¼ cup malted milk powder

1 tablespoon baking powder

½ teaspoon baking soda

½ teaspoon kosher salt

3 large eggs, at room temperature

¼ cup granulated sugar

2 cups buttermilk, at room temperature

4 tablespoons (½ stick) unsalted butter, melted, plus more for serving

Warm maple syrup, for serving

NOTE FROM UNCLE AL

The malted milk powder adds a dash of nutty sweetness. You'll find jars of it in the baking section of your grocery store.

Sometimes life-changing discoveries happen by accident: penicillin, X-rays, Velcro, and these savory-sweet waffles that will have you wondering, *Where have bacon waffles been all my life? Why are chicken and waffles getting all the attention?* Picture it. I'm standing in my kitchen, extra waffle batter to my left and a few slices of cooked bacon to my right. Could I be on the verge of a brilliant breakfast discovery? I combined the two and then poured that bacon-laden batter into the hot waffle iron and *Ding! Ding! Ding!* What came out was more than a waffle, it was a breakfast miracle and the perfect transport system for bacon, butter, and syrup.

Preheat the oven to 375°F. Line a baking sheet with parchment paper.

Lay the bacon slices on the prepared baking sheet in a single layer. Bake for 8 to 10 minutes, until browned on one side. Remove the baking sheet from the oven and pour off the fat. Using tongs, turn the slices over and return to the oven until cooked through and crispy, 8 to 10 minutes. Transfer the bacon to a paper towel–lined plate and let cool. Rough-chop the bacon and set aside.

In a large bowl, whisk together the flour, malted milk powder, baking powder, baking soda, and salt.

In a medium bowl, whisk the eggs and sugar until frothy. Add the egg mixture, along with the buttermilk and melted butter, to the dry ingredients and gently stir until just combined. Set aside 2 tablespoons of the bacon for a topping, if you like, and gently fold the rest of the chopped bacon into the batter.

Preheat a waffle iron and spray with cooking spray. Ladle in ½ cup to 1 cup of the batter (depending on the manufacturer's instructions). Close the waffle iron and cook to the desired doneness. Serve topped with bacon (if using), butter, and warm maple syrup.

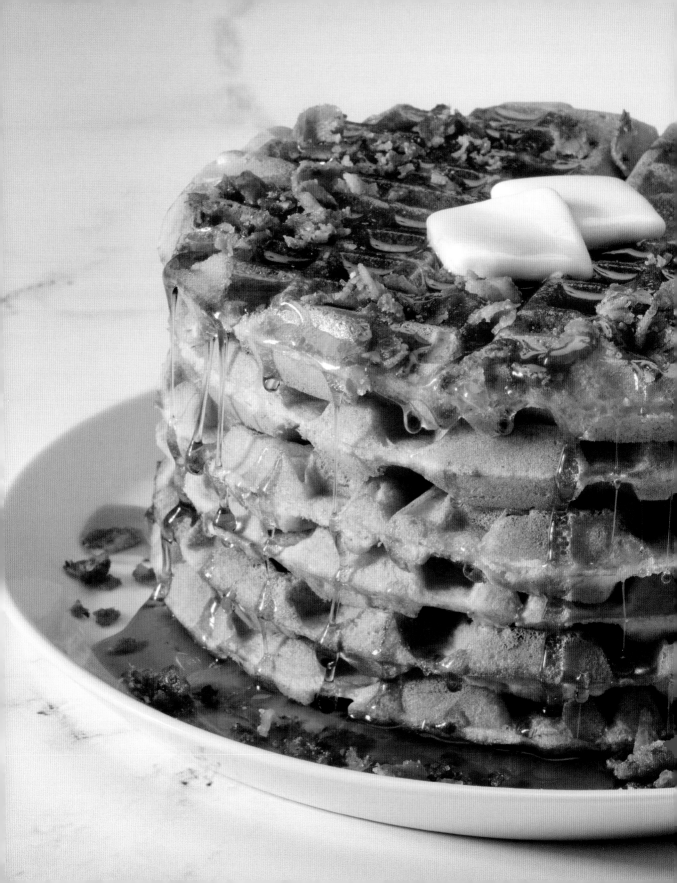

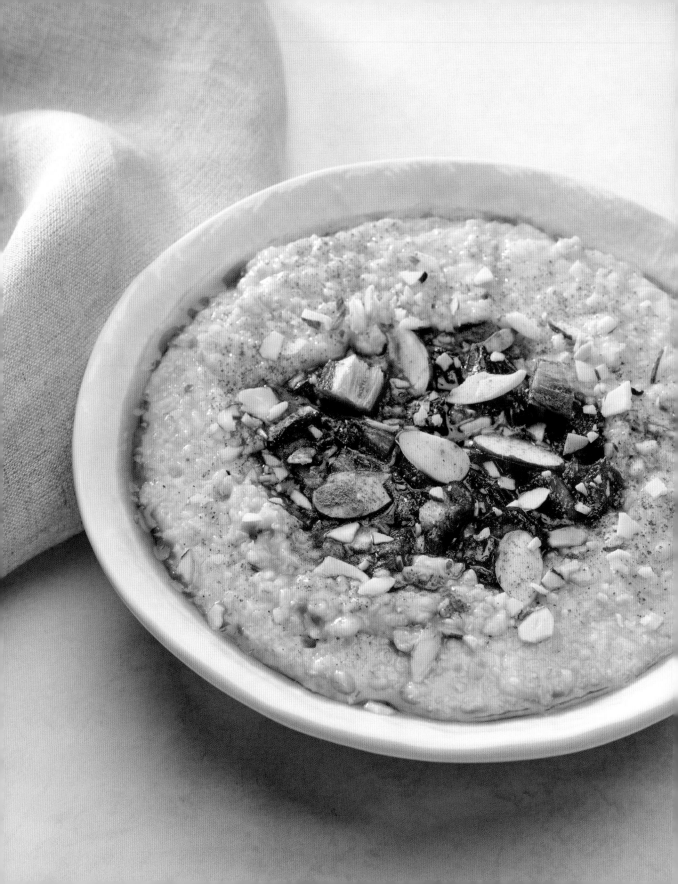

NEXT-LEVEL OATMEAL

2 cups water

1 cup half-and-half

2 cups old-fashioned rolled oats

½ teaspoon kosher salt

2 tablespoons maple syrup

2 tablespoons firmly packed brown sugar

1 tablespoon unsalted butter

½ teaspoon vanilla extract

⅛ teaspoon ground cinnamon, plus more for serving

½ cup pitted dates, coarsely chopped

¼ cup toasted almonds, coarsely chopped

I'm old enough to remember oats coming in a round, cardboard container that was always saved because it could be turned into a drum. Alas, when I was a kid, that container was oatmeal's greatest quality. Each morning my siblings and I were presented with bowls of tasteless mush that we dutifully shoved in our mouths before heading to school. Here I give oatmeal a makeover. There's nothing better than the warm, earthy, fill-your-soul goodness you get when you combine oats with butter, brown sugar, maple syrup, vanilla, dates, and almonds. While I wholeheartedly approve of modern oatmeal, I draw the line at oatmeal brûlée. Breakfast should never require the use of a blowtorch!

Bring the water and half-and-half to a boil in a medium saucepan. Stir in the oats and salt. Reduce the heat to medium-low and cook, stirring occasionally, for 5 minutes, or until the oatmeal thickens. Remove from the heat.

Stir in the maple syrup, brown sugar, butter, vanilla, and cinnamon.

Top each bowl of oatmeal with dates, almonds, and a sprinkling of cinnamon and serve.

SHAKSHUKA

PREP TIME: **20 MINUTES** • COOK TIME: **35 MINUTES**

2 tablespoons olive oil

1 large yellow onion, chopped

1 large red bell pepper, chopped

6 garlic cloves, finely chopped

1½ teaspoons kosher salt

1 teaspoon ground cumin

1 teaspoon ground coriander

1 teaspoon curry powder

1 teaspoon paprika

1 (28-ounce) can crushed tomatoes

⅔ cup vegetable stock

6 large eggs

½ cup crumbled feta cheese

Freshly ground black pepper

Fresh herbs, such as mint, cilantro, or parsley, for garnish

Warm crusty bread, for serving

The first time I saw shakshuka on a menu, I ordered it immediately even though I wasn't sure what to expect. It was just fun to say. *I'll have the shakshuka!* This showstopper of a brunch dish is equally delightful to eat. Poach eggs in a sauce of tomatoes and red peppers gussied up with aromatic spices, and it's almost like they shout, *Hey, look what else we can do!* This flavorful dish is easy to make and sure to impress friends, family, future in-laws, and even the ultra-picky.

Preheat the oven to 375°F.

Heat the oil in a large ovenproof skillet with a lid over medium heat. Add the onion and bell pepper and cook until softened, about 10 minutes. Add the garlic, salt, cumin, coriander, curry powder, and paprika and cook until the garlic is fragrant, about 1 minute. Reduce the heat to medium-low and add the tomatoes and vegetable stock. Cover and cook, stirring occasionally, until the sauce thickens, about 8 minutes.

Remove from the heat and, with the back of a spoon, make 6 indentations in the tomato sauce. Crack an egg into each one. Transfer the skillet to the oven and cook until the eggs are just set, or until they're cooked the way you like them, 10 to 14 minutes.

Top with the crumbled feta, black pepper, and herbs and serve immediately with warm bread.

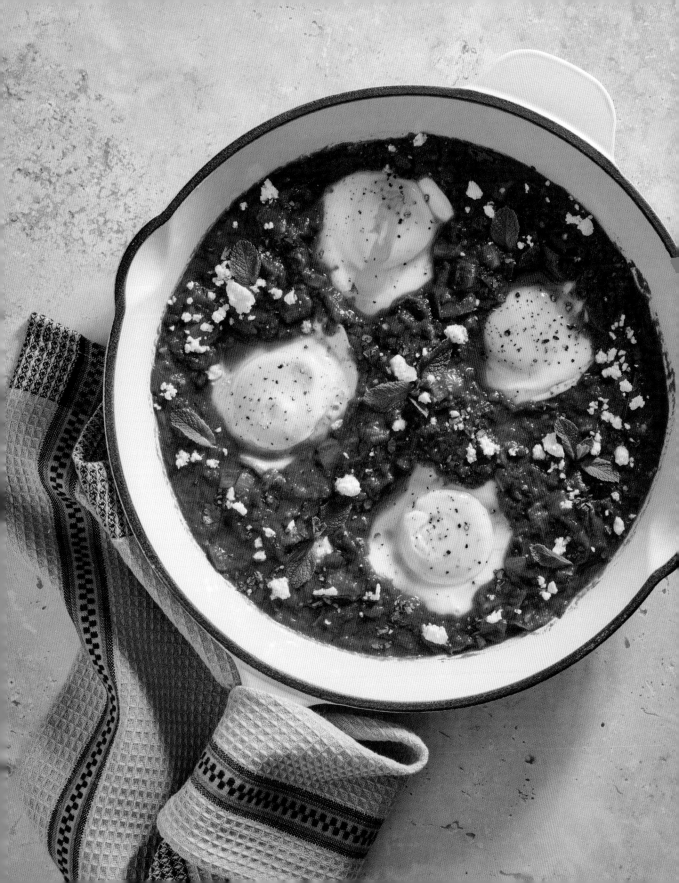

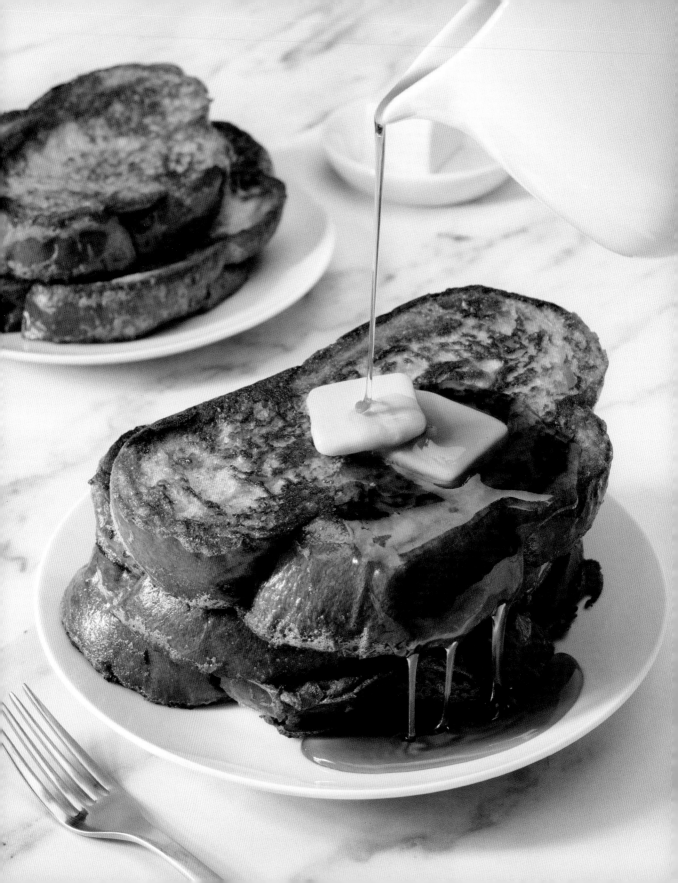

LIFE-SKILLS FRENCH TOAST

PREP TIME: **15 MINUTES** • COOK TIME: **10 MINUTES**

3 large eggs

¾ cup whole milk

1½ tablespoons granulated sugar

1 teaspoon vanilla extract

¼ teaspoon ground cinnamon

⅛ teaspoon ground nutmeg

⅛ teaspoon kosher salt

4 (1½-inch-thick) slices challah bread, preferably 1 to 2 days old

Butter and warm maple syrup, for serving

I call this life-skills French toast because it's a perfect example of how, with just a touch of culinary creativity, it's possible to transform something very basic into something decadent. Here, we're taking a slice of plain ole bread and soaking it in eggs and cream that have been seasoned with vanilla, cinnamon, and nutmeg. It's the ultimate bread makeover. Challah is my favorite here because it helps achieve the embodiment of French toast balance: a crisp exterior and a soft, almost custard-like center that is harmony on a plate.

In a shallow baking dish, whisk together the eggs, milk, sugar, vanilla, cinnamon, nutmeg, and salt.

Add the bread slices to the egg mixture and let them soak on one side for 5 minutes. Flip and let soak on other side for 5 minutes.

Lightly coat a large griddle or skillet with cooking spray, then heat over medium-high heat. The pan is ready when a few drops of water sprinkled on the surface roll around for a second before evaporating. Working in batches as necessary, remove the custard-soaked toast from the bowl, shake off the excess egg mixture, and place in the hot pan. Cook until the undersides are golden brown, about 2 minutes, pressing down on the bread occasionally. Flip and cook until the other sides are golden brown, about 2 minutes.

Serve with butter and warm maple syrup.

If you can't find challah, you can substitute brioche. Or, if you have any dry, stale loaf of bread staring at you from the countertop, that will do too.

EVERYTHING-BAGEL AND LOX STRATA

PREP TIME: **15 MINUTES** • COOK TIME: **40 MINUTES**

3 everything bagels, preferably 1 to 2 days old, split

7 large eggs

1 cup heavy cream

1 cup half-and-half

¼ teaspoon kosher salt

4 ounces cream cheese, at room temperature

4 ounces sliced lox or smoked salmon

Thinly sliced red onion, capers, and dill sprigs, for garnish

No human being has ever walked into a bagel shop on a Sunday morning and ordered the right number of bagels. It's impossible. The second I walk up to the counter and say, "Give me two everything bagels and two sesame," a miniature bagel devil materializes on my shoulder. *C'mon Roker! Four lousy bagels? What if someone wants seconds? A neighbor could stop over. You wanna look stingy? What's wrong with you? Go with the dozen!* The result? Extra bagels. The solution? This mouthwatering strata, which is basically bagels, lox, and cream cheese in casserole form.

Preheat the oven to 350°F. Spray a 9-inch-square baking dish with cooking spray.

Cut the bagel halves into 1-inch pieces (you should have 6 to 7 cups) and put them in the prepared baking dish.

Whisk the eggs, cream, half-and-half, and salt in a large bowl until combined. Pour the egg mixture on top of the bagels, gently pressing on the pieces to help cover them with the egg mixture. Using a spoon, dollop bits of cream cheese on top evenly. Bake for 35 to 40 minutes, until the center is set and the edges are golden brown.

Let the casserole cool for at least 10 minutes. Arrange the lox on top and sprinkle with red onion, capers, and dill sprigs. Cut into squares and serve.

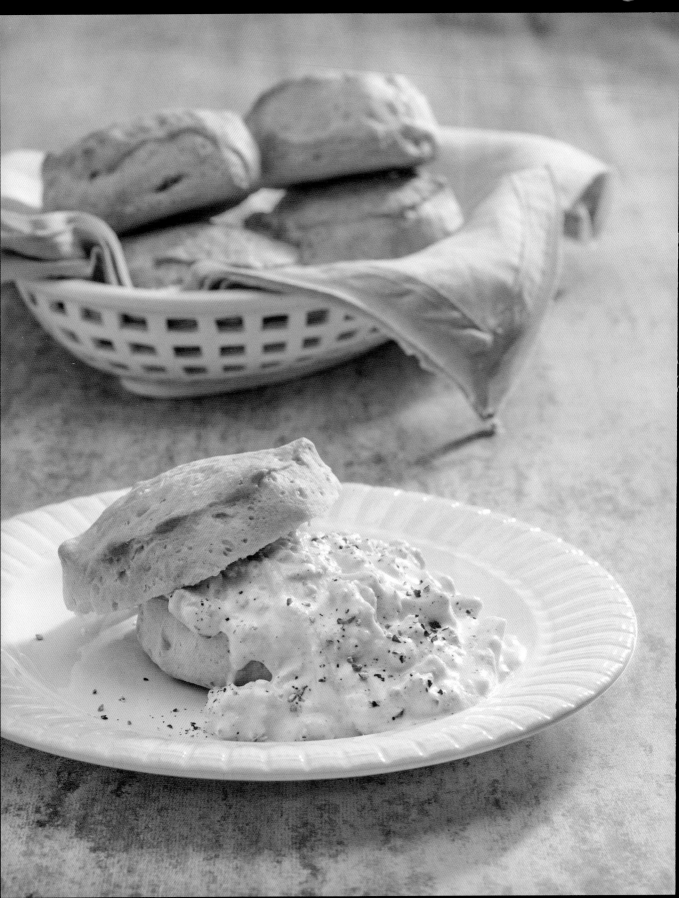

BISCUITS AND CHICKEN-APPLE SAUSAGE GRAVY

PREP TIME: **20 MINUTES** • COOK TIME: **30 MINUTES**

BISCUITS

3 cups all-purpose flour, plus more for dusting

12 tablespoons (1½ sticks) unsalted butter, chilled and cut into pieces

2 tablespoons granulated sugar

2 tablespoons baking powder

1 teaspoon kosher salt

1¼ cups buttermilk

SAUSAGE GRAVY

2 teaspoons canola oil

1 pound ground chicken

1 Honeycrisp or other sweet apple, peeled, cored, and finely diced

2 teaspoons ground sage

1½ teaspoons kosher salt

1 teaspoon freshly ground black pepper

1 teaspoon dried thyme

1 teaspoon garlic powder

1 teaspoon onion powder

2 tablespoons unsalted butter

3 tablespoons all-purpose flour

2 cups half-and-half

2 teaspoons apple cider vinegar

NOTE If the gravy gets too thick, add a bit more half-and-half to thin it out.

You know the breakfast quandary. *Do I want to go sweet or savory? I want pancakes and syrup . . . wait, no! I want eggs and sausage! I just don't know!* Let me solve your dilemma with this fresh take on a Southern classic. The buttermilk biscuits satisfy your desire for something on the saltier side—and who doesn't like biscuits?—while the Honeycrisp apple and sausage lend just enough sweetness to ensure you won't regret skipping the pancakes. Think of this dish as the ultimate breakfast tiebreaker topped off with gravy.

FOR THE BISCUITS: Preheat the oven to 425°F. Line a baking sheet with parchment paper.

Combine the flour, butter, sugar, baking powder, and salt in a food processor. Pulse 5 or 6 times, until the butter is pea-sized. Transfer the flour mixture to a large bowl, add the buttermilk, and mix with a fork until the dough is combined. Transfer the dough to a generously floured work surface and knead just until the dough comes together, about 3 minutes. Roll out to a ½-inch thickness. Using a 3-inch biscuit cutter or the top of a glass, cut out biscuits. Gather the scraps together, roll out again, and cut out more biscuits; you should have 8 biscuits. Place the biscuits 1 inch apart on the prepared baking sheet. Bake for about 15 minutes, until golden brown.

MEANWHILE, FOR THE SAUSAGE GRAVY: Heat the oil in a large skillet over medium heat. Add the ground chicken, apple, sage, salt, pepper, thyme, garlic powder, and onion powder and cook, stirring the chicken with a fork to break it up, until fully cooked and crumbled, about 5 minutes.

Add the butter and stir until melted. Stir in the flour and continue to cook for 1 minute, stirring constantly. Add the half-and-half and cook, stirring occasionally, for about 5 minutes, until thickened. Stir in the vinegar.

Ladle the sausage gravy over the biscuits and serve.

CHOCOLATE CHIP PANCAKES

PREP TIME: **15 MINUTES** • COOK TIME: **15 MINUTES**

2 cups all-purpose flour

2 tablespoons granulated
sugar

1 tablespoon baking powder

¼ teaspoon kosher salt

1⅔ cups whole milk

1 large egg

4 tablespoons (½ stick)
unsalted butter, melted and
cooled, plus more butter for
serving

½ cup semisweet chocolate
chips, plus more for serving

Warm maple syrup, for
serving

Nothing says *Hello, Saturday morning* like a stack of warm pancakes studded with chocolate chips. Breakfast is the only meal where it is acceptable to eat sweets, and let's face it, the second you add chocolate to a breakfast item, *voilà!* It becomes a dessert. Another benefit of these pancakes is that the sweet smell of the melted chocolate is like a magnet, drawing everyone right to the table even when they are engrossed in a *New York Times* crossword, playing video games, watching cartoons, or trying to sleep in.

Whisk the flour, sugar, baking powder, and salt in a large bowl.

In a medium bowl, whisk together the milk, egg, and melted butter. Add the wet ingredients to the dry and stir until just combined. Stir the chocolate chips into the batter.

Lightly coat a large griddle or skillet with cooking spray and heat over medium-high heat. The pan is ready when a few drops of water sprinkled on the surface roll around for a second before evaporating. Working in batches, pour ¼ cup batter onto the hot pan for each pancake, spacing them about 1 inch apart. Cook, undisturbed, until bubbles rise to the surface of the batter and the undersides are nicely browned, 2 to 3 minutes. Flip and cook until the other sides are lightly browned, about 1 minute.

Serve immediately, with butter, maple syrup, and additional chocolate chips.

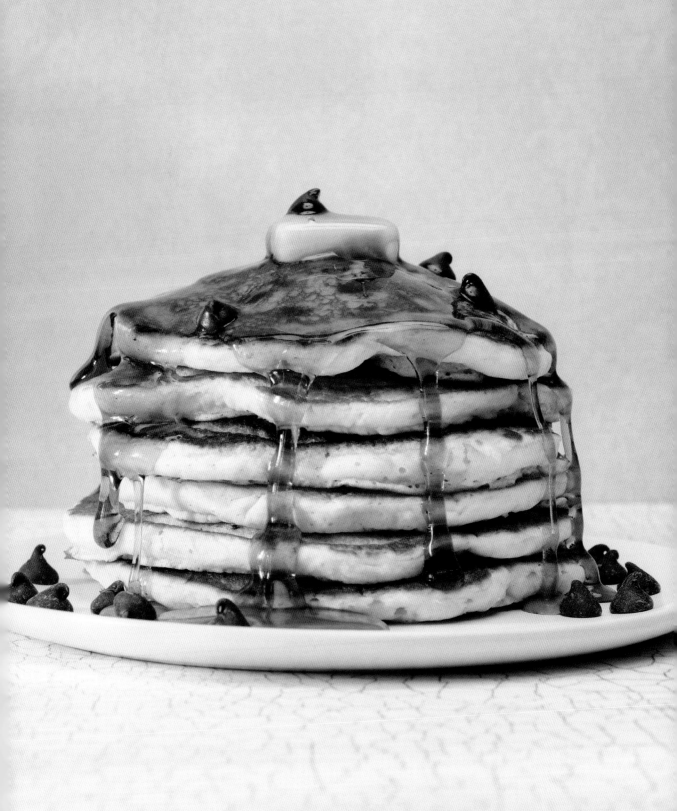

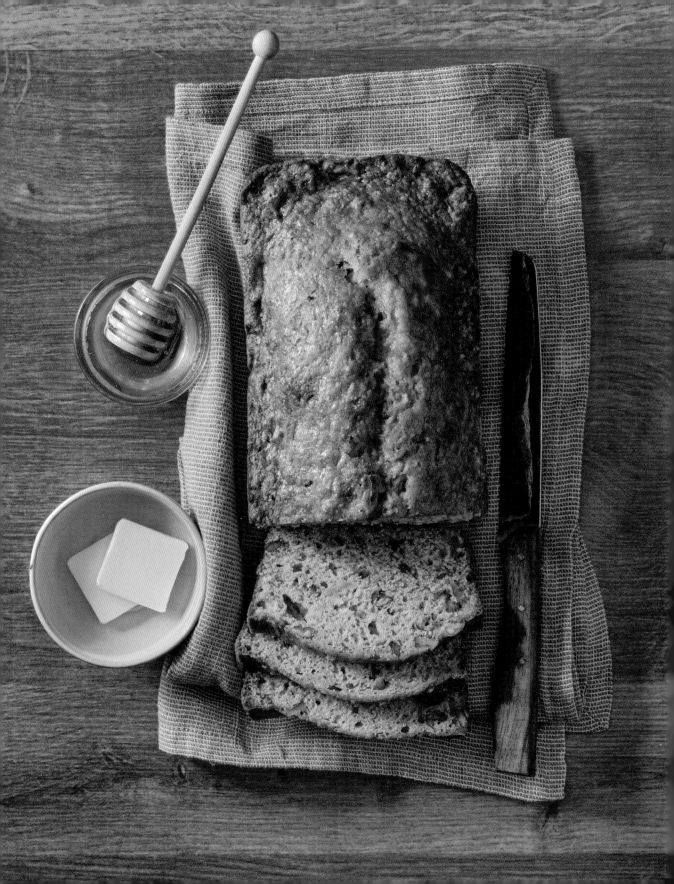

MIND-ALTERING BANANA BREAD

PREP TIME: **15 MINUTES** • COOK TIME: **40 MINUTES**

3 overripe bananas, peeled

8 tablespoons (1 stick) unsalted butter, melted

¾ cup granulated sugar

2 large eggs

1 teaspoon vanilla extract

1¼ cups all-purpose flour

½ teaspoon baking soda

½ teaspoon kosher salt

½ teaspoon ground cinnamon

½ cup chopped pecans

Confession: I'm not a huge banana bread guy. To me it's like unfrosted cake. Sure, I'll eat a banana in its natural state, and I appreciate its contribution to the classic comedy trope, but bananas in a baked form just aren't my go-to. That being said, my wife, Deborah, jumped on the banana-bread wagon during the Covid-19 pandemic, and the smell of it baking was undeniably wonderful, providing a much-needed sense of comfort during a difficult time. The aroma alone was enough to get me to try it. And as it turns out, this pecan-studded loaf is good enough to win over even a jaded banana-bread eater like me.

Preheat the oven to 350°F. Lightly grease a 9×5-inch loaf pan.

Mash the bananas in a large bowl with a potato masher or a fork. Add the butter, sugar, eggs, and vanilla and mix to combine. Add the flour, baking soda, salt, and cinnamon and stir until combined. Gently fold in the chopped pecans.

Scrape the batter into the prepared loaf pan and bake for 35 to 40 minutes, until a toothpick inserted in the middle comes out clean.

Let the bread cool in the pan for 20 minutes, then run a knife around the edges and turn it out onto a rack. Invert again, then slice and serve.

 To kick your banana bread up to another level, add ½ cup semisweet chocolate chips to the batter.

CHRISTMAS MORNING CINNAMON ROLLS

PREP TIME: **25 MINUTES** • COOK TIME: **25 MINUTES**

FILLING

½ cup firmly packed dark brown sugar

¼ cup granulated sugar

2 teaspoons ground cinnamon

ROLLS

½ cup half-and-half, warmed (110°F to 115°F)

1 tablespoon granulated sugar

1 teaspoon rapid-rise instant yeast

2 cups all-purpose flour, plus more for dusting

2 large eggs, at room temperature

7 tablespoons unsalted butter, melted and cooled, divided

¼ teaspoon kosher salt

½ cup heavy cream, at room temperature

FROSTING

4 ounces cream cheese, at room temperature

½ cup powdered sugar

2 tablespoons heavy cream, at room temperature

1 teaspoon vanilla extract

While my dad didn't feel the need to limit cinnamon rolls to special occasions, he made them every Christmas without fail. When I became a father, I decided to follow in his floury footsteps and learn to make them myself. Thanks to the miracle of instant yeast, they can go into the oven right after I've whipped them together, and they start emitting their irresistible, better-than-Cinnabon aroma in the middle of our gift exchange. By the time we've opened presents, they're ready to be frosted and we sit down to eat them, as jolly as Christmas elves.

Preheat the oven to 375°F. Lightly grease a 9-inch square baking pan with cooking spray.

FOR THE FILLING: Mix the sugars and cinnamon in a small bowl.

FOR THE ROLLS: Mix the half-and-half, granulated sugar, and yeast in the bowl of a stand mixer fitted with the dough hook. Add the flour, eggs, 4 tablespoons of the melted butter, and the salt. Mix the dough on low speed for 5 minutes, scraping the sides of the bowl with a silicone spatula occasionally.

Transfer the dough to a lightly floured workspace. Roll it out into a 12×16-inch rectangle. With a pastry brush, brush the remaining 3 tablespoons melted butter all over the dough. Sprinkle the filling all over the dough, pressing it in. Roll up the dough tightly into a log and cut crosswise into 1½-inch-thick pieces.

Place the rolls in the prepared pan, next to each other, cut sides up. Press down on each roll to make it slightly wider. Pour the cream on top of the rolls and bake for about 25 minutes, until the rolls are light golden brown.

MEANWHILE, FOR THE FROSTING: Stir together the cream cheese, powdered sugar, cream, and vanilla in a small bowl.

Spread the rolls with half of the frosting. Let sit for 5 minutes. Spread the remaining frosting on top and serve.

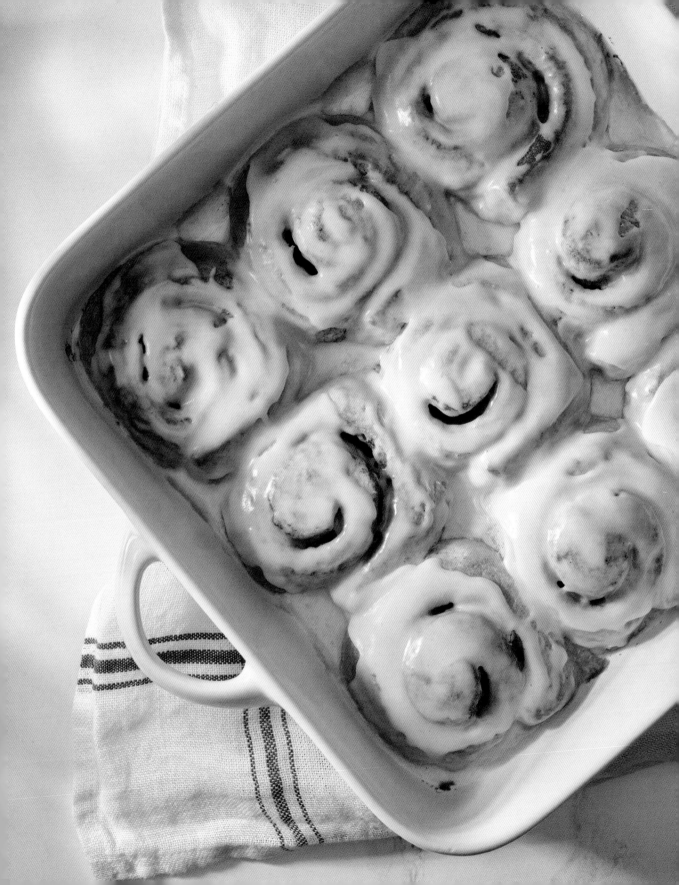

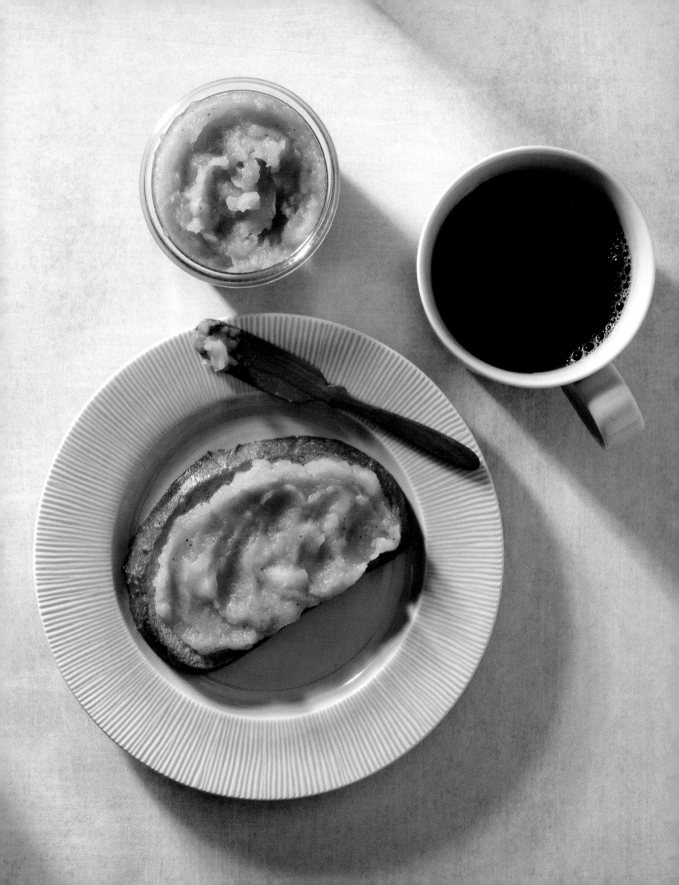

COURTNEY'S APPLE BUTTER

PREP TIME: **15 MINUTES** ◆ COOK TIME: **20 MINUTES**

2 pounds Granny Smith apples (about 4), peeled, cored, and cut into ½-inch dice

⅓ cup water

2 tablespoons unsalted butter

¼ teaspoon ground cinnamon

⅛ teaspoon ground nutmeg

½ cup granulated sugar

2 teaspoons lemon juice

½ teaspoon vanilla extract

¼ teaspoon kosher salt

The taste of apple butter takes me right back to the simple pleasures of a Sunday afternoon. When Courtney was little, and before Deborah and I were married, we'd all go to church together, followed by brunch at Sarabeth's in New York City. Courtney, who had a great palate even then, would go straight for the apple butter and plaster it on just about anything. I swear you could smear this stuff on a saltshaker and it would be rendered edible, so you can imagine what it will do for toast, pancakes, and even oatmeal.

Combine the apples, water, butter, cinnamon, and nutmeg in a medium saucepan. Cook over medium heat, stirring frequently, until the apples are slightly tender, about 10 minutes.

Reduce the heat to medium-low and stir in the sugar, lemon juice, vanilla, and salt. Continue to cook, stirring frequently, until the mixture thickens and the apples break down to a chunky puree, about 10 minutes. Remove the pan from the heat.

Let cool to room temperature before refrigerating. Store in an airtight container in the refrigerator for up to 1 week.

PEPPER'S CHEESY THUMBPRINT COOKIES

PREP TIME: **10 MINUTES** • COOK TIME: **15 MINUTES**

1 cup oat flour

1 cup shredded cheddar cheese

1 large egg

2 tablespoons olive oil

2 tablespoons water

Hello, humans! Pepper here. I'm a Havanese who has lived with the Rokers for eleven years now, and I've picked up a thing or two hanging around in the family kitchen. While Al never shares his bacon with me, he does make me these treats. It's true that we dogs generally love to eat everything, including shoes, but we really appreciate food made with wholesome ingredients without any of the fillers or preservatives found in treats from the store. These cookies are a cost-effective way to provide your pooch with something extra special. After I eat one of these cheesy delights, I flop onto the floor and offer up my belly as thanks.

Preheat the oven to 375°F. Line a baking sheet with parchment paper.

Combine the oat flour, cheese, egg, olive oil, and water in a medium bowl and, using a silicone spatula, mix until a dough forms.

Using a tablespoon, scoop out the dough and roll into balls. Place the balls on the prepared baking sheet about 1 inch apart. Press your thumb down lightly on each ball. Bake for about 15 minutes, until the treats are slightly puffed and the cheese has melted.

Cool the cookies on a rack, then transfer to an airtight container and store in the refrigerator for up to 1 week.

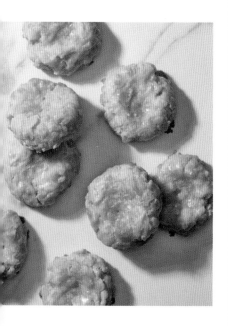

NOTE — FROM UNCLE AL

If you can't find oat flour in your store, just put old-fashioned oats in a food processor and blend until powdery.

SALAD GREENS

AND LIQUID LOVE

I'LL BE HONEST WITH YOU. I'M NOT A SALAD-FOR-LUNCH- every-day kind of guy. I'm more of a side-of-simple-greens-with-dinner person...ideally with my fresh ginger dressing. There are times, though, when a good salad as a meal is just the ticket. It's like my body and mind have talked it over and have sent me a clear message: *Hey you, it's time to get your greens on. We could really go for a nice fresh tuna Niçoise today. Got it?* When those moments hit, I'm armed and ready with inventive salad recipes that are full of colors and flavors.

When precipitation pelts your windows, there are few things more satisfying than a pot simmering on the stove. Soups are like the classic charcoal-gray suit of food—they can serve you well in a variety of situations. A French onion soup filled with fragrant caramelized onions, cheese, and croutons is just the thing to serve at a quiet dinner with friends who like you enough to brave the elements. Or, if you're aiming to feed a crowd, a big pot of silky, hearty bean soup will do the job.

Soups and salads have a super-power—they make everyone feel better. Either will come together quickly, and while they can't exactly rub your feet, a nice salad or a bowl of liquid love will set everything straight.

Courtney and Leila in Greece

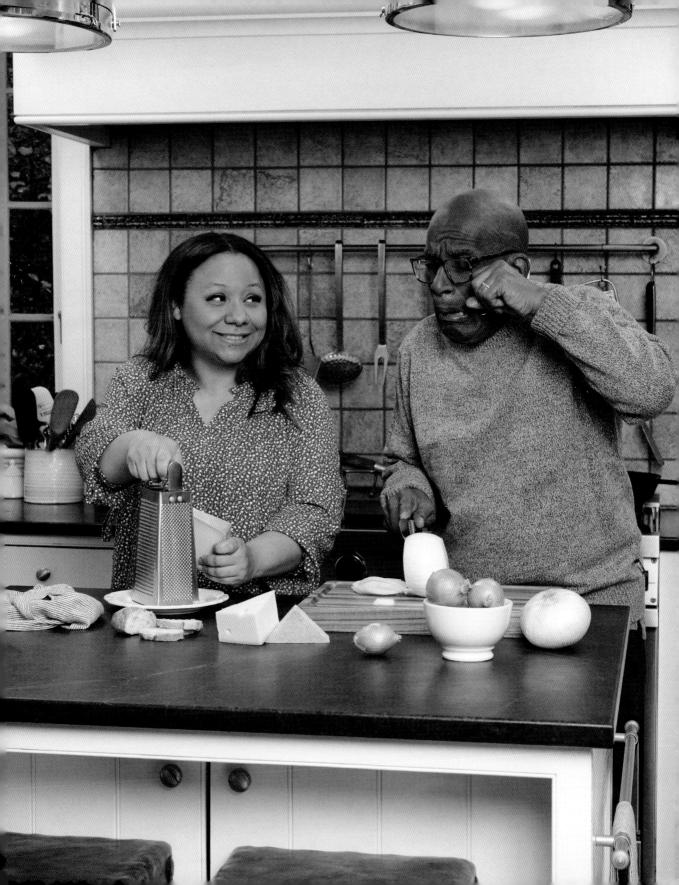

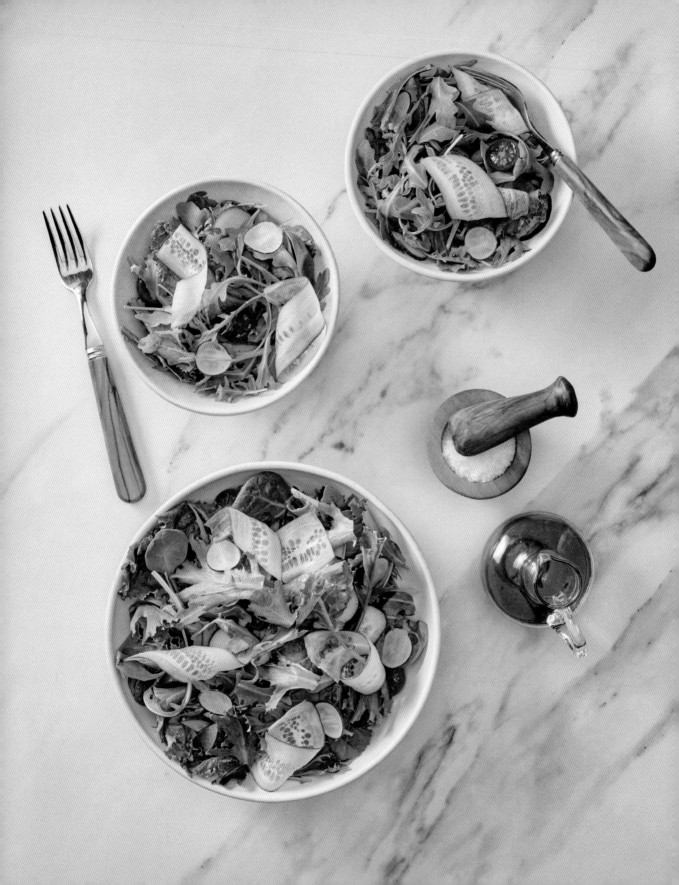

MIXED GREENS WITH GINGER DRESSING

PREP TIME: **20 MINUTES** • COOK TIME: **5 MINUTES**

DRESSING

½ cup rice vinegar

¼ cup granulated sugar

2 tablespoons soy sauce

1 tablespoon toasted sesame oil

1 tablespoon ginger paste

1 teaspoon garlic paste

¼ cup canola oil

SALAD

5 ounces mixed greens

5 ounces baby arugula

1 cucumber, sliced or shaved

1 cup cherry tomatoes, halved

5 radishes, thinly sliced

If you can't find ginger paste and garlic paste in your local grocery store (look for them in squeeze tubes in the produce section or jarred with the seasonings), then minced fresh ginger and garlic will do just fine.

Every family should have a go-to salad dressing recipe. By having this gingery dressing on hand, you'll find it ridiculously easy to whip up a healthy green salad to go along with any meal. Ginger and greens: two superfoods! This salad is a winner, and it works great with the ginger dressing. Move over, romaine, and make room for arugula. Arugula is like the cool, older cousin you've always admired. It's a bit on the sophisticated side with its unique flavor, but other ingredients can tag along with it, no problem. Everyone in this salad has a good time together!

FOR THE DRESSING: Bring the rice vinegar and sugar to a boil in a small saucepan, stirring to dissolve the sugar. Remove from the heat and let cool for 5 minutes. Pour the warm vinegar mixture into a medium bowl. Add the soy sauce, sesame oil, ginger paste, and garlic paste and whisk together. Slowly whisk in the canola oil. Let the dressing come to room temperature. (This dressing yields about ¾ cup; leftovers will keep in an airtight container in the refrigerator for up to a week.)

FOR THE SALAD: Toss the mixed greens, arugula, cucumber, cherry tomatoes, and radishes together in a serving bowl. It's best to add the dressing gradually so you don't oversaturate the leaves. Start with 2 tablespoons or so, toss, and taste, then add more dressing as needed, and serve.

CLASSIC WEDGE SALAD

PREP TIME: **15 MINUTES** • COOK TIME: **5 MINUTES**

BLUE CHEESE DRESSING

1 cup crumbled Stilton cheese, plus more for topping

⅔ cup mayonnaise

⅓ cup sour cream

⅓ cup buttermilk

2 teaspoons sherry vinegar

¼ teaspoon garlic powder

¼ teaspoon kosher salt

SALAD

4 slices uncured bacon

1 medium head iceberg lettuce, cored and cut into quarters

1 cup cherry tomatoes, halved

2 tablespoons minced fresh chives

Freshly ground black pepper

What would your last meal be? I'm always a little puzzled when people need to pause when this question comes up. *Really? You don't know?* I'd go with the traditional steak house dinner, and the wedge salad would be the opening number for that spectacular meal. (Additional acts would include a 3-inch-thick T-bone, creamed spinach, and steak fries, with an apple crumble for the finale.) Leave it to a steak house to invent a great salad. Iceberg lettuce is crisp and fairly sturdy, which means it can hold up to hearty ingredients like bacon, blue cheese dressing, and fresh tomatoes. This salad is on the old-school side, but it has stuck around for good reason. There's no need to wait for your last meal to enjoy it.

FOR THE DRESSING: Combine the crumbled cheese, mayonnaise, sour cream, buttermilk, vinegar, garlic powder, and salt in a medium bowl. Mix well, using the back of a spoon to press the cheese into the mixture. (This dressing yields about 2 cups; leftovers will keep in an airtight container in the refrigerator for up to a week.)

FOR THE SALAD: Cook the bacon in a medium skillet over medium heat, turning halfway through, for about 5 minutes, until crisp. Transfer to a paper towel–lined plate to drain, then chop.

Place each quartered iceberg wedge on a serving plate. Generously top each wedge with some of the blue cheese dressing, cherry tomatoes, chopped bacon, and chives. Season with pepper, top with more crumbled cheese, and serve.

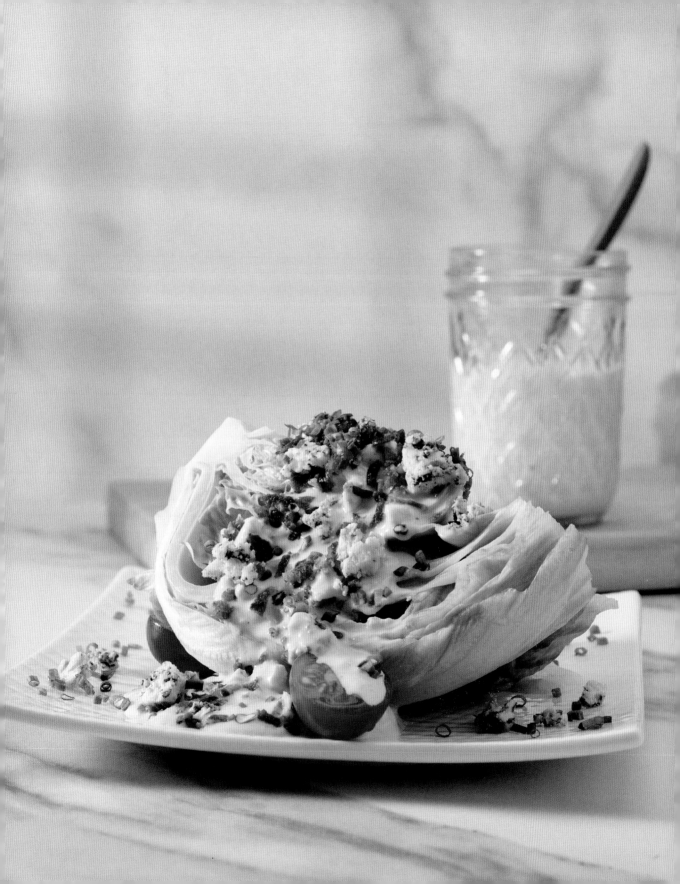

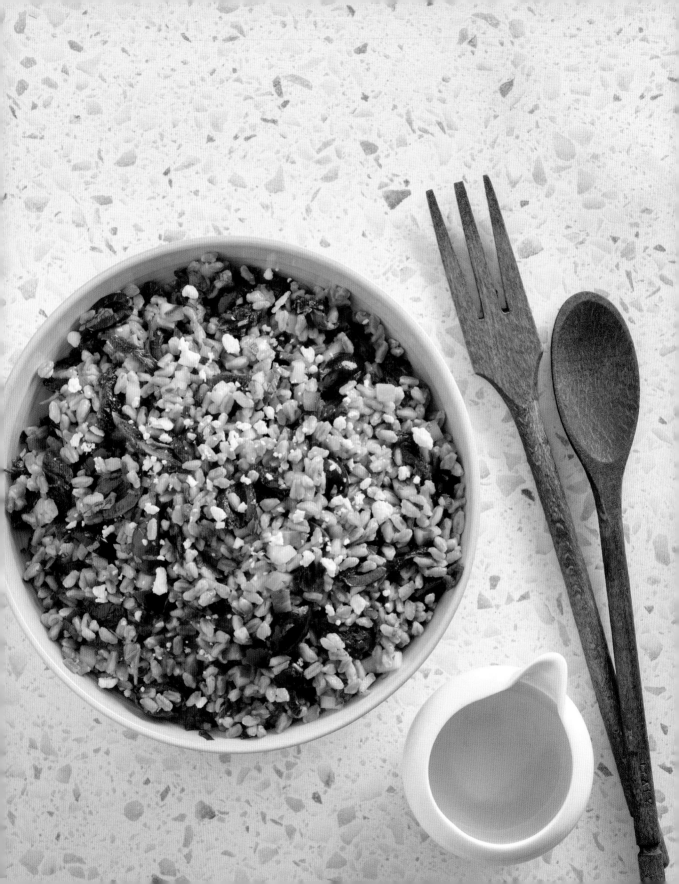

MEDITERRANEAN FARRO SALAD

PREP TIME: **25 MINUTES** • COOK TIME: **15 MINUTES**

2½ cups farro (about 1 pound)

6 tablespoons lemon juice

¼ cup champagne vinegar

2 tablespoons honey

1 teaspoon dried oregano

½ teaspoon kosher salt

½ cup olive oil

1 (14-ounce can) artichoke hearts, drained and chopped

1 small red bell pepper, finely diced

1 cucumber, finely diced

1 cup pitted kalamata olives, halved

½ cup chopped sun-dried tomatoes

¼ cup chopped fresh parsley

¼ cup chopped fresh mint

½ cup unsalted roasted shelled pistachios, chopped

½ cup crumbled feta cheese

I love a grain that's outside the box, and farro fits the bill perfectly. It's toothsome, it's smooth but not overly chewy, and it absorbs flavors like lemon and champagne vinegar with aplomb. This salad is a festival of flavors, from the zap of the vinegar and sweetness of the honey to the unexpected crunch of the pistachios and saltiness of the feta. Each bite brings a delicious new surprise. Whoa, there's an artichoke! An olive! The salad makes a pleasant lunch or a side at dinner.

Bring a large saucepan of water to a boil, stir in the farro, and cook according to the package directions until al dente, about 15 minutes. Drain in a colander and rinse with cold water until cool.

Mix the lemon juice, vinegar, honey, oregano, and salt in a medium bowl. Slowly pour in the olive oil and whisk until the dressing comes together.

Transfer the cooked farro to a large bowl and add the artichoke hearts, bell pepper, cucumber, olives, sun-dried tomatoes, parsley, mint, pistachios, and feta. Pour in the salad dressing and toss to combine. Serve or cover and refrigerate for up to 2 hours.

ROBERTS' FAMILY SOUTHERN POTATO SALAD

- 3 large russet (Idaho) potatoes, peeled and cut into 1-inch chunks
- 3 large eggs
- ½ cup mayonnaise
- ⅓ cup sweet pickle relish
- 1 tablespoon yellow mustard
- 3 tablespoons finely diced celery
- 1 tablespoon finely diced onion
- 2 teaspoons diced jarred pimientos
- 1 teaspoon kosher salt
- ½ teaspoon freshly ground black pepper
- Paprika, for garnish

Any time there's a need for potato salad, Deborah jumps in immediately, and for good reason. Her recipe, an homage to her mom, Ruth Roberts, should be in the Potato Salad Hall of Fame. I've learned to stand back and let her do her thing, then offer up my services as taste tester.

Put the potatoes in a pot and add water to cover by at least 2 inches. Cover the pot and bring the water to a boil over high heat. Carefully add the eggs with a slotted spoon, cover, reduce the heat to low, and simmer until the potatoes are soft but still hold their shape, about 15 minutes.

Remove the eggs from the pot with the slotted spoon and cool under cold running water. Drain the potatoes and place in a large bowl. Peel and chop 2 of the eggs and add to the potatoes. Add the mayonnaise, relish, mustard, celery, onion, pimientos, salt, and pepper and gently mix to combine.

Peel the last egg and slice it. Lay the slices of egg on top of the potato salad and sprinkle with paprika. Serve, or cover and refrigerate for up to 4 hours.

To save time, Deborah efficiently combines the cooking of the potatoes and eggs in one pot.

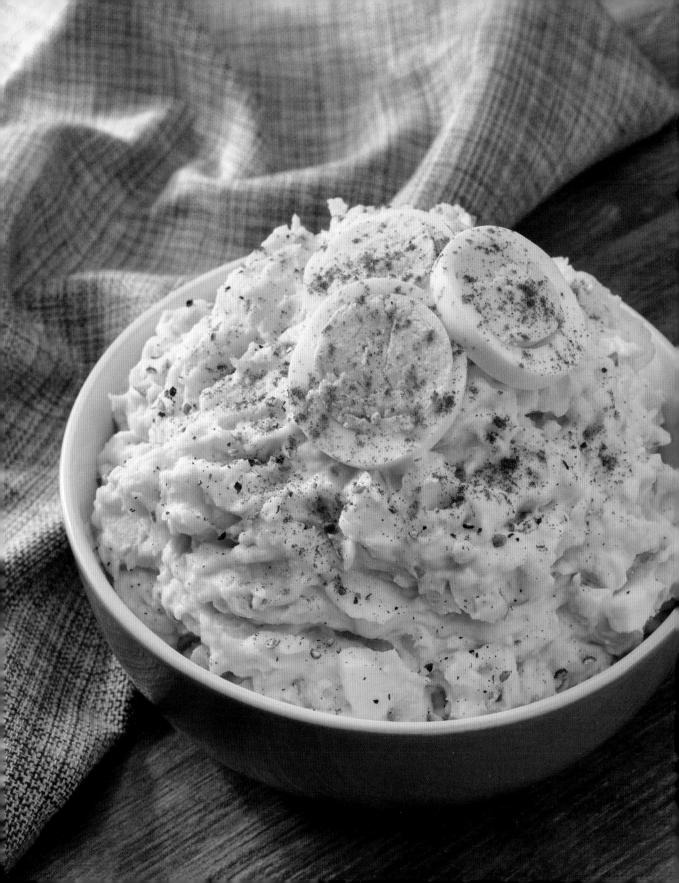

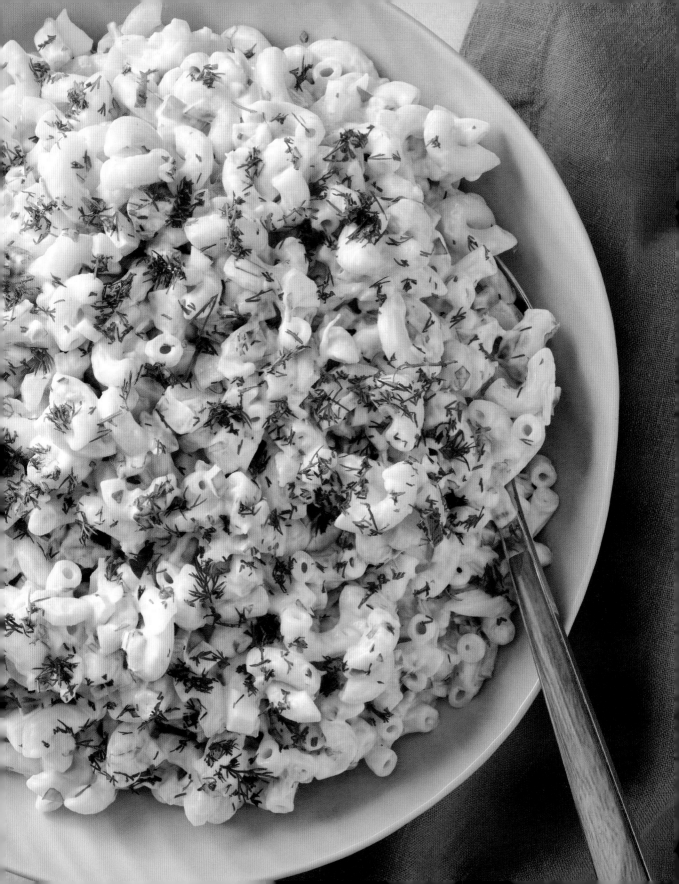

MY MOM'S MACARONI SALAD

PREP TIME: **30 MINUTES** • COOK TIME: **15 MINUTES**

1 (1-pound) box elbow macaroni

5 large eggs

1½ cups mayonnaise

⅔ cup sweet pickle relish

3 tablespoons Dijon mustard

1½ teaspoons kosher salt

1 teaspoon freshly ground black pepper

1 teaspoon paprika

1 celery stalk, finely chopped

1 medium red onion, finely chopped

2 tablespoons chopped fresh dill

2 tablespoons chopped fresh parsley

My mother made this slightly sweet but tangy macaroni salad often, especially for family gatherings. A picnic essential, it was a staple when the Roker clan took a day trip to Rockaway Beach. I can remember the sun on my back, the sand beneath my feet, the sound of the waves crashing on the shore, and eating my macaroni salad with lightning speed because my mother was convinced it spoiled within five seconds of being exposed to the sun. While I am not a food scientist, I suspect all would have been well because it was kept in my father's heavy-duty Igloo cooler right up until it was time to eat. Whether you make this for a picnic, a trip to the beach, or as part of a summer lunch, it's a winner.

Bring a large pot of salted water to a boil and cook the pasta according to the directions on the package. Drain the pasta in a colander and let cool for about 20 minutes.

Meanwhile, place the eggs in a medium pot and cover with cold water by 2 inches. Bring to a boil over medium-high heat and cover. Remove the pot from the heat and set aside, covered, for 10 minutes. Drain and cool the eggs in a bowl of ice water. Once cool, peel and coarsely chop the eggs.

Mix the mayonnaise, relish, mustard, salt, pepper, and paprika in a medium bowl and stir to combine.

Transfer the pasta to a large bowl, add the mayo dressing, and stir until the pasta is coated. Add the eggs, celery, red onion, dill, and parsley and stir to combine. Serve, or cover and refrigerate for up to 4 hours.

Peeling hard-boiled eggs is easiest if you do it under cold running water.

NIÇOISE SALAD WITH FRESH TUNA

PREP TIME: **25 MINUTES** • COOK TIME: **15 MINUTES**

DRESSING

2 tablespoons Dijon mustard

2 tablespoons lemon juice

2 tablespoons finely chopped fresh tarragon

¼ teaspoon kosher salt

½ cup olive oil

SALAD

2 (8-ounce) fresh ahi (yellowfin) tuna steaks, about 1 inch thick

2 tablespoons olive oil, divided

1½ teaspoons kosher salt, divided

1 teaspoon herbes de Provence

8 ounces haricots verts or other slender, young green beans

Bibb lettuce leaves

1 cup cherry tomatoes, halved

1 cup pitted kalamata olives, halved

1 cup radishes, quartered

3 large eggs, hard-boiled (see page 71) and halved

Freshly ground black pepper

I don't believe in the "entrée salad." I always feel like someone's trying to pull one over on me when I hear those words. Salads should be served before dinner or perhaps right along with it. They're not a meal. The Niçoise, however, is a notable exception. It's a hearty combination of haricots verts, lettuce and other vegetables, eggs, and fresh tuna (rare to medium-rare for me, please). This is the only salad someone could serve me for dinner that wouldn't leave me wondering, *Where's the rest?*

Preheat the oven to 350°F.

FOR THE DRESSING: Stir together the mustard, lemon juice, tarragon, and salt in a medium bowl. Slowly whisk in the olive oil until incorporated.

FOR THE SALAD: Spray a baking sheet with cooking spray. Coat the tuna steaks with 1 tablespoon of the olive oil and season both sides with 1 teaspoon of the salt and the herbes de Provence. Put the green beans in a medium bowl and toss with the remaining 1 tablespoon olive oil and remaining ½ teaspoon salt. Place the seasoned steaks on one side of the baking sheet and place the seasoned green beans on the other side. Bake for about 15 minutes, until the inside of the tuna is slightly pink and registers 125°F when an instant-read thermometer is inserted into the middle.

Remove from the oven and let the tuna rest for at least 5 minutes. With your hands, flake the tuna into pieces into a large bowl. Pour ¼ cup of the dressing into the bowl and carefully toss to coat the tuna.

Line a platter with lettuce leaves. Artfully arrange the tuna, green beans, cherry tomatoes, olives, radishes, and boiled eggs on top. Season with black pepper and serve with the remaining dressing on the side for drizzling over the rest of the salad.

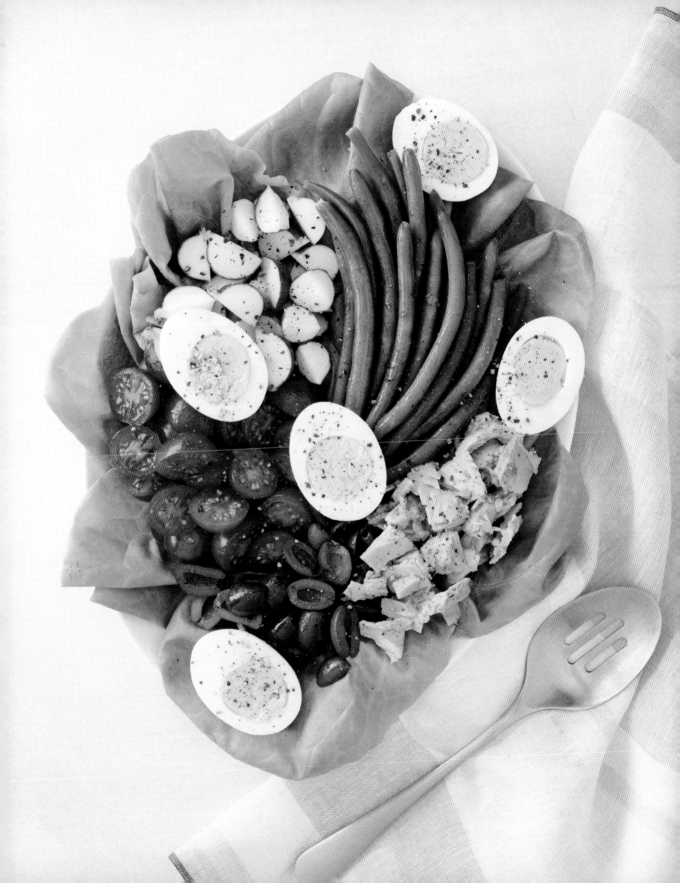

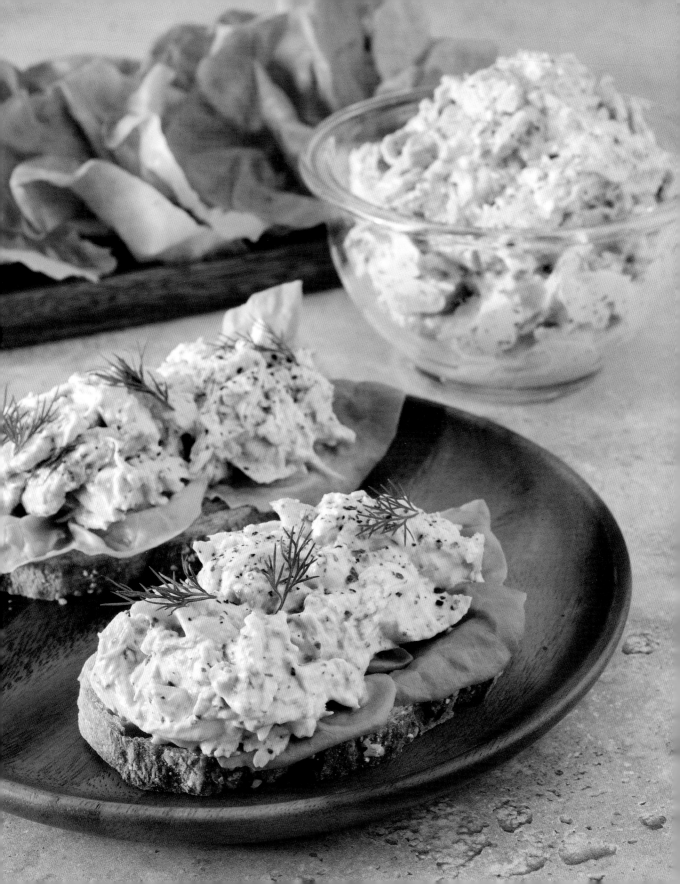

GREEN GODDESS CHICKEN SALAD

PREP TIME: **25 MINUTES, PLUS 1 HOUR TO CHILL** • COOK TIME: **30 MINUTES**

CHICKEN

2 pounds boneless, skinless chicken breasts

1 tablespoon olive oil

1½ teaspoons kosher salt

1 teaspoon freshly ground black pepper

1 teaspoon herbes de Provence

GREEN GODDESS DRESSING

½ Hass avocado

½ cup mayonnaise

½ cup sour cream

¼ cup fresh tarragon leaves

¼ cup fresh dill fronds

¼ cup fresh basil leaves

3 tablespoons chopped fresh chives

2 tablespoons olive oil

2 tablespoons lemon juice

¼ teaspoon kosher salt

Toasted bread, for serving (optional)

Lettuce, for serving (optional)

Sea salt and freshly ground black pepper, for serving (optional)

Shortly after Courtney graduated from culinary school, we were talking in the kitchen while she was chopping vegetables. She was cutting them quicky but precisely. I thought, *Wow, she's really good at this. She's all grown up!* I was full of fatherly pride. I also knew if I attempted to chop vegetables as quickly as she did while talking to someone, I'd lose at least one digit. But when she told me she was making green goddess dressing, I initially thought, *Green? Suspicious. Goddess? That's taking things a bit far, isn't it?* I kept these thoughts to myself because it was time for me to accept she's no longer four and she knows her way around food. Good thing, because as it turns out, this creamy, delicious dressing is downright goddess-like with its velvety smooth texture.

FOR THE CHICKEN: Position a rack in the middle of the oven and preheat to 400°F. Line a baking sheet with aluminum foil or parchment paper.

Put the chicken breasts on the prepared baking sheet, brush with the oil, and season with the salt, pepper, and herbes de Provence. Bake for about 30 minutes, until an instant-read thermometer inserted in the middle reaches 165°F. Transfer the chicken to a cutting board and let cool for about 15 minutes.

MEANWHILE, FOR THE DRESSING: Scoop the avocado flesh into a large, deep bowl and add the mayonnaise, sour cream, tarragon, dill, basil, chives, olive oil, lemon juice, and salt. Using an immersion blender, pulse the mixture until smooth. (Alternatively, combine all of the ingredients in a regular blender or food processor and blend until smooth.) Cover and refrigerate until you are ready to assemble the salad.

FOR THE SALAD: With two forks, shred the chicken, then fold it into the dressing. Cover and refrigerate for at least 1 hour, or until thoroughly chilled. Serve as is or as an open-face sandwich on top of toasted bread with lettuce, sea salt, and pepper, if desired.

SATURDAY EVENING FRENCH ONION SOUP

PREP TIME: **30 MINUTES** • COOK TIME: **1½ HOURS**

4 tablespoons (½ stick) unsalted butter

1 tablespoon olive oil

2 pounds white onions, sliced ¼ inch thick

2 pounds Vidalia onions, sliced ¼ inch thick

2 teaspoons balsamic vinegar

1 teaspoon granulated sugar

1 teaspoon dried thyme

1 teaspoon kosher salt

5 garlic cloves, finely chopped

4 cups beef stock

¼ cup dry red wine

2 teaspoons Dijon mustard

2 teaspoons Worcestershire sauce

CROUTONS

6 (1-inch-thick) slices baguette

2 tablespoons olive oil

2 cups shredded Gruyère cheese

If there is a better take on this soup out there, I haven't found it. I'm usually inspired to make onion soup when the days are getting shorter: I pull my favorite cardigan out of the closet and we invite a small group of friends over for a casual dinner. I open up a bottle of red wine, our guests take a seat in the kitchen, and we all chat away while I slice onions.

I like the mingling of flavors when you use two types of onions, with the yellow being earthier and the Vidalia adding a touch of sweetness. But if there's a chill in the air and all that's standing between you and a perfect cheese-and-crouton-laden-onion soup is that you have only one variety in the house, don't stress it.

Heat the butter and olive oil in a large Dutch oven over medium heat. Add the sliced onions and cook, stirring occasionally, until softened, about 20 minutes. Add the balsamic vinegar, sugar, thyme, and salt and continue to cook, stirring frequently, until the onions are browned and caramelized, about 15 minutes.

Add the garlic and cook for about 1 minute, until fragrant. Stir in the stock, wine, mustard, and Worcestershire, making sure to scrape up the bits at the bottom of the pot. Cover the pot, reduce the heat to low, and simmer for 45 minutes. Once the soup is finished, turn the heat off and prepare the bread.

FOR THE CROUTONS: Preheat the oven broiler. Place the baguette slices on a baking sheet and brush both sides with the olive oil. Broil the bread until well toasted on both sides, about 2 minutes; watch closely, so it doesn't burn. Remove from the oven; leave the broiler on.

Place six ovenproof bowls or ramekins on a baking sheet. Ladle in the soup and top each with a crouton. Divide the Gruyère among the bowls. Carefully transfer the baking sheet to the oven and broil until the cheese melts and is golden brown, about 5 minutes. Let cool for 2 to 3 minutes before serving.

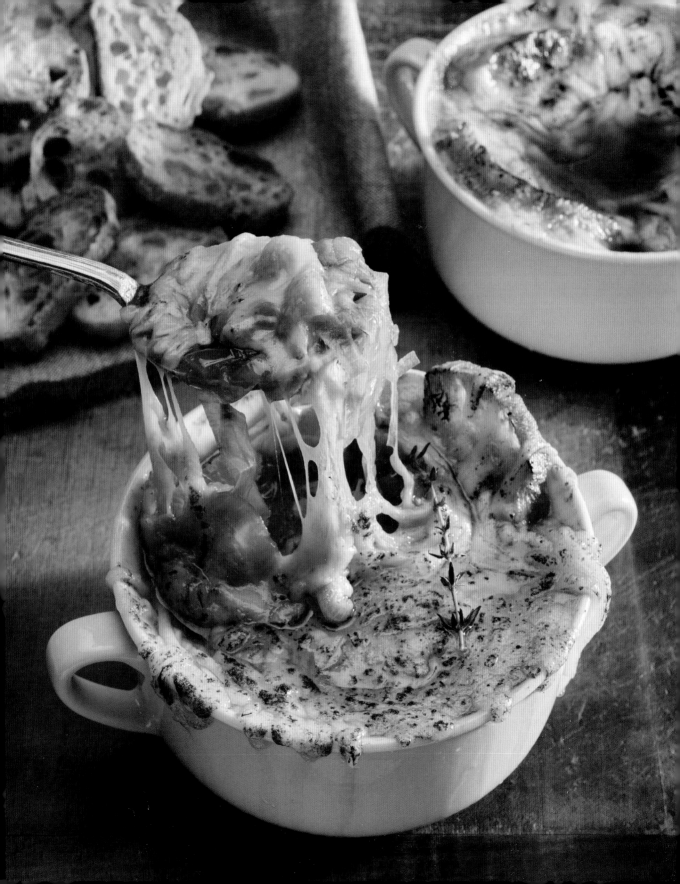

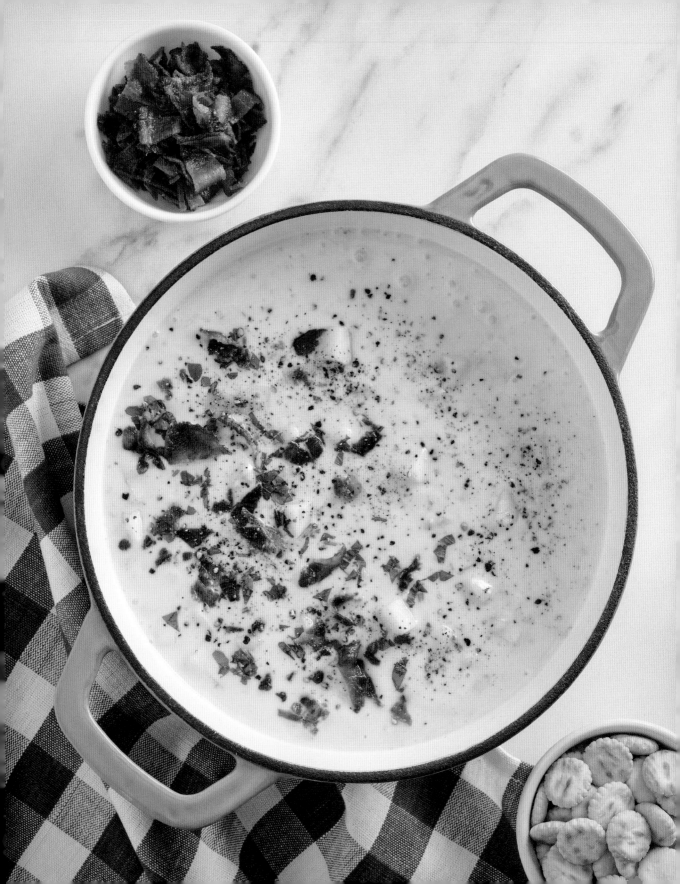

NEW ENGLAND CLAM CHOWDER

PREP TIME: **25 MINUTES** • COOK TIME: **40 MINUTES**

- 2 teaspoons olive oil
- 8 ounces uncured bacon, cut into ½-inch pieces
- 2 tablespoons unsalted butter
- 3 small leeks, trimmed, cleaned, white and light green parts finely chopped
- 2 celery stalks, finely chopped
- 6 garlic cloves, thinly sliced
- 3 medium Yukon Gold potatoes, cut into 1-inch pieces
- 1 cup seafood stock
- 1 (8-ounce) bottle clam juice
- ¼ cup dry white wine
- 1½ teaspoons kosher salt
- 1 teaspoon freshly ground black pepper
- ½ teaspoon dried thyme
- ¼ cup all-purpose flour
- 2 cups heavy cream, at room temperature, divided
- 3 (6½-ounce) cans chopped clams, drained
- Chopped fresh parsley, for garnish
- Oyster crackers, for serving

I'm not going to knock canned soup—it serves its purpose. And for a long time, I was under the impression that I liked canned clam chowder *just fine*. That is, until I had the real thing in a New York City restaurant, and my mind was blown. After the first spoonful of that creamy goodness mixed with chunks of potatoes, bacon, and fresh clams, I swear I heard a chorus of angels singing. But you don't need to go whole clam to get a transcendent experience. A combination of rich seafood stock, which you can get at most big supermarkets, and canned clams delivers the proper saline punch, with leeks, cream, thyme, white wine, and, of course, bacon chiming in.

Heat the oil in a large Dutch oven over medium heat. Add the bacon and cook for about 5 minutes, until crisp, stirring occasionally. Transfer to a paper towel–lined plate to drain.

Add the butter, leeks, celery, and garlic to the pan and cook, stirring occasionally, until the leeks begin to soften, about 8 minutes. Stir in the potatoes, stock, clam juice, wine, salt, pepper, and thyme. Turn the heat down to medium-low and cook until the potatoes are tender, about 15 minutes.

Whisk the flour and 1 cup of the cream in a medium bowl until combined. Whisk the cream mixture into the soup. Continue to cook, stirring occasionally, until thickened, about 5 minutes. Stir in the clams and the remaining 1 cup cream and cook for a few more minutes to heat through.

Top with the bacon and parsley and serve with oyster crackers.

You'll find canned or boxed seafood stock in most supermarkets with the soups or in the seafood section. Kitchen Basics and Bar Harbor are two common brands.

FIFTEEN-BEAN SOUP

PREP TIME: **10 MINUTES** • COOK TIME: **6 HOURS**

1 (16-ounce) package HamBeens 15 Bean Soup mix (seasoning packet discarded)

1 small yellow onion, finely diced

¼ cup finely chopped garlic

1½ tablespoons paprika

1 tablespoon onion powder

1 tablespoon freshly ground black pepper

¼ teaspoon kosher salt, plus more for serving

2 tablespoons hot sauce

8 cups water

4 large bay leaves

8 ounces smoked turkey tails or smoked turkey necks

There comes a moment when you are tasked with bringing food to a potluck at church or maybe a school event. What will feed many people easily? Avoid the well-trodden path of mac and cheese and baked ziti or risk the mother-of-all humiliations, having your dish passed over. The answer is this stick-to-your-ribs soup that my sister Alisa brings to church lunches, so it's basically potluck pretested. It hits all the right chords: it's rich and hearty, and it practically cooks itself, thanks to the slow cooker. This is definitely not your average bean soup. It has an extra-special layer of smoky flavor from the addition of smoked turkey tails, which are plump, slightly gelatinous, and exquisitely tender. Next best thing: turkey necks, which my aunt says are a bit less succulent.

Put the bean mix, onion, garlic, paprika, onion powder, pepper, salt, hot sauce, water, bay leaves, and smoked turkey in a slow cooker and stir to combine. Cover and cook on high for 6 hours, or until the beans are tender. Check occasionally to make sure the liquid is always covering the beans and add more water if it isn't.

When the soup is done, fish out the turkey tails and set aside. Remove and discard the bay leaves. When the tails are cool enough to handle, remove the meat with your fingers and stir it into the soup. Season with salt to taste and serve.

Smoked turkey tails can be on the salty side, which is why there is not a lot of salt in this recipe. Make sure to season to taste once the soup is finished. Can't find turkey tails or necks? Substitute a smoked ham hock.

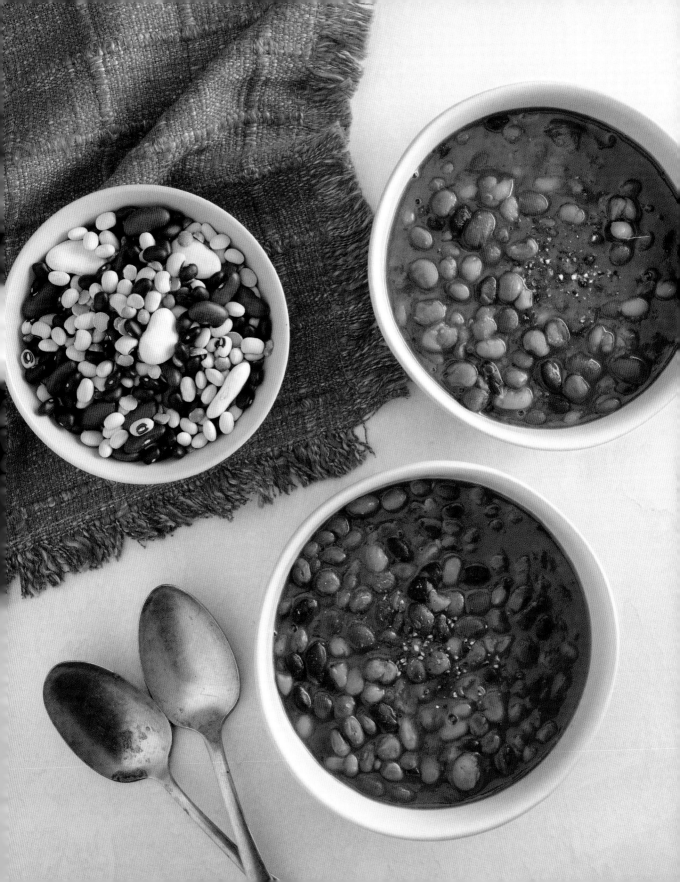

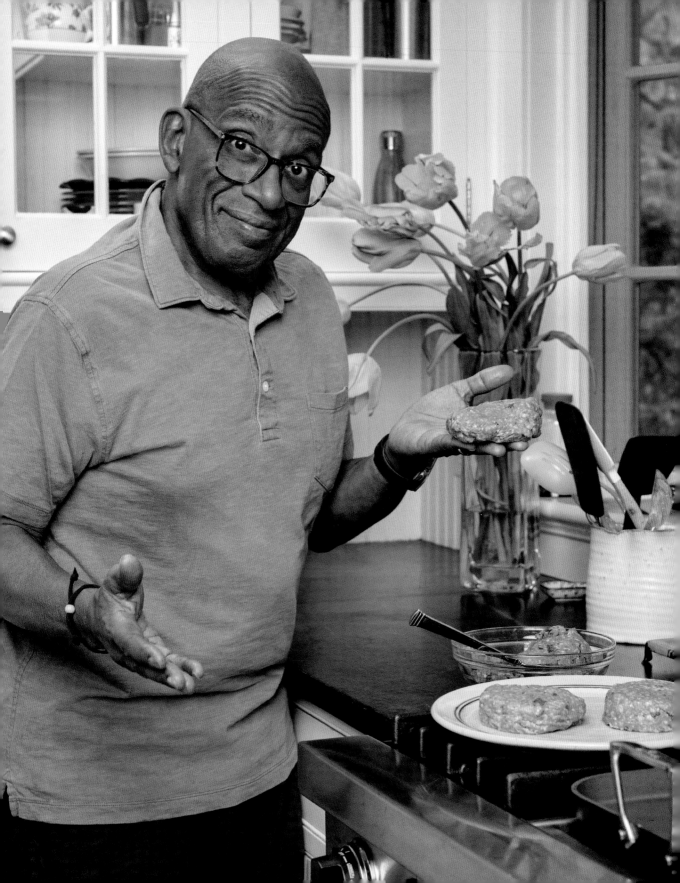

HANDHELD DELIGHTS:
BURGERS AND SANDWICHES

WHEN I PUT A PERFECTLY DONE BURGER IN FRONT OF my starving college-aged son, he thinks I'm the best dad in the world. Whip up a fresh veggie hummus wrap for my wife when she gets back from a trip, and after one bite she remembers why she married me (it was strictly for the food). Master burgers and sandwiches and you've mastered the art of people pleasing.

My daughter Leila is vegetarian(ish), Courtney has the high food expectations of a chef, Nick loves beef, and Deborah would eat fish daily if it were up to her. A burger has the power to please everyone if you simply think outside the beef box. Lamb, salmon, and veggie burgers, all equal bliss in a bun when prepared properly and dressed with the right toppings.

While the word *sandwich* can conjure up the dull bag lunches of yore, like the hamburger, sandwiches have been reborn into a new era. Vegetables rule! There are different kinds of ham—and exciting sausages! Don't forget the lobster roll!

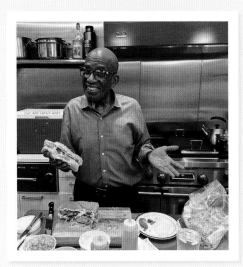

Al's sub shop

The best sandwiches are mini-architectural designs. You can't slap a bunch of random ingredients on whatever kind of bread you have lying around and expect a masterpiece. You need a plan, and I've outlined some of my favorites for you. There are flavors and textures to consider. There are countless condiments to highlight your meat and cheese choices. And of course, you need a proper foundation. The right bread must be tasty, while also having the wherewithal to hold your creation together. Assembled carefully with the right materials, the sandwich is instant satisfaction on a plate.

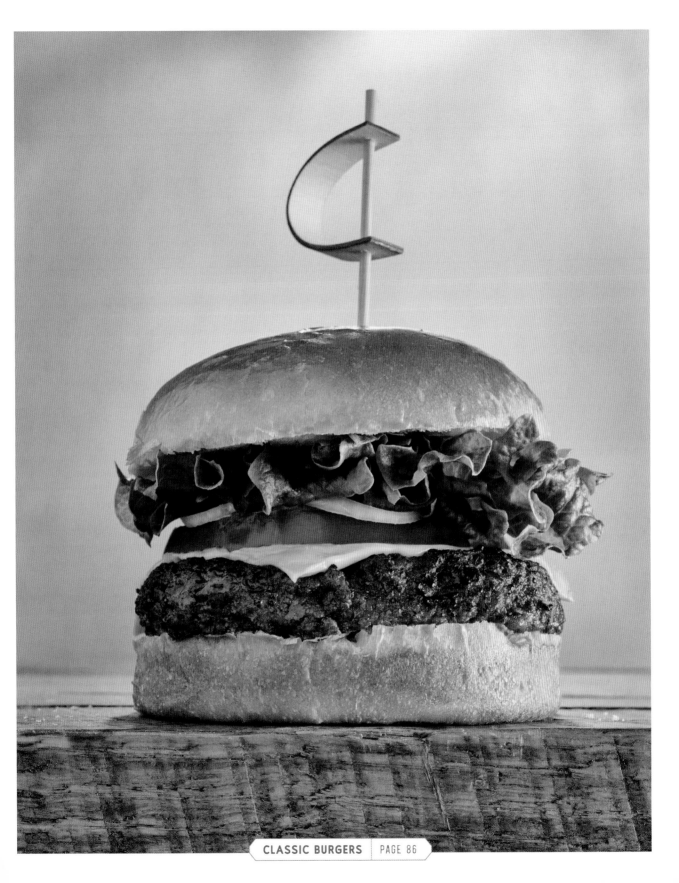

CLASSIC BURGERS

PREP TIME: **15 MINUTES** • COOK TIME: **15 MINUTES**

SECRET SAUCE

¼ cup mayonnaise

2 tablespoons bottled French dressing

2 tablespoons sweet pickle relish

1 teaspoon white vinegar

BURGERS

1½ pounds ground beef, preferably 80% lean

1½ teaspoons kosher salt

1 teaspoon freshly ground black pepper

1 tablespoon canola oil

4 slices American cheese

4 hamburger buns, split and toasted

Green leaf lettuce, sliced tomato, and sliced red onion, for serving

Before we start, we need to get clear on one thing: The key to classic burger perfection is to respect the meat. You've got to have faith in the burger. It knows what to do! Your job is to prepare the patty, get the grill or cast-iron pan heated up, and stand back. The second you start poking that burger, flipping it prematurely (a cardinal sin), or smashing it, you rob that burger of its deliciousness. Please, for the sake of all that is holy, let it sit there and form a crust...then flip it. It's like what your mom always said—and this holds true for most things: Don't play with your food! Also keep in mind that your burger will keep cooking after you remove it from the heat. I like my burger medium-rare to medium. But however you like yours, don't let it sit there until it shrinks into an unrecognizable lump. At that point, no amount of ketchup, mustard, relish, or secret sauce can help you. As for my secret sauce, think of it as *flavor enhancement.* When its sweetness meets that beef patty, you end up with an unbeatable flavor combination that will have people lining up at the grill for seconds.

Wonderful at lunch, delightful at dinner, this crowd-pleaser of a burger is always a hit—unless, of course, you neglect to follow my advice. The photo is on page 85.

FOR THE SAUCE: Mix the mayonnaise, French dressing, sweet pickle relish, and vinegar in a small bowl. Set aside.

FOR THE BURGERS: Shape the ground beef into 4 patties, ¾ to 1 inch thick. Sprinkle the patties on both sides with the salt and pepper.

Heat the oil in a large (11- to 12-inch) skillet over medium heat until very hot, about 3 minutes. Add the burgers and cook undisturbed until nicely browned on one side, about 4 minutes. Flip the burgers and cook on the other side for about 3 minutes for medium-rare, or until they're cooked the way you like. I use an instant-read thermometer to check for doneness. Medium-rare to medium is my happy place, and that means I'm looking

Family time: Courtney, Deborah, Leila, and Nick

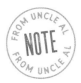

NOTE
FROM UNCLE AL
FROM UNCLE AL

If you don't have a skillet large enough to cook the burgers all at once, fry them in batches.

for a window of 130°F to 145°F. At that point, place a slice of cheese on each burger and let it melt, about 1 minute.

Transfer the burgers to a plate and let rest for 5 minutes to let some of the juices be reabsorbed. Serve the burgers in the buns with the sauce, lettuce, tomato, and onion.

LAMB BURGERS WITH FETA TZATZIKI

PREP TIME: **20 MINUTES** • COOK TIME: **10 MINUTES**

TZATZIKI

¾ cup plain Greek yogurt

½ unwaxed cucumber (unpeeled), finely diced

½ cup crumbled feta cheese

2 tablespoons finely chopped fresh dill

2 tablespoons lemon juice

1 garlic clove, minced

¼ teaspoon kosher salt

LAMB BURGERS

1½ pounds ground lamb

3 tablespoons finely chopped fresh mint

2 teaspoons herbes de Provence

1½ teaspoons kosher salt

2 teaspoons olive oil

4 ciabatta rolls, split and toasted

Thinly sliced red onion and baby arugula, for serving

I'm always surprised by how many people say they don't like lamb. My response to a lamb denier is that they probably haven't experienced the meat properly prepared. (People tend to overcook it, especially those in my mother's generation.) I've served these juicy, flavorful lamb burgers with their delicious sauce to folks who were staunch members of the "no lamb" club. The result? *Oh, wow, this is good, and I can't believe I like it!* The burgers are highlighted further by tzatziki, a lemony, herby, creamy Greek sauce. Really, this burger is the gateway to other lamb dishes.

FOR THE TZATZIKI: Mix the yogurt, cucumber, feta, dill, lemon juice, garlic, and salt in a small bowl. Set aside.

FOR THE BURGERS: Combine the ground lamb, mint, herbes de Provence, and salt in a large bowl. Being firm but gentle, shape into 4 patties, each about 1 inch thick.

Heat the oil in a large (11- to 12-inch) skillet over medium heat until very hot, about 3 minutes. Add the burgers and cook undisturbed until nicely browned on one side, about 4 minutes. Flip the burgers and cook on the other side for about 3 minutes for medium-rare, or until they're cooked the way you like.

Transfer the burgers to a plate and let them rest for 5 minutes to allow some of the juices to be reabsorbed. Serve the burgers in the ciabatta rolls with the tzatziki, sliced onion, and arugula.

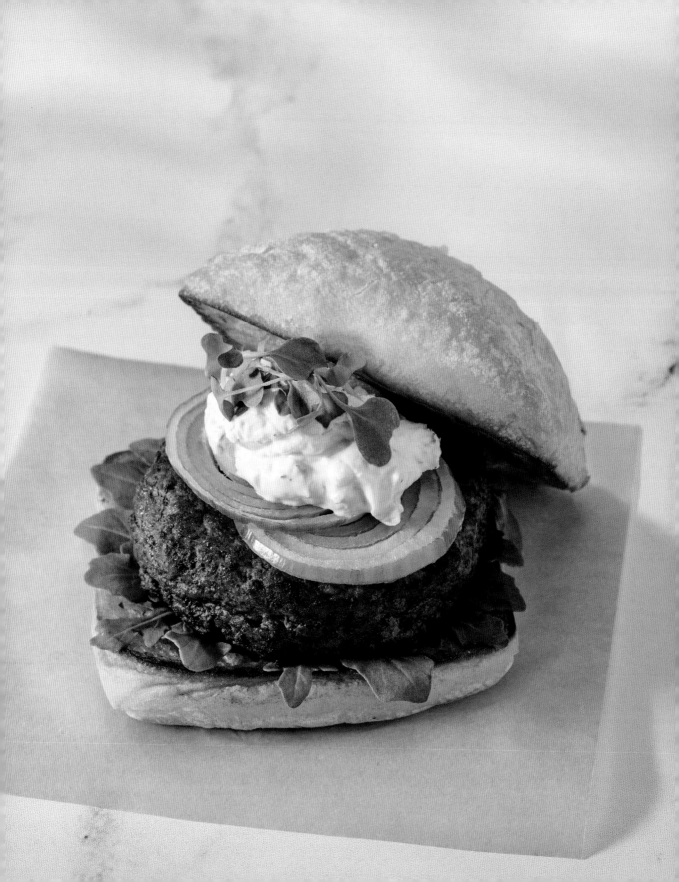

LEILA'S VEGGIE BURGERS

PREP TIME: **30 MINUTES** • COOK TIME: **20 MINUTES**

1 tablespoon olive oil

1 small yellow onion, finely diced

5 garlic cloves, finely chopped

1 (15-ounce) can black beans, rinsed and drained

1 pound sliced cremini mushrooms

1 teaspoon ground cumin

1 teaspoon kosher salt

½ teaspoon freshly ground black pepper

1 large egg

1 cup cooked brown rice

1 cup panko breadcrumbs

1 tablespoon canola oil

4 slices pepper Jack cheese

1 cup favorite barbecue sauce

4 whole wheat hamburger buns, split and toasted

Sliced tomato, sliced avocado, and alfalfa sprouts, for serving

My daughter Leila leans toward vegetarianism. So, when we have a dinner out at the Polo Bar in New York City, which is a carnivore's delight (think pigs in blankets, corned beef sandwiches, steaks, and epic burgers), she eschews the meats for the veggie burger. As a connoisseur, Leila gives the one she devised a big thumbs-up, and it's so good that I've been known to order it myself.

Preheat the oven to 350°F.

Heat the olive oil in a medium skillet over medium-low heat. Add the onion and garlic and cook until the onion softens, about 5 minutes. Transfer to a large bowl.

Put the black beans and mushrooms in a food processor and pulse 5 or 6 times, until slightly chunky. Transfer the mixture to the bowl with the onion and garlic and add the cumin, salt, pepper, egg, rice, and panko. Mix well. Form into 4 patties, each about ¾ inch thick.

Heat the canola oil in a large (11- to 12-inch) ovenproof skillet over medium-high heat. Add the patties and cook until crisp and browned on one side, about 5 minutes. Flip the patties, transfer the skillet to the oven, and bake for about 10 minutes, until fully cooked through.

Place a slice of cheese on top of each burger and return to the oven to melt, about 1 minute.

To build each burger, smear barbecue sauce on the bun bottoms and top with the burgers, tomato, avocado, and alfalfa sprouts. Cover with the bun tops and serve.

FROM UNCLE AL • NOTE

Make the brown rice from ½ cup raw brown rice. You want the rice to be completely cool, so make it the night before or earlier in the day.

SALMON BURGERS WITH MAYO-HERB SAUCE

PREP TIME: **20 MINUTES** • COOK TIME: **10 MINUTES**

HERB SAUCE

1 cup mayonnaise

¼ cup chopped fresh chives

2 tablespoons chopped fresh dill

2 tablespoons chopped fresh tarragon

2 tablespoons prepared horseradish

1 tablespoon lemon juice

¼ teaspoon kosher salt

SALMON BURGERS

1½ pounds skinless salmon fillets, cut into 1-inch pieces

½ cup panko breadcrumbs

2 teaspoons Dijon mustard

1 teaspoon garlic powder

1 teaspoon kosher salt

1 tablespoon canola oil

4 pretzel buns, split and toasted

Bibb lettuce and sliced cucumber, for serving

This juicy salmon burger, accented with Dijon mustard and garlic powder, is packed with flavor. A mayo sauce, with plenty of fresh green herbs and just the right amount of sting from horseradish, plays the hero. The recipe results in a burger that sticks together while it's cooking. I recommend opting for a nonstick pan for this one.

FOR THE SAUCE: Mix the mayonnaise, chives, dill, tarragon, horseradish, lemon juice, and salt in a deep medium bowl. Using an immersion blender, blend until smooth. (Alternatively, use a countertop blender or food processor.) Cover and refrigerate.

FOR THE BURGERS: Put the salmon in a food processor and pulse until finely chopped but not quite paste-like; it should retain some texture, which makes for juicy burgers. Transfer the salmon to a bowl and fold in the panko, mustard, garlic powder, and salt, mixing well. Form into 4 patties, each ¾ to 1 inch thick.

Heat the oil in a large (11- to 12-inch) nonstick skillet over medium-low heat. Add the burgers and cook until nicely browned on one side, about 5 minutes. Flip the burgers and cook until browned on the other side but still pink inside, about 3 minutes (the internal temperature should read 140°F on an instant-read thermometer).

Transfer the burgers to a plate and let rest for 5 minutes to allow some of the juices to be reabsorbed. Serve the salmon burgers in the pretzel buns with the sauce, lettuce, and cucumber.

Pretzel buns are perfect for these burgers, since the chewiness of the bun complements the soft salmon patty. If you can't find them, though, just use regular hamburger buns.

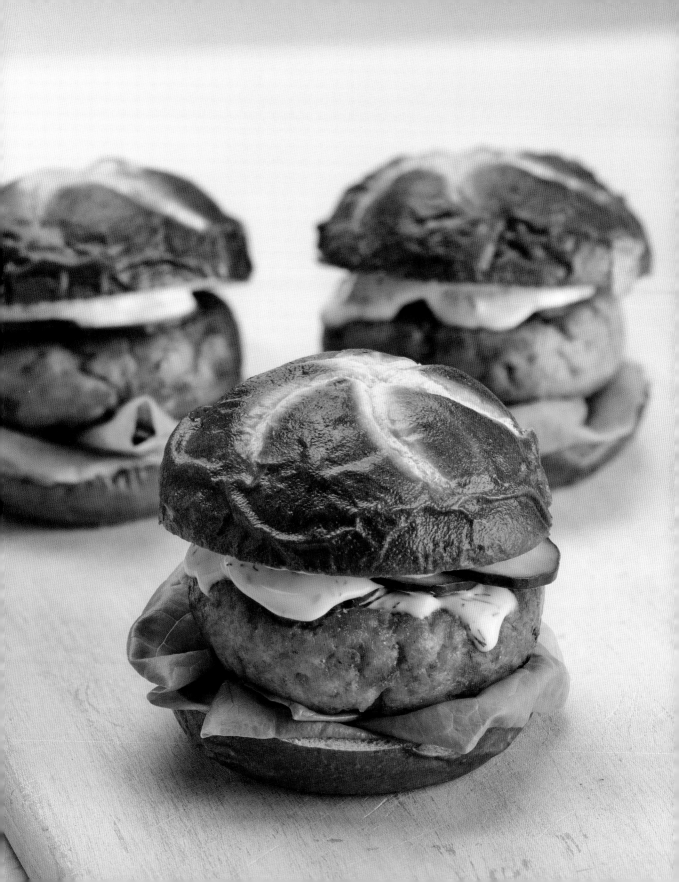

AVOCADO-HUMMUS VEGGIE SANDWICHES

HUMMUS

½ Hass avocado

1 (15-ounce) can chickpeas, rinsed and drained

¼ cup fresh cilantro leaves

1 large chipotle chili from a can of chipotle chilies in adobo

2 tablespoons lemon juice

1 garlic clove, peeled

¼ teaspoon kosher salt

¼ cup olive oil

SANDWICHES

1 (14-ounce) ciabatta loaf

1 (8-ounce) block feta cheese, sliced ¼ inch thick

1 cucumber, sliced lengthwise ¼ inch thick

2 ripe medium heirloom tomatoes, sliced ¼ inch thick

⅓ cup pickled red onions, drained, store-bought or homemade (opposite)

¼ cup fresh basil leaves

Kosher salt and freshly ground black pepper (optional)

1½ cups alfalfa sprouts

Every time I prepare this creamy hummus sandwich with a hit of tang from chilies and crunch from the fresh veggies, I hear John Cleese in the sketch comedy *Monty Python's Flying Circus*, "And now for something completely different!" That catch phrase always announced the unexpected: old ladies beating innocent passersby with their handbags, penguins playing tennis, or Vikings discussing their battle strategy. The line helps me remember that life can't be a parade of bacon and burgers—you've got to dial back on the meat from time to time. Eating something different doesn't mean it won't be delicious and full of flavor. This healthy, light sandwich is completely different in the best possible way.

Preheat the broiler.

FOR THE HUMMUS: Scoop the avocado flesh into a blender. Put the chickpeas, cilantro, chipotle, lemon juice, garlic, salt, and olive oil in a blender and blend until smooth. (The hummus can be made up to 3 days ahead and stored in an airtight container in the refrigerator.)

FOR THE SANDWICHES: Halve the ciabatta horizontally. Place the halves cut side up on a baking sheet and toast lightly under the broiler, about 3 minutes; watch carefully so as not to burn them. Spread some of the hummus on each half. Cover the bottom half with the feta, cucumber, tomatoes, pickled onions, and basil. Sprinkle with salt and pepper, if desired. Press the alfalfa sprouts into the top half. Place the top on the bottom half and press down lightly to secure the vegetables. Slice crosswise into 4 sandwiches and serve.

Toasting the bread adds flavor and makes the sandwich sturdier.

You can buy pickled red onions or make them with the recipe at right; you'll need to prepare them at least 30 minutes ahead.

Pickled Red Onions

1 large red onion, sliced ¼ inch thick

1 cup white vinegar

1 cup water

2 tablespoons granulated sugar

¼ teaspoon kosher salt

Put the onion slices in a large mason jar or deep bowl. Heat the vinegar, water, sugar, and salt in a medium saucepan over medium heat, stirring to dissolve the sugar. Pour the mixture over the onion and let cool. Cover and refrigerate for at least 30 minutes before serving. The pickled onions will keep for a week refrigerated; the pickle flavor becomes more pronounced the longer the onions sit.

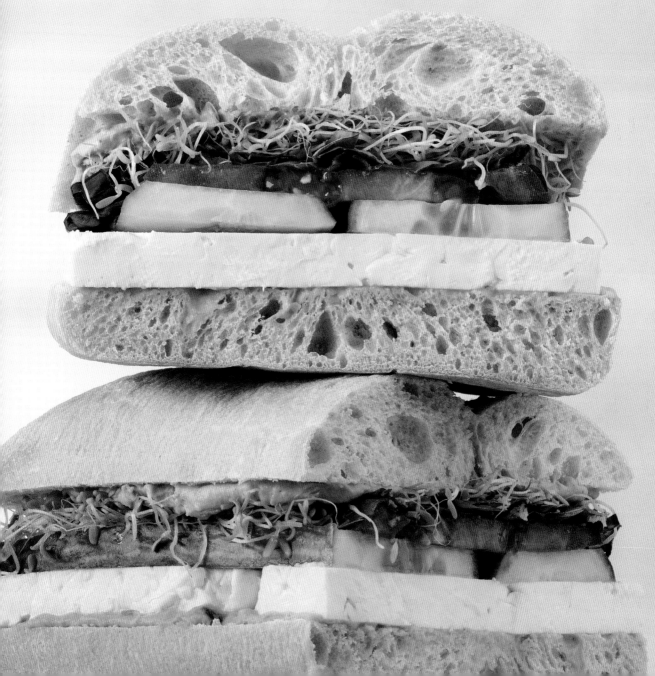

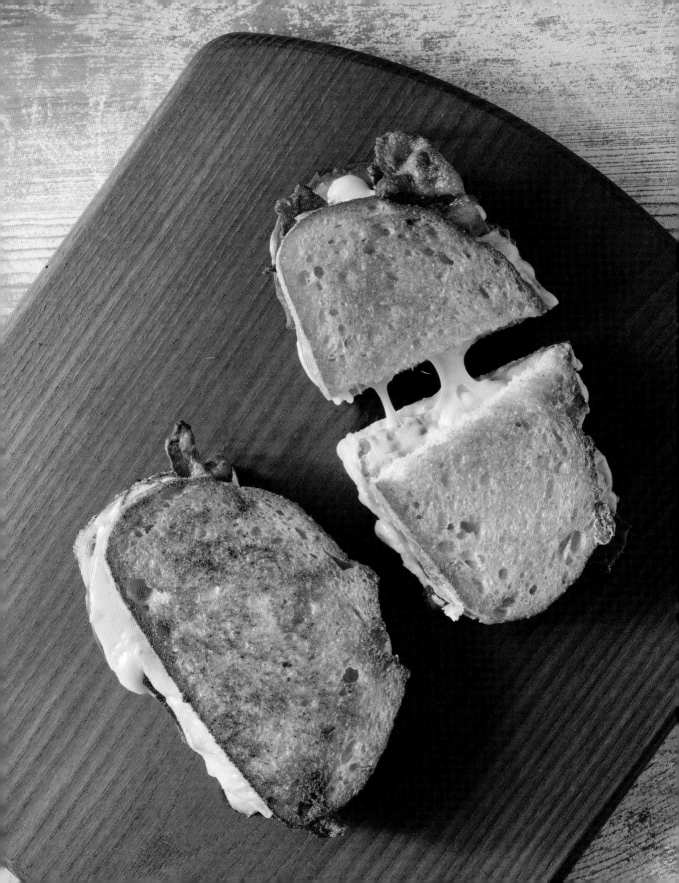

BACON-TOMATO GRILLED CHEESE

PREP TIME: **5 MINUTES** • COOK TIME: **10 MINUTES**

4 slices uncured bacon

1 tablespoon unsalted butter

2 tablespoons mayonnaise

4 slices white bread

4 slices American cheese

4 slices tomato, ¼ inch thick

Make sure to use traditional full-fat mayonnaise. Reduced-fat mayonnaises have a higher water content, which will make your sandwich soggy.

In my early years at NBC, there was a commissary where anyone could grab a quick bite. The walls were a nonidentifiable color that might have been baked-on grease or a sad shade of institutional pain. Beat-up tables were scattered here and there, and the lighting gave the ambience of a nursing home. I couldn't have loved the spot more. The NBC commissary had the best-seasoned grill in all of New York City, and the grilled cheese sandwiches that came off that baby were like the sun, the stars, and the moon placed between two pieces of buttery bread. As you were eating this divine sandwich and thinking the world couldn't get any better, you'd look around and see geniuses at work. Dana Carvey and Billy Crystal working on a script for *SNL*. Tom Brokaw grabbing a coffee before going on air. In the com, everyone was equal, everyone was welcome, and we all had access to the greatest sandwich on earth. I won't try to replicate the magic that came from a grill that served up fried sandwiches for decades, but this grilled cheese is my way of paying homage to a truly special place.

Cook the bacon in a large skillet over medium heat, turning halfway through, for about 5 minutes, until crisp. Transfer it to a paper towel–lined plate to drain.

Heat the butter in a large nonstick skillet over medium heat. Spread ½ tablespoon of the mayonnaise on each slice of bread. Once the butter has melted, place 2 slices of bread in the pan, mayo side down. On each piece of bread place 1 slice of cheese, 2 pieces of bacon, 2 slices of tomato, and a final slice of cheese. Top each sandwich with a second slice of bread, mayo side up.

Cook the sandwiches for 2 to 3 minutes on each side, until the cheese has melted and the bread is golden brown. Serve immediately.

HAM SANDWICHES WITH CALABRIAN CHILI MAYO

PREP TIME: **10 MINUTES** • COOK TIME: **0 MINUTES**

CALABRIAN CHILI MAYO

¾ cup mayonnaise

2 tablespoons minced jarred Calabrian chili peppers

1 tablespoon lemon juice

1 tablespoon chopped fresh parsley

1 garlic clove, minced

¼ teaspoon kosher salt

¼ teaspoon freshly ground black pepper

SANDWICHES

1 French baguette

8 ounces thinly sliced Swiss cheese

8 ounces thinly sliced prosciutto cotto (see note)

2 cups arugula

You can't go wrong with ham, but it can stand a little zhuzhing up, hence the chili mayo here. I like to splurge on the ham. Prosciutto cotto is an Italian ham that is brined and steamed. It has a delicate taste, unlike its counterpart prosciutto crudo, which is cured and has a more intense flavor. Don't underestimate the impact the Calabrian chilies have on this sandwich. They pack a punch, but not at a melt-your-face-off level. Their flavor manages to be smoky, fruity, slightly sweet, earthy, and tangy all at once. Once you stock a jar in your pantry, you'll never want to go without them again. Put these ingredients in a crusty baguette and you can practically see yourself sitting at a café table with a brightly colored umbrella in Nice, France. This isn't just a sandwich, it's an experience.

FOR THE MAYO: Mix the mayonnaise, minced chilies, lemon juice, parsley, garlic, salt, and pepper in a medium bowl.

FOR THE SANDWICHES: Slice the baguette in half lengthwise and generously spread the chili mayo on both sides. Layer the bottom with the sliced cheese, then the sliced ham, and top with the arugula. Cover with the other half of the baguette. Cut into 4 sandwiches and serve.

Head to a good Italian deli or specialty store to find prosciutto cotto. If you don't have one near you, regular deli ham will suffice.

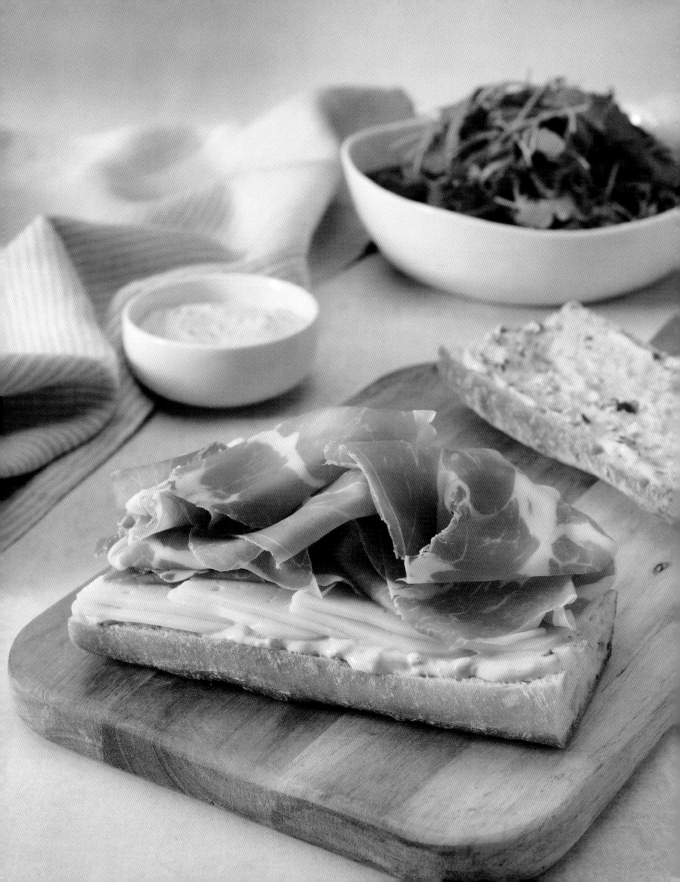

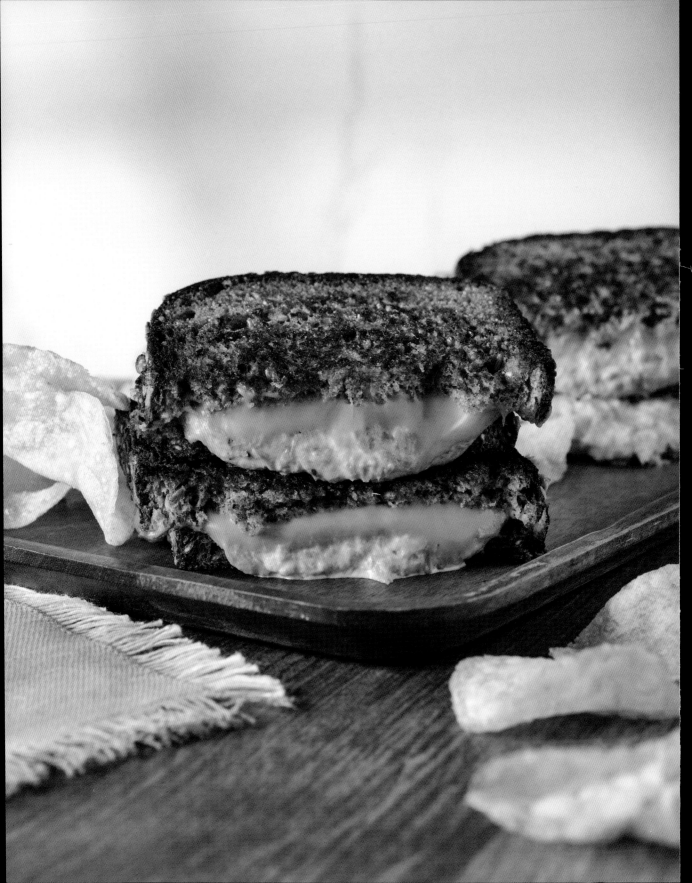

MANHATTAN TUNA MELTS

PREP TIME: **10 MINUTES** • COOK TIME: **5 MINUTES**

1 (5-ounce) can solid white albacore tuna, drained

1 scallion, thinly sliced

¼ cup mayonnaise

1 teaspoon lemon juice

½ teaspoon garlic powder

¼ teaspoon paprika

¼ teaspoon kosher salt

¼ teaspoon freshly ground black pepper

4 slices whole-grain bread

2 tablespoons unsalted butter, at room temperature

4 slices American cheese

I didn't develop a real appreciation for tuna until later in life. Frankly, the advertising guys from Madison Avenue are to blame. When I was a kid, there were two competing tunas, and the ad campaigns for each were baffling. The first, StarKist, featured "Charlie the Tuna," who was offering himself up to be eaten, only to be told "Sorry, Charlie." Apparently, he wasn't deemed delicious enough to be a StarKist tuna? The other brand was Chicken of the Sea. What does that even mean? Between the rejected tuna and the seafaring chicken, I opted to avoid tuna altogether. Years later, when I got a great tuna melt in a midtown diner, I thought, *OK, I get it now*. A good tuna melt has everything the grilled cheese has to offer but with the bonus of fish. Every time I enjoy this sandwich, I can't help but wonder, why didn't Madison Avenue just say, "Eat tuna fish because you'll love it"?

Mix the tuna with the scallion, mayonnaise, lemon juice, garlic powder, paprika, salt, and pepper in a medium bowl.

Spread each slice of bread with ½ tablespoon butter and flip it over. Divide the tuna mixture evenly between 2 slices of bread and top each with 2 slices of cheese. Top with the remaining 2 slices of bread, butter side up.

Heat a large (11- to 12-inch) skillet over medium heat. Place the sandwiches in the pan and cook for 2 to 3 minutes per side, until the cheese has melted and the bread is golden brown. Serve.

MERGUEZ SAUSAGE SANDWICHES

PREP TIME: **10 MINUTES** • COOK TIME: **5 MINUTES**

¼ cup Dijon mustard

1 tablespoon mayonnaise

1 tablespoon lemon juice

1 teaspoon za'atar

1 teaspoon garlic powder

8 ounces merguez sausage links

2 teaspoons olive oil

1 (10- to 12-ounce) ciabatta loaf

1 (12-ounce) jar roasted sweet red peppers, drained

2 cups arugula

NOTE

FROM UNCLE AL · FROM UNCLE AL

Za'atar is a fragrant Middle Eastern spice blend that adds a savory spice element to a dish. You can find it in large grocery stores, Middle Eastern shops, or online. Merguez, a spicy North African sausage, is available in specialty meat stores, or you can order it online.

On weekends in the country, Deborah and I like to eat at a French café in Hudson called Le Gamin Country. This joint has no shortage of charm, and the formidable chef-owner, Astrid, can look directly into your soul and see what you want to eat.

Me: "I'll have *le jambon beurre*, please."

Astrid: "No. You don't want that. You're having *le merguez à la moutarde forte*."

Well, all righty then. And it turned out that she was 100 percent right. This zesty lamb sausage sandwich with peppers and arugula stuffed into ciabatta bread is *le plus délicieux*. This recipe may not provide you with a dose of Astrid's personality, but I assure you it is well worth making.

Combine the mustard, mayonnaise, lemon juice, za'atar, and garlic powder in a medium bowl. Set aside.

Using a small knife, slice the sausages lengthwise about two-thirds of the way through, then flatten into 2 connected halves. Heat the olive oil in a large skillet over medium heat. Add the sausages and cook for about 4 minutes, turning frequently, until both sides are browned and the sausage is cooked through. Transfer to a plate and let cool for 5 minutes.

Slice the ciabatta in half horizontally. Spread the mustard sauce on both halves. Place the sausage on the bottom half of the bread, followed by the roasted peppers, and finally the arugula. Close with the top half of the bread, cut the sandwich in half, and serve.

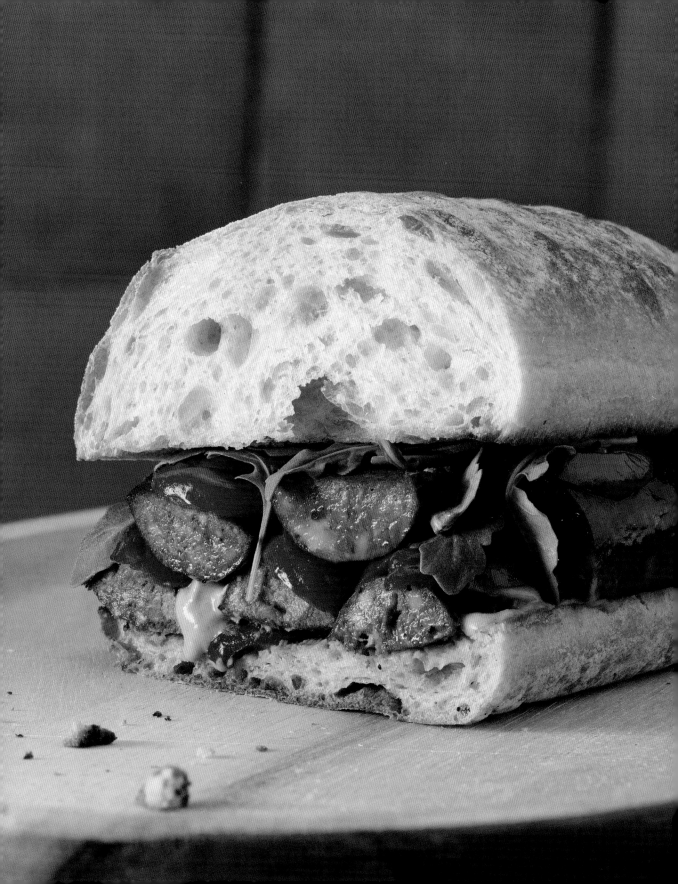

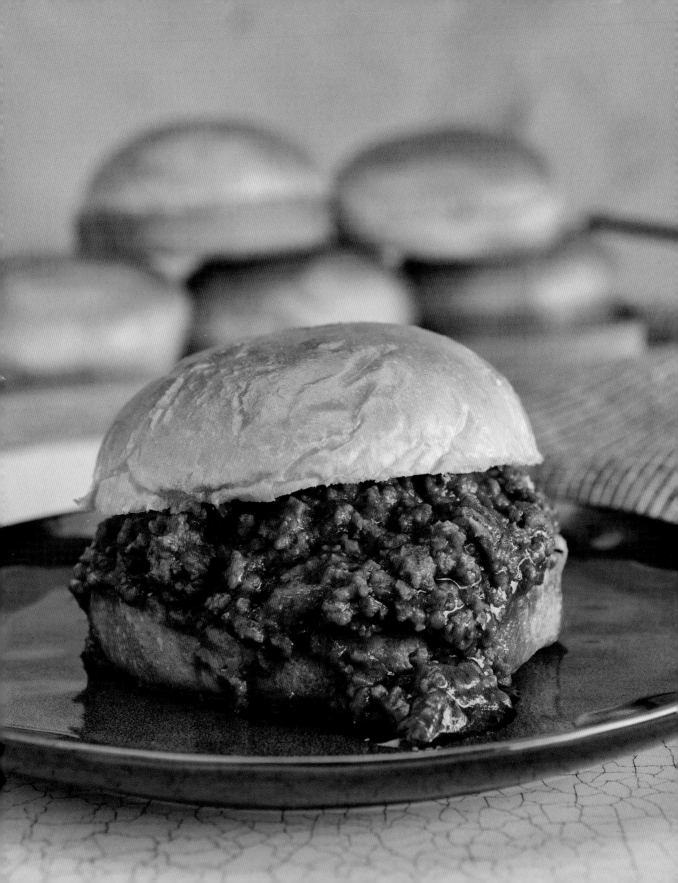

AL'S SLOPPY JOES

PREP TIME: **15 MINUTES** • COOK TIME: **20 MINUTES**

1 teaspoon canola oil

2 pounds ground beef, preferably 80% lean

1 small onion, finely chopped

1 small green bell pepper, finely diced

6 garlic cloves, finely chopped

2 teaspoons kosher salt

2 cups ketchup

2 tablespoons firmly packed brown sugar

1 tablespoon Dijon mustard

2 teaspoons Worcestershire sauce

2 teaspoons chili powder

2 teaspoons smoked paprika

½ teaspoon freshly ground black pepper

6 brioche buns, split and toasted

Bread and butter pickles, for topping (optional)

Shredded cheddar cheese, for topping (optional)

At the beginning of the Covid-19 pandemic, I was rummaging around in the pantry taking inventory of what we had on hand. Behind a box of chicken stock and some canned tomatoes I was surprised to find Manwich, the canned sloppy joe sauce. It wasn't something I normally keep on hand, but I was glad to see it. It had been ages since I had enjoyed the happy mess that is a sloppy joe. We had ground beef in the freezer, and I decided a sloppy joe was just the ticket to an easy, comforting dinner. One bite and I was ten years old again, sitting at the kitchen table with my family as we all devoured our sloppy joes, meat falling out the side, plopping onto our plates, our mouths covered in sloppy sauce. I decided that I wanted to invent my own sauce, using fresh ingredients. The result is a delicious sloppy delight.

Heat the oil in a large skillet over medium-high heat. Add the beef and cook, stirring occasionally with a wooden spoon to break up any clumps, until almost browned, about 5 minutes.

Reduce the heat to medium-low and add the onion, bell pepper, garlic, and salt and cook, stirring frequently, until the vegetables are softened, about 5 minutes. Spoon the excess fat from the pan. Add the ketchup, brown sugar, mustard, Worcestershire, chili powder, smoked paprika, and black pepper and stir to combine. Cook, stirring frequently, to reduce the sauce slightly and meld the flavors, about 10 minutes.

Remove the pan from the heat. Spoon the sloppy joe mixture over the bun bottoms, dividing it evenly. Top with pickles and shredded cheese, if desired, then cover with the bun tops and serve.

LOBSTER ROLLS WITH FRESH HERBS

PREP TIME: **15 MINUTES** • COOK TIME: **20 MINUTES**

¼ cup mayonnaise

1 tablespoon lemon juice

1 celery stalk, finely diced

2 tablespoons finely sliced fresh chives, plus more for garnish

1 tablespoon chopped fresh tarragon

¼ teaspoon kosher salt

¼ teaspoon freshly ground black pepper

4 (6-ounce) lobster tails, steamed, meat removed and chopped into ½-inch pieces

2 tablespoons unsalted butter

4 top-split hot dog buns

My viewpoint here might be controversial, but the lobster roll is *really* the best way to enjoy lobster. No judgment if you're into lobster in its original state, but I'll eschew the plastic bib, the shell cracking tool, the hard work, and the confusion. Which parts do I eat? What do I need to crack? When it comes to the lobster roll, some people use a combo of lobster meat, including the claw and the knuckle, which is softer and on the flaky side. This recipe calls for just the tail meat, which is firmer, meatier, and the most satisfying part of the lobster. I mean, it's not every day that you make a lobster roll, so why hold back? This is a sandwich that sheds the work and showcases the best the lobster has to offer, all in a delightfully soft roll.

Mix the mayonnaise, lemon juice, celery, chives, tarragon, salt, and pepper in a medium bowl. Add the lobster meat and fold it into the dressing. Cover and refrigerate.

Melt the butter in a large skillet over medium heat. Add the buns, sliced side down, and toast until golden brown on one side, 1 to 2 minutes. Flip and toast the other side until golden brown, about 1 minute.

Divide the lobster salad among the toasted buns, garnish with chives, and serve.

You can substitute the meat of a cooked 2-pound whole lobster for the lobster tails.

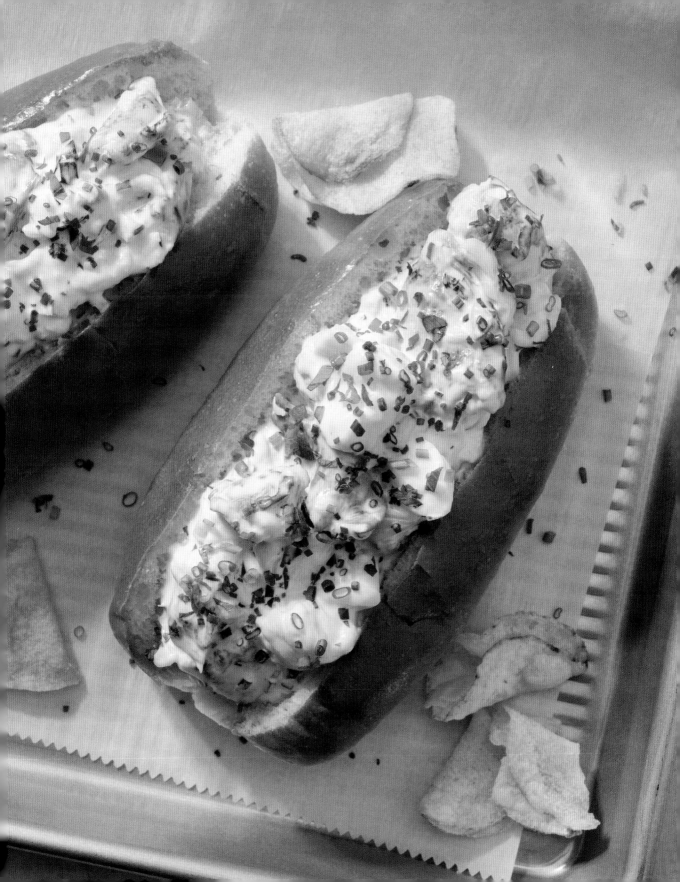

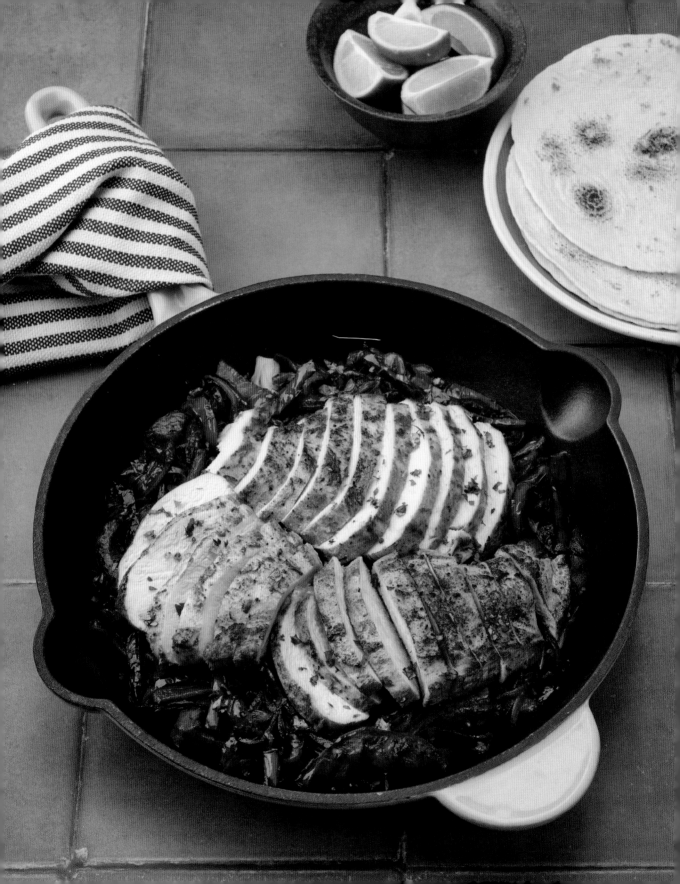

CHICKEN FAJITAS

PREP TIME: **20 MINUTES** • COOK TIME: **15 MINUTES**

1½ pounds boneless, skinless chicken breasts, cut into ½-inch-thick slices

2 teaspoons adobo seasoning with salt

1 teaspoon dried oregano

2 tablespoons canola oil, divided

2 medium red bell peppers, sliced into ½-inch-thick strips

1 medium red onion, halved and sliced into ¼-inch-thick strips

½ teaspoon kosher salt

½ teaspoon garlic powder

4 (6-inch) flour tortillas, warmed

Sour cream, chopped fresh cilantro, and lime wedges, for serving

While this recipe is a sure winner, my philosophy on fajitas is you can put almost anything in them as long as it sizzles. Get yourself comfortable with this basic recipe and you'll soon be making fajitas with your own flair. If you're ever staring into your refrigerator and thinking, *What on earth can I make with this leftover meat and these random vegetables?* The answer is likely fajitas! Get those leftovers cracklin' and it's like you've given them an entirely new chance to shine.

Toss the chicken with the adobo seasoning and oregano in a large bowl.

Heat 1 tablespoon of the oil in a large skillet over medium-high heat until hot. Add the chicken and cook, stirring occasionally, until browned on all sides and cooked through, about 6 minutes. Cut into lengthwise strips and transfer to a plate.

Add the remaining 1 tablespoon oil to the pan and increase the heat to high. When the oil is hot, add the peppers, onion, salt, and garlic powder and cook, stirring, until the vegetables are browned and softened, about 6 minutes. Return the chicken to the pan and stir over high heat until heated through, about 2 minutes. Spoon into the warm tortillas, top with sour cream and cilantro, and serve with lime wedges.

Adobo seasoning is an all-purpose dry spice blend used in Latin American cuisine. You can find it at large grocery stores, stores that sell Latin products, and online.

CHICKEN CHIMICHANGAS

1½ pounds boneless, skinless chicken thighs, cut into 1-inch pieces

1 (1¼-ounce) packet fajita seasoning

1 tablespoon plus 1 cup canola oil, divided

1 cup jarred salsa

4 (10-inch) flour tortillas

2 cups shredded Monterey Jack cheese

½ cup Mexican crema

Shredded iceberg lettuce, for serving

Chopped fresh cilantro, for serving

FROM UNCLE AL
NOTE
FROM UNCLE AL

If you can't find Mexican crema, use sour cream loosened with a splash of lime juice.

One afternoon when I saw Courtney making tidy tortilla packages filled with succulent chicken thighs, cheese, and fajita seasoning, I knew I had to get in on the action. They are everything you love about a burrito and a fajita rolled up in one crispy package.

Toss the chicken with the fajita seasoning in a large bowl.

Heat 1 tablespoon of the oil in a large skillet over medium heat. Add the chicken and cook, stirring frequently, until most of the pieces are no longer pink, about 6 minutes. Add the salsa and cook, stirring until the sauce thickens, about 5 minutes. Transfer the chicken to a bowl and let cool for 10 minutes.

Spread out the tortillas on a work surface. Divide the cheese evenly among the tortillas, placing it in the center. Top with the chicken mixture, dividing it evenly. Fold the bottom edge of each tortilla over the filling, tuck in the sides, and roll up from the bottom. Secure the seams with toothpicks. Refrigerate for at least 10 minutes to allow the chimis to firm up.

Heat the remaining 1 cup oil in a large, deep skillet over medium-high heat until it registers as 350°F on an instant-read thermometer, about 5 minutes. If you don't have one, toss a tiny piece of tortilla into the oil; the oil should instantly bubble around it.

Add 2 chimichangas, seam side down, and fry until golden brown on one side, about 2 minutes. Using tongs or a slotted spoon, carefully turn the chimichangas and cook until browned on the other side, about 2 minutes. Transfer them to a paper towel–lined plate. Fry the remaining 2 chimis in the same way.

Remove the toothpicks and serve the chimichangas immediately, drizzled with crema, topped with lettuce, and sprinkled with cilantro.

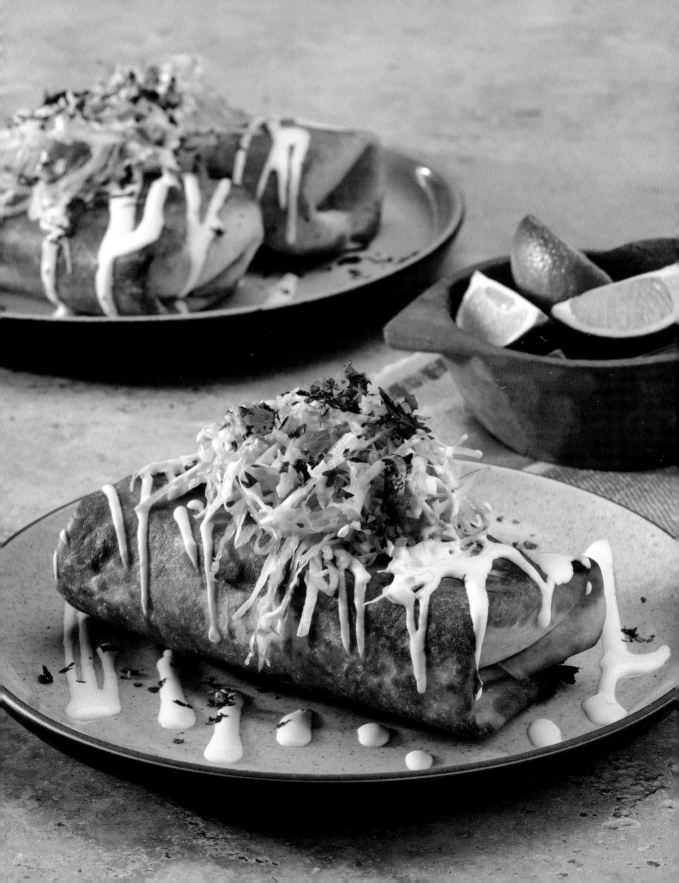

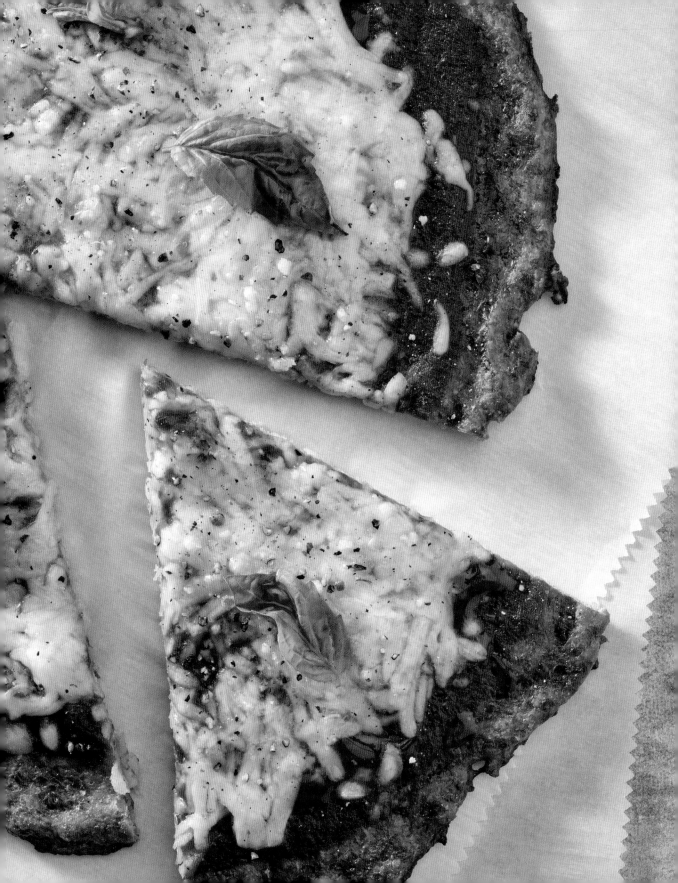

MEATZA

PREP TIME: **10 MINUTES** • COOK TIME: **25 MINUTES**

1 pound ground pork

1 teaspoon Italian seasoning

½ teaspoon kosher salt

¼ cup marinara sauce

½ cup shredded mozzarella cheese

Fresh basil leaves, for garnish

NOTE FROM UNCLE AL

Add the toppings of your choice. Our family loves pepperoni, sliced mushrooms, and sliced bell peppers.

Meatza is a wonderful holdover from my keto days. An unexpected plus of the diet was that I got creative, pushing the limits of what can be done with meats and cheese. One day I found myself contemplating lunch, wondering what to make with some sausage, cheese, and pepperoni that wasn't pizza. I had some good tomato sauce in the pantry, and I thought, *Hmmmm. Wait a minute!* And meatza was born. It's delicious, it's easy, and it's the ultimate meat lover's pizza—without the dough. The meatza is now a valued member in the Roker family recipe rotation.

Preheat the oven to 475°F.

Mix the ground pork, Italian seasoning, and salt in a large bowl. Transfer the seasoned pork to a sheet of parchment paper and spread it into a rough rectangle. Cover with another piece of parchment and, using a rolling pin, roll the meat out evenly so it is about ¼ inch thick. Remove the top piece of parchment and discard.

Transfer the parchment paper with the pork to a baking sheet and bake for 15 minutes. Remove from the oven and drain off any fat that has accumulated. Using a spatula, carefully flip the pork rectangle over and return it to the oven for 5 minutes.

Remove from the oven and spread with the marinara sauce and mozzarella cheese. Place it back in the oven and bake until the cheese melts, about 5 minutes. Garnish with fresh basil and serve.

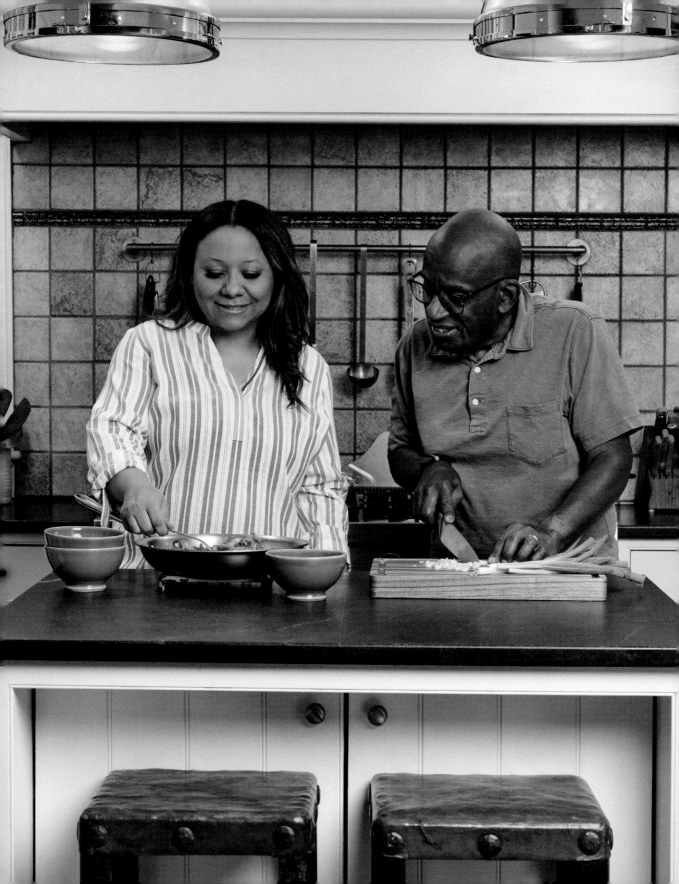

DINNER

IN REAL LIFE

CAN WE PLEASE STOP GETTING STRESSED OUT ABOUT dinner? Your kid approaching you after school and asking, "Hey, what's for dinner tonight?" isn't supposed to cue foreboding music and send you into a panic because you don't know what you're making. Dinner is a meal, it's not supposed to cause anxiety! Nor is dinner a test. No one will show up at your house and brand you on the forehead with a letter F if you don't produce a perfectly balanced meal. Finally, dinner is not a magazine shoot. You do not need to serve multiple courses with wine pairings, set the table with starched linen napkins and your best china. Centerpieces created out of wildflowers you foraged from a nearby forest are not necessary either. What you do need to do is find a way to prepare and enjoy a dinner that fits in with the insanity of life. I know that commutes, deadlines, the never-ending ping of text messages, homework, kids and their sports, pets who need walking, and laundry make it tempting to forgo the work of planning meals, prepping food, and cooking when, theoretically, *there is always pizza.*

Please remember, too, that dinner isn't only about the cooking—it's also about the eating. There's one goal: feeding yourself (and whoever you live with). I view it as my reward after putting in a good day's work, and I don't stress about it because *dinner can be whatever I want it to be.* Before Nick left for college, dinner could have been the two of us sitting at the breakfast bar eating his cheesy eggs (these are on page 23 in the breakfast chapter, but it's my dinner and I can eat what I want). If I'm flying solo, I might set myself up with the reliably satisfying and quick pan-seared chicken thighs. If a scheduling miracle occurs and Deborah and I are in the same place at the same time, we might actually set the table and catch up over crispy-skin salmon with broccoli and brown rice.

Nor is dinner meant to be a competition about who is a domestic deity. It's meant to nourish you. It's a time to unwind, check in, and catch up with family and enjoy the food in front of you. These recipes are intended to inspire and remind you that *you deserve a good meal.* So, the next time *What am I going to make for dinner?* gets you wound up, take control. Sweep the paperwork of life (homework! bills!) off to the side of the dining room table, and just make something to eat.

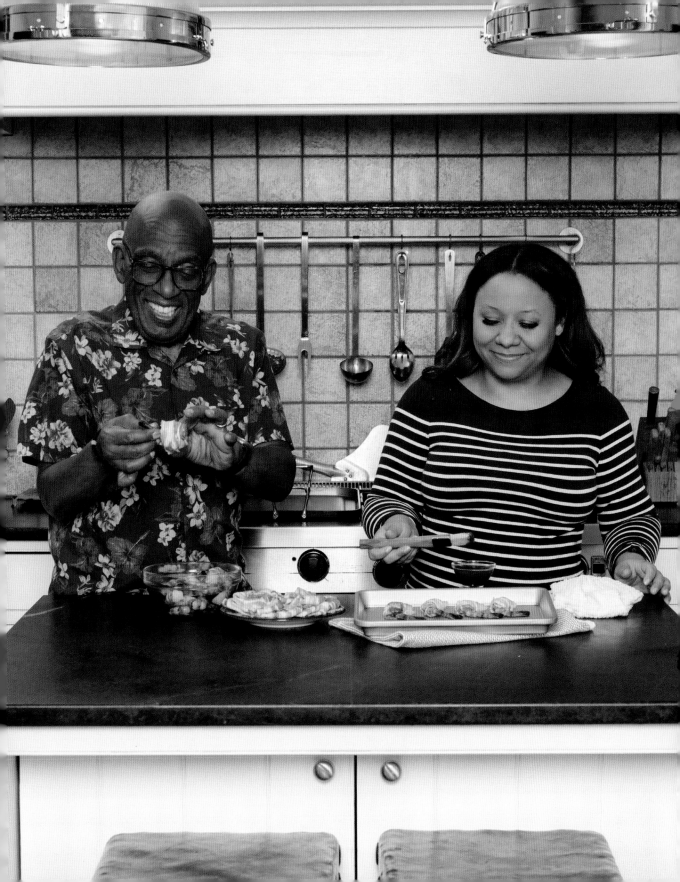

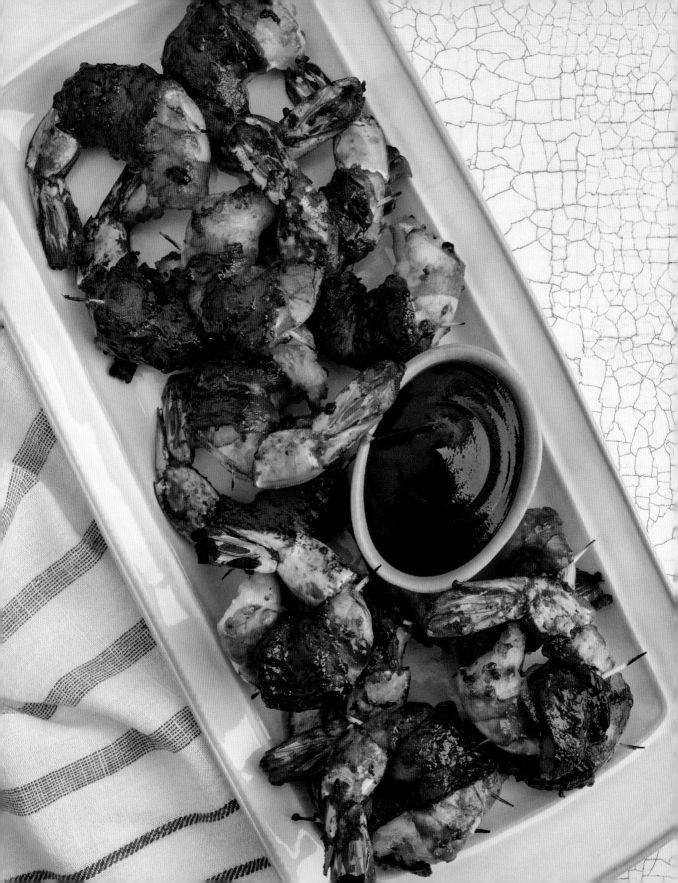

BARBECUED BACON-WRAPPED SHRIMP

½ cup barbecue sauce

2 tablespoons honey

2 tablespoons hot sauce

4 teaspoons firmly packed brown sugar

20 jumbo or extra-large shrimp (16/20 per pound, or the largest you can find), peeled and deveined

7 slices smoked bacon, cut crosswise into thirds

When a guest brings a dish that is over-the-top delicious to your house, gush over it. Repeatedly. You'll need to go well beyond the basic thank-you for something this great. Act *amazed* . . . as if the person who brought the scrumptious food just split the atom right there in your dining room. The goal is to ensure that your guest happily shows up with this dish every time they come over.

The first time I tasted my brother Chris's barbecued bacon shrimp, I knew I couldn't live without them. He took two of my favorite foods, shrimp and bacon, wrapped them up together, and topped them with a tangy barbecue sauce. Now, when he arrives, platter in hand, he's practically tackled before he can get his coat off—they're that good.

Preheat the oven to 425°F. Line a baking sheet with aluminum foil.

Combine the barbecue sauce, honey, hot sauce, and brown sugar in a medium bowl and mix well.

Wrap each shrimp with a piece of bacon and place on the prepared baking sheet, seam side down. (You'll have an extra piece of bacon for a cook's treat.)

Brush the bacon-wrapped shrimp liberally with half of the sauce. Bake for about 20 minutes, until the bacon has rendered its fat and is golden brown on the edges.

Remove the sheet from the oven and set the oven to broil. Brush the remaining sauce on the shrimp and return to the oven for about 3 minutes, until bubbly. Watch them like a hawk to make sure they don't burn. Serve immediately.

BROWN BUTTER SEARED SCALLOPS

PREP TIME: **5 MINUTES** • COOK TIME: **10 MINUTES**

1 pound dry-packed sea scallops, adductor muscles removed (see note)

½ teaspoon kosher salt

2 tablespoons olive oil

4 tablespoons (½ stick) unsalted butter

2 tablespoons dry white wine

1 tablespoon lemon juice

1 tablespoon drained capers

1 tablespoon chopped fresh parsley

1 teaspoon grated lemon zest

Scallops and browned butter are the hosts of this banquet of flavor that is soon to take place in your mouth. Like a nutty cousin, brown butter outshines plain butter in the flavor department. This is the kind of dish that gives off an I-really-know-my way-around-a-kitchen vibe, when the truth is it could not be easier to put together.

Pat the sea scallops dry and season with the salt.

Heat the olive oil in a large skillet over medium-high heat. Add the scallops and cook for about 2 minutes, until they are golden brown. Flip the scallops and cook for about 1 minute, until golden brown on the other side. Using a slotted spoon, transfer the scallops to a plate and cover with aluminum foil.

Reduce the heat to medium-low. Add the butter to the pan and cook until it starts to foam and turn light brown, about 1 minute. Turn off the heat and add the white wine, lemon juice, capers, parsley, and lemon zest. Return the heat to medium-low and cook, stirring, for about 1 minute.

Return the scallops to the pan and spoon the sauce on top. Serve immediately.

Buying dry-packed scallops is key here. Scallops in many supermarkets have been soaked in a preservative, which can leave a bitter taste. So pass right by any sea scallops you see sitting in a puddle of cloudy water. Dry scallops have no preservatives, and while they're usually pricier, you're not paying for water weight.

Look for a tiny flap on the side of your scallops. It's called the adductor muscle, and it opens and closes the shell and helps the scallop swim, so it is super tough, which is why you should pull it off before cooking.

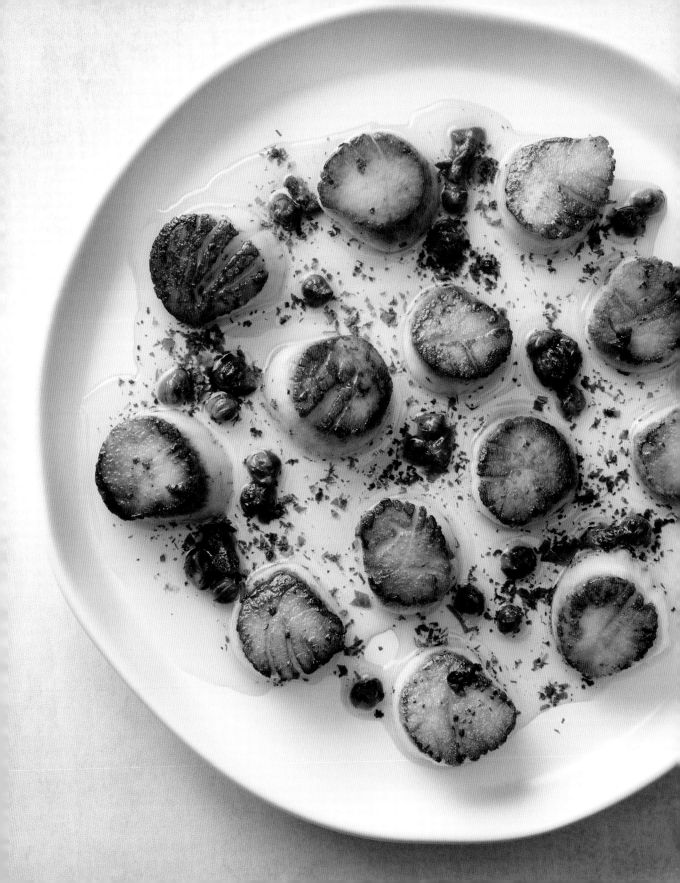

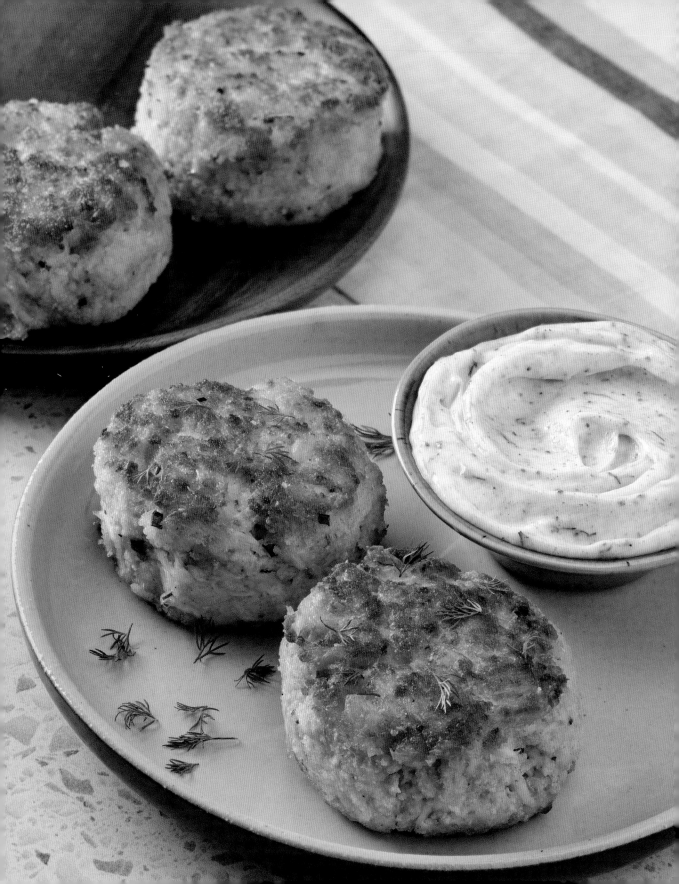

MARYLAND-STYLE CRAB CAKES

PREP TIME: **20 MINUTES** • COOK TIME: **20 MINUTES**

DILL SAUCE

½ cup mayonnaise

¼ cup buttermilk

1 garlic clove, minced

3 tablespoons finely chopped fresh dill, plus more for garnish

1 tablespoon lemon juice

CRAB CAKES

½ cup mayonnaise

1 large egg

1 tablespoon Dijon mustard

1 teaspoon Worcestershire sauce

1 teaspoon Old Bay seasoning

2 tablespoons finely sliced fresh chives

½ teaspoon kosher salt

1 pound fresh jumbo lump crabmeat

1 cup crushed saltine crackers

1 teaspoon grated lemon zest

2 tablespoons olive oil

1 tablespoon unsalted butter

Lemon wedges, for serving

Whenever work lands me in Baltimore, I visit Faidley's Seafood, which serves giant crab cakes that taste so good they transport you to another realm. This recipe is my attempt to recreate a touch of their out-of-this-world goodness. There are three things you need to know before embarking on this crab cake journey: (1) Don't mess with the saltines. The crackers are a major contributor to the deliciousness factor, so don't be tempted by panko or regular breadcrumbs. (2) Your crab cakes will only be as good as your crabmeat. You want fresh crabmeat. Frozen or the kind that comes in cans is not going to cut it here. (3) In *Madagascar: Escape 2 Africa*, when attempting to land a plane, one of the penguins advises the other that he needs to do it smoothly, "a smooch, like you're kissing your sister." The same applies here. Don't manhandle the crabmeat! Gentle is the way!

FOR THE SAUCE: Combine the mayonnaise, buttermilk, garlic, dill, and lemon juice in a small bowl and mix well. Cover and refrigerate.

FOR THE CRAB CAKES: Stir together the mayonnaise, egg, mustard, Worcestershire, Old Bay, chives, and salt in a medium bowl. Gently fold in the crabmeat, saltines, and lemon zest. Scoop out about one-sixth of the mixture with a ½-cup dry measure. Invert the mixture onto one hand and gently use the other to round the edges, then place on a large plate. Repeat to make 6 cakes total. Cover and refrigerate for 1 hour to firm them up.

Heat the oil and butter in a large skillet over medium-high heat until shimmering. Add half of the crab cakes and cook until golden brown, 4 to 5 minutes per side. Repeat with the remaining cakes.

Garnish with dill and serve 1 or 2 to a person, with the dill sauce and lemon wedges.

CRISPY-SKIN SALMON

PREP TIME: **5 MINUTES** • COOK TIME: **10 MINUTES**

2 (6-ounce) salmon fillets, skin on

2 tablespoons canola oil

½ teaspoon kosher salt

½ teaspoon freshly ground black pepper

Lemon wedges, for serving (optional)

For the life of me, I do not understand why anyone would take the skin off a piece of fish. When the waiter asks you how you'd like a steak prepared, would you say, "Without any flavor whatsoever"? You wouldn't. Yet this is essentially what happens when you remove the skin from the fish. Dry it, salt it, sear it, and eat it…flavor and all. And don't fuss with the fish while it's searing! I serve it with the skin side on top for two reasons. First, I want to experience that crackliness and all the flavor that comes with it right up front. Second, I don't want my guests thinking I forgot to remove it. Unlike tuna, which I prefer rare, I tend to cook other fish more fully. We usually serve this with brown rice and steamed asparagus, but it works with any side you want.

Dry the salmon fillets with a paper towel.

Preheat a large skillet over medium heat for about 5 minutes. Add the oil and heat until it shimmers. Season the salmon fillets on both sides with the salt and pepper.

Lay the salmon fillets, skin side down, in the pan. Cook without disturbing for about 5 minutes, until the underside is crispy. Flip the salmon and continue to cook for about 1 minute, until the fish is cooked the way you like it. Serve skin side up with lemon wedges, if desired.

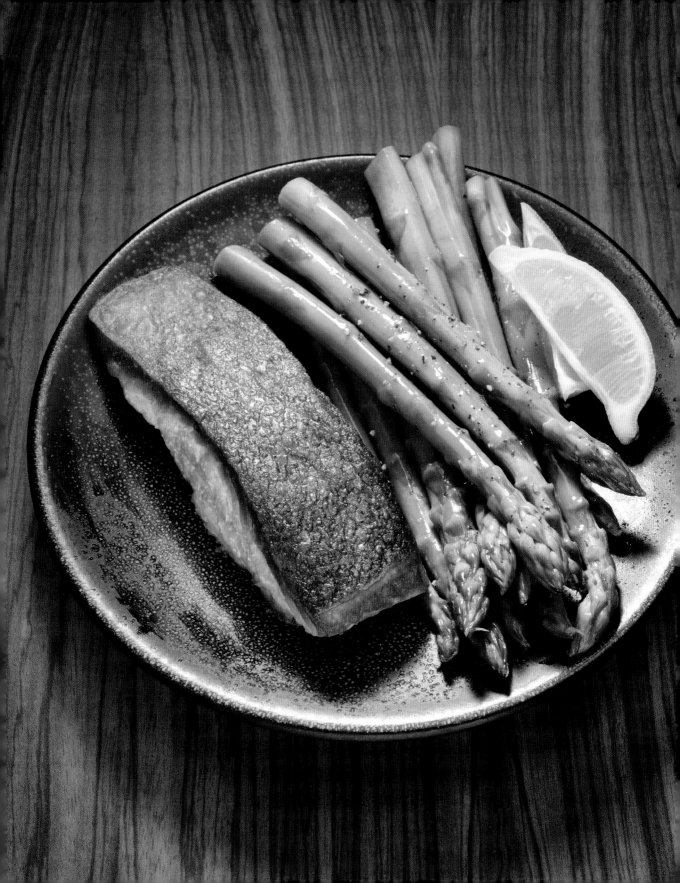

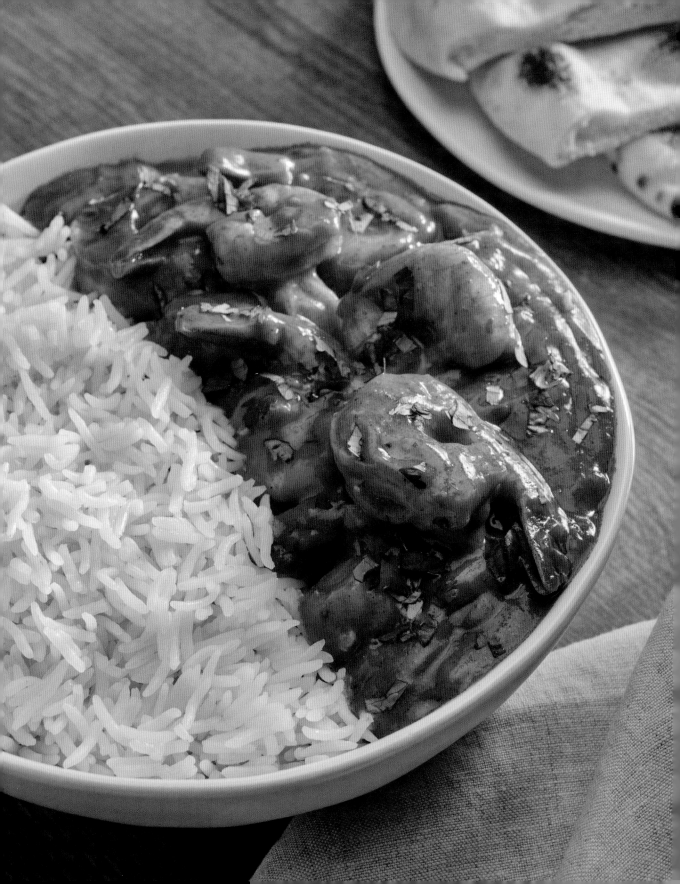

COURTNEY'S SHRIMP TIKKA MASALA

1½ pounds extra-large shrimp, peeled and deveined

1½ teaspoons kosher salt, divided

1 teaspoon ground cumin

3 tablespoons unsalted butter

1 medium yellow onion, diced

8 garlic cloves, chopped

2 tablespoons minced fresh ginger

1 tablespoon curry powder

2 teaspoons garam masala

2 teaspoons chili powder

1 (28-ounce) can crushed tomatoes

1 cup heavy cream

½ cup chicken stock

¼ cup chopped fresh cilantro, plus more for garnish

Cooked basmati rice, for serving

Warm naan (flatbread), for serving (optional)

I hadn't had much exposure to Indian food until Courtney made me this dish, which has become a favorite in our house. When all the Roker kids are back in the nest, this is what they're begging her to make. It manages to be flavorful, rich, tangy, and vibrant all at the same time. The blend of spices in the oh-so-creamy sauce harmonizes as smoothly as a barbershop quartet.

Put the shrimp in a large bowl and season with 1 teaspoon of the salt and the cumin, stirring to coat. Cover and refrigerate.

Melt the butter in a large skillet over medium heat. Add the onion and remaining ½ teaspoon salt and cook, stirring occasionally, for about 6 minutes, until browned. Add the garlic and ginger and cook for 1 minute, stirring. Add the curry powder, garam masala, and chili powder and cook for 1 minute, stirring constantly. Add the tomatoes, cream, chicken stock, and cilantro and stir to combine. Cook the sauce, stirring occasionally, for about 15 minutes. Turn the heat down to low and stir in the shrimp. Cook, stirring occasionally, until the shrimp are pink, about 5 minutes.

Garnish with additional chopped cilantro and serve over basmati rice, with warm naan, if you like.

STRIPED BASS WITH SUN-DRIED TOMATO BUTTER

PREP TIME: **10 MINUTES** • COOK TIME: **5 MINUTES**

SUN-DRIED TOMATO BUTTER

8 tablespoons (1 stick) salted butter, at room temperature

¼ cup drained finely chopped oil-packed sun-dried tomatoes

¼ cup chopped fresh basil, plus more for serving

1 teaspoon garlic powder

BASS

4 (6- to 8-ounce) striped bass fillets

1 tablespoon olive oil, plus more for brushing

1 teaspoon kosher salt

¼ teaspoon freshly ground black pepper

Tasty, versatile, and crowd-friendly, striped bass has a mild taste that's easily enhanced with simple ingredients. In this case, we're using the queen of flavor—butter—which embraces the sun-dried tomatoes, basil, and garlic so well. Make sure you have someone else on table-setting duty on the nights you make this, because it comes together in about five minutes, less time than it takes to put out the plates, napkins, and flatware.

FOR THE BUTTER: Combine the butter, sun-dried tomatoes, basil, and garlic powder in a medium bowl and mix well so everything is evenly distributed. Cover and set aside. The butter can be made up to 1 week before and refrigerated.

FOR THE BASS: Brush the fish fillets lightly with oil and season with the salt and pepper.

Heat the oil in a large skillet over medium-high heat until almost smoking. Lay the fish in the skillet, skin side down, pressing down with a spatula. Cook until the skin becomes golden brown and crispy, about 3 minutes. Carefully turn the fish and continue to cook for about 2 minutes, or until it is white and no longer translucent.

Transfer the fish to a plate and serve with the sun-dried tomato butter on top, about 2 tablespoons per fillet. Garnish with additional basil.

You can substitute red snapper, grouper, or sea bass for the striped bass.

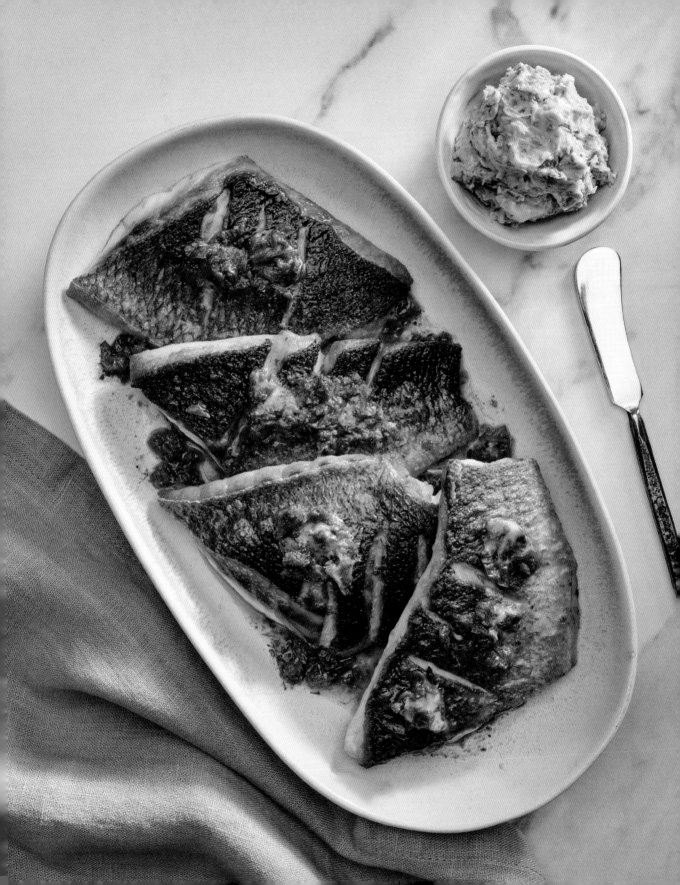

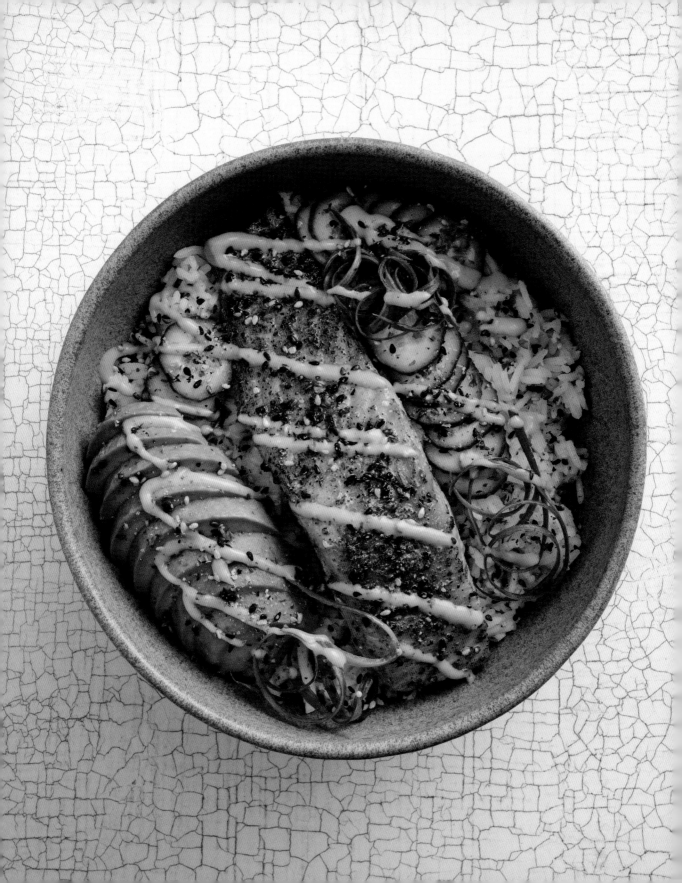

SALMON RICE BOWLS

PREP TIME: **15 MINUTES** • COOK TIME: **15 MINUTES**

⅓ cup mayonnaise, preferably Kewpie

2 teaspoons toasted sesame oil

1½ teaspoons sriracha

½ teaspoon kosher salt

½ teaspoon paprika

½ teaspoon garlic powder

½ teaspoon ground cumin

½ teaspoon chili powder

⅛ teaspoon freshly ground black pepper

2 (6-ounce) skinless salmon fillets

1 tablespoon canola oil

4 cups cooked sushi rice (from 2 cups raw)

Sliced cucumber, avocado, and scallions, for serving

Furikake (see headnote), for sprinkling

Roasted nori snack sheets, for serving (optional)

You can enjoy the rice bowl with a fork, or you can mix everything together and wrap in roasted nori snack sheets and enjoy as a mini roll-up.

Salmon is always a winner in my book, but this dish is truly a win-win because it encourages us to try out some new flavors. Furikake, a Japanese condiment made with sesame seeds, green seaweed flakes, nori, and sometimes dried fish flakes, makes a welcome appearance here. The recipe also uses one of my favorite condiments of all time, Kewpie mayonnaise, which is King of Mayo. If you're thinking, *Mayonnaise, okay, what's the big deal?*, the deal is that this Japanese mayonnaise is smoother and creamier because it's made with only the yolks rather than the whole egg. It also has a unique zip of flavor since it's made with a blend of vinegars. Then there's the squeezy package and the cute little baby on the front with a topknot curl. You can find Kewpie in Asian markets and there's always the internet, people.

Preheat the oven to 375°F. Line a baking sheet with parchment paper.

Combine the mayonnaise, sesame oil, and sriracha in a small bowl and mix well. Set aside.

Stir together the salt, paprika, garlic powder, cumin, chili powder, and pepper in another small bowl. Place the salmon fillets on the prepared baking sheet at least 2 inches apart from each other. Brush with the oil and sprinkle with the spice mixture. Bake until the internal temperature reaches 125°F on an instant-read thermometer for medium-rare, or until it's as done as you like, 10 to 12 minutes. Transfer to a plate and let rest for 5 minutes.

Divide the rice between two bowls. Top with the salmon, cucumber, avocado, and scallions. Drizzle with the spicy sauce, garnish with the furikake (if using), and serve with the nori sheets, if desired.

SAM ZIEN'S CEREAL-CRUSTED SEARED TUNA

PREP TIME: **10 MINUTES** • COOK TIME: **2 MINUTES**

¼ cup mayonnaise

2 tablespoons sweetened condensed milk

1 teaspoon sriracha, plus more for serving

2 cups regular Cap'n Crunch cereal

1 pound sushi-grade ahi (yellowfin) tuna, cut into 2 long rectangular logs

2 tablespoons canola oil, divided

1 teaspoon kosher salt

Toasted sesame seeds and minced fresh chives, for sprinkling

Mixed greens, for serving

Back in the day, the word *sugar* was featured on cereal boxes like it was a plus. I love a good throwback cereal (sugar and all), but no one was more surprised than me that it could be used for fish. Chef Sam Zien of *Sam the Cooking Guy* visited *Today* and showed us how to coat tuna in Cap'n Crunch cereal, and it was divine. It's crazy and yet it works. You've got the sweetness of the cereal and the coolness of the tuna topped off with a spicy, creamy, and slightly sweet sauce. Bonus: after making this recipe you'll have over a half a box of cereal left to enjoy. (Hide it from your kids—I won't tell.) This is my take on Sam's genius creation.

Mix the mayonnaise, condensed milk, and sriracha in a small bowl. Set aside.

Pulse the cereal in a food processor until powdery. Transfer to a shallow bowl.

Brush the tuna with 1 tablespoon of the oil and season with the salt. Press the tuna into the cereal, making sure it is coated on all sides.

Heat the remaining 1 tablespoon oil in a medium nonstick skillet over medium-high heat. Add the tuna and sear quickly on all sides until lightly browned—no more than about 20 seconds per side for rare. Remove from the heat and cut into ½-inch pieces.

Sprinkle with the sesame seeds and chives and serve with the sriracha mayo, alongside the mixed greens.

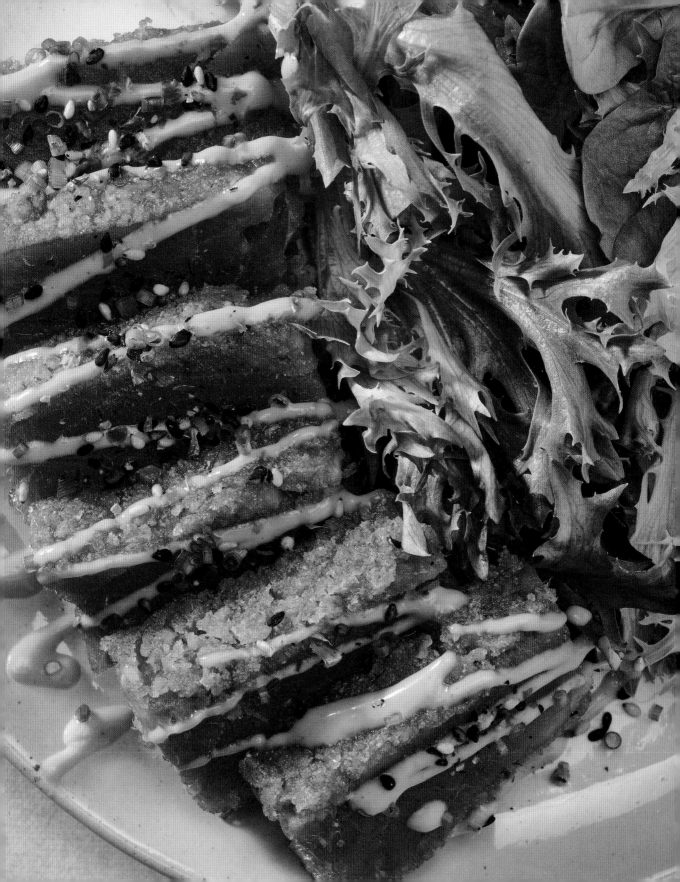

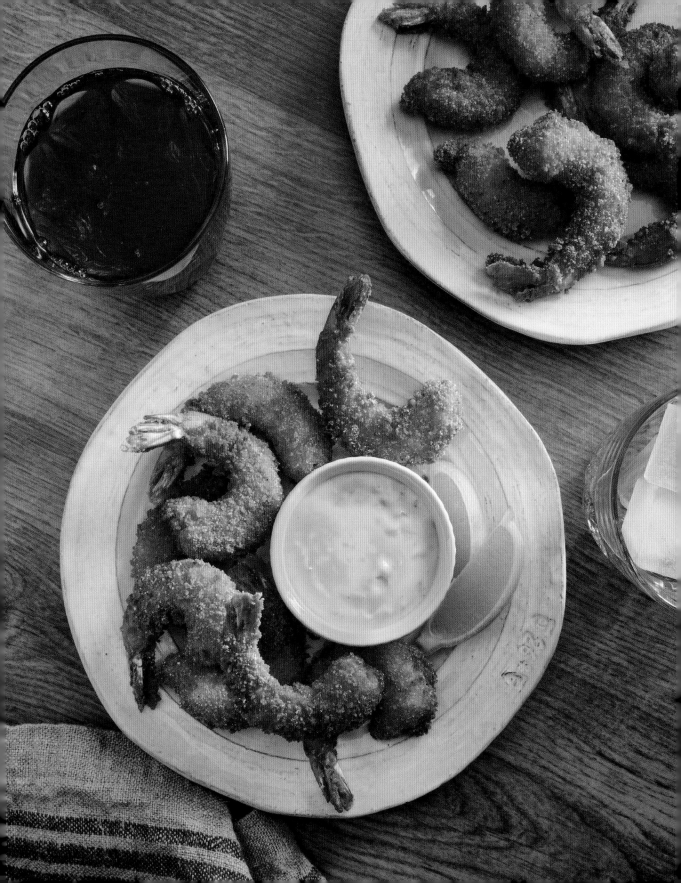

CORNMEAL-FRIED SHRIMP

½ cup all-purpose flour

1 cup yellow cornmeal

¾ cup panko breadcrumbs

1 teaspoon dried tarragon

1½ teaspoons kosher salt, plus more for serving

¼ teaspoon freshly ground black pepper

3 large eggs

1 tablespoon water

1 pound large shrimp, peeled and deveined

3 cups canola oil

Tartar Sauce (page 139), for serving

Lemon wedges, for serving

Cornmeal-fried shrimp is the corndog of the seafood world. It's crunchy and light at the same time, and the cornmeal is the perfect outerwear for the meaty shrimp. A quick word of warning: you have no idea how easy it is to throw back a dozen or so of these babies before coming up for air. Sure, you think you can handle it, but if you don't watch out, you'll dig in and within a couple of minutes be looking at an empty plate wondering, *Where's the shrimp?* Avoid this situation by sharing with friends.

Put the flour in a shallow dish.

Stir together the cornmeal, panko, tarragon, salt, and pepper in a second shallow dish. In a third shallow dish, whisk together the eggs and water.

Dredge half of the shrimp in the flour, then turn them in the egg mixture to coat on both sides. Transfer the egg-coated shrimp to the cornmeal mixture, making sure to press the mixture into the shrimp so it adheres well. Put the breaded shrimp on a large plate and repeat with the remaining shrimp.

Heat the oil in a Dutch oven or other large, wide pot over medium-high heat until it reaches 350°F. If you don't have an instant-read thermometer, toss some panko into the oil to test if it is ready; the oil should become bubbly around the panko. Once the oil has reached 350°F, add the shrimp, 10 at a time, and fry until browned, about 1 minute. Remove the fried shrimp from the oil with a slotted spoon and transfer to a paper towel–lined plate to drain. Repeat the process with the remaining shrimp. Season with salt to taste. Serve right away with tartar sauce and lemon wedges.

SHRIMP AND GRITS WITH BELL PEPPERS AND BACON

PREP TIME: **20 MINUTES** • COOK TIME: **40 MINUTES**

1 pound large shrimp, peeled and deveined

2 teaspoons Old Bay seasoning

4 cups seafood stock

3 teaspoons kosher salt, divided

1 cup old-fashioned grits

2 tablespoons unsalted butter

1 tablespoon olive oil

4 slices smoked bacon, cut into ½-inch dice

1 small yellow onion, finely chopped

1 small red bell pepper, finely chopped

5 garlic cloves, chopped

¼ cup dry white wine

1 (14½-ounce) can diced tomatoes, drained

1 tablespoon hot sauce

1 tablespoon lemon juice

Sliced scallions, for garnish

NOTE Deveining shrimp is easy. With kitchen shears, cut along the back, then use a paring knife to lift out the dark vein and discard.

You can find grits in the cereal section. Stone-ground grits are tastier, but they take longer to cook, about 45 minutes.

Shrimp and grits is a common dish on the Gulf Coast and the Carolina Lowcountry. It's a beautiful combo. I've got to give credit to grits here. If you don't have them in your life, you are missing out on a simple but exquisite pleasure. They're highly versatile and take well to either a sweet or savory preparation. Contrary to their name, they have a welcoming creamy-smooth texture. While there are many varieties—blue grits, yellow grits, stone-ground grits—my tried-and-true favorites are the easiest to find: Quaker grits from the grocery store. This dish is a dream in a bowl, with the grits sucking up all the fantastic flavor from the fast-cooking shrimp.

Toss the shrimp with the Old Bay in a bowl. Cover and refrigerate.

Bring the stock and 2 teaspoons of the salt to a boil in a medium saucepan over medium-high heat. Whisk in the grits, then reduce the heat to low, cover, and simmer until all the liquid is absorbed and the grits are tender, 10 to 15 minutes, stirring occasionally. Stir in the butter. Cover and remove from the heat.

While the grits are cooking, heat the oil in a large skillet over medium heat. Add the bacon and cook until crispy on both sides, about 6 minutes. Transfer the bacon with a slotted spoon to a paper towel–lined plate, leaving the grease in the pan.

Reduce the heat to medium-low, add the onion, bell pepper, and garlic and cook, stirring occasionally, until the vegetables begin to soften, about 5 minutes. Pour in the white wine, tomatoes, and remaining 1 teaspoon salt and stir. Cook until the sauce thickens, about 10 minutes. Add the shrimp to the pan and cook until opaque and cooked through, about 4 minutes. Remove the pan from the heat and stir in the hot sauce and lemon juice.

Serve the grits immediately, topped with the shrimp and sauce, bacon, and scallions.

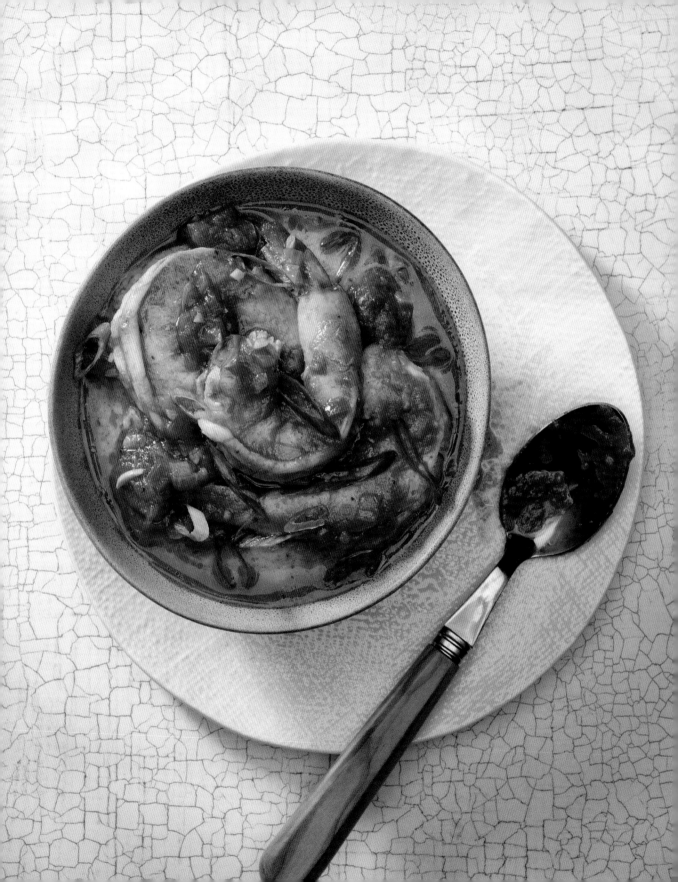

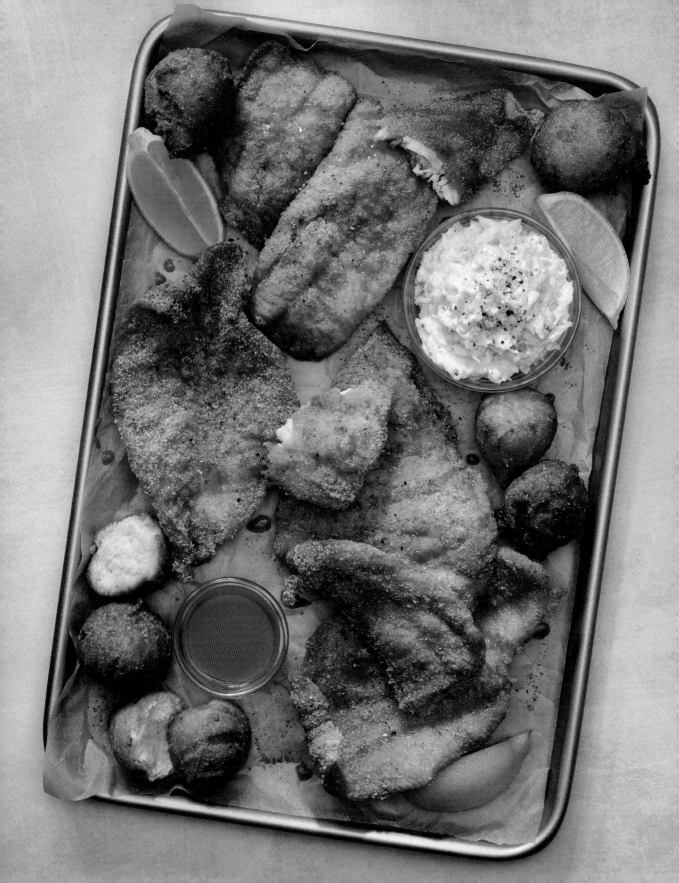

CRUNCHY CORNMEAL-FRIED WHITE FISH

PREP TIME: **10 MINUTES** • COOK TIME: **10 MINUTES**

TARTAR SAUCE

1 cup mayonnaise

⅔ cup dill pickle relish

2 tablespoons capers, drained and finely chopped

2 tablespoons finely chopped fresh dill

2 tablespoons lemon juice

1 teaspoon Worcestershire sauce

WHITE FISH

1½ pounds skinless whiting or flounder fillets

1½ cups buttermilk

1 cup fine yellow cornmeal

1 cup all-purpose flour

2 tablespoons Old Bay, Cajun, or Creole seasoning

1 cup canola oil

Hot sauce and lemon wedges, for serving

This recipe is inspired by my father, Albert Roker Sr., who loved to go fishing whenever he had the chance. He brought me along a few times but gave up on me fairly quickly. I just didn't understand why it was fun to stand for hours staring at the water waiting for a bite. How was this relaxing? I liked to eat his catch, though. He'd fry up the fish on a Friday or Saturday for dinner, and there was something so simple and perfect about the meal of fried fish, tartar sauce, coleslaw, and hush puppies—and sometimes our old standbys like mac and cheese or cornbread—and the prep didn't eat up any of my dad's family time.

FOR THE TARTAR SAUCE: Combine all of the ingredients in a small bowl. The sauce can be refrigerated for up to 5 days.

FOR THE FISH: Put the fish in a large bowl and pour the buttermilk over it, ensuring all pieces are coated. Cover and refrigerate for 30 minutes.

Line a baking sheet with paper towels and place a wire rack over it.

Meanwhile, mix the cornmeal, flour, and seasoning in a wide, shallow bowl.

Working with one fillet at a time, dredge the fish in the cornmeal mixture, turning and pressing to coat it well. Transfer to another baking sheet.

Heat the oil in a large, deep skillet over medium-high heat until it reaches 375°F on an instant-read thermometer. If you don't have one, toss a tiny piece of bread into the oil to test if it is ready; it should bubble around the bread. Carefully add half of the fillets. Fry for 2 to 3 minutes, flipping them over halfway, until they are golden brown. Using tongs, transfer the fish to the prepared rack. Repeat with the remaining fillets.

Serve immediately with the tartar sauce, hot sauce, and lemon wedges.

SHRIMP DIABLO

2 pounds large shrimp, peeled and deveined

2 teaspoons kosher salt, divided

1 teaspoon freshly ground black pepper

¼ cup olive oil

1 large yellow onion, finely chopped

8 garlic cloves, finely chopped

¾ cup dry white wine

1 (28-ounce) can crushed tomatoes

1 cup low-sodium chicken stock

⅓ cup chopped fresh basil

1 teaspoon red pepper flakes

Warm crusty bread, for serving

Announcing "We are having shrimp diablo for dinner!" makes me feel like Zorro, the swordsman dedicated to protecting the commoners from villains. Dinner guests will think you are a truly skilled cook who left work hours early to prepare this masterpiece. The real hero here is the recipe, and only you know the truth: You got home forty-five minutes ago. You took a quick shower, walked the dog, set the table, had a cup of tea, and threw together this luxury-level dish in mere minutes. Thankfully I've never been tackled while serving this like my brother Chris and his riot-inducing Barbecued Bacon-Wrapped Shrimp (page 119), but this is a definite crowd-pleaser.

Put the shrimp in a bowl and season with 1½ teaspoons of the salt and the pepper. Cover and refrigerate.

Heat the oil in a large, deep skillet over medium heat. Add the onion and cook until slightly softened, about 6 minutes. Add the garlic and cook until fragrant, about 1 minute. Pour in the white wine, crushed tomatoes, chicken stock, basil, red pepper flakes, and remaining ½ teaspoon salt and stir to combine. Turn the heat down to medium-low and cook for about 20 minutes, stirring occasionally.

Add the shrimp to the sauce and cook, stirring occasionally, until opaque, about 5 minutes. Serve with warm, crusty bread for dunking in the sauce.

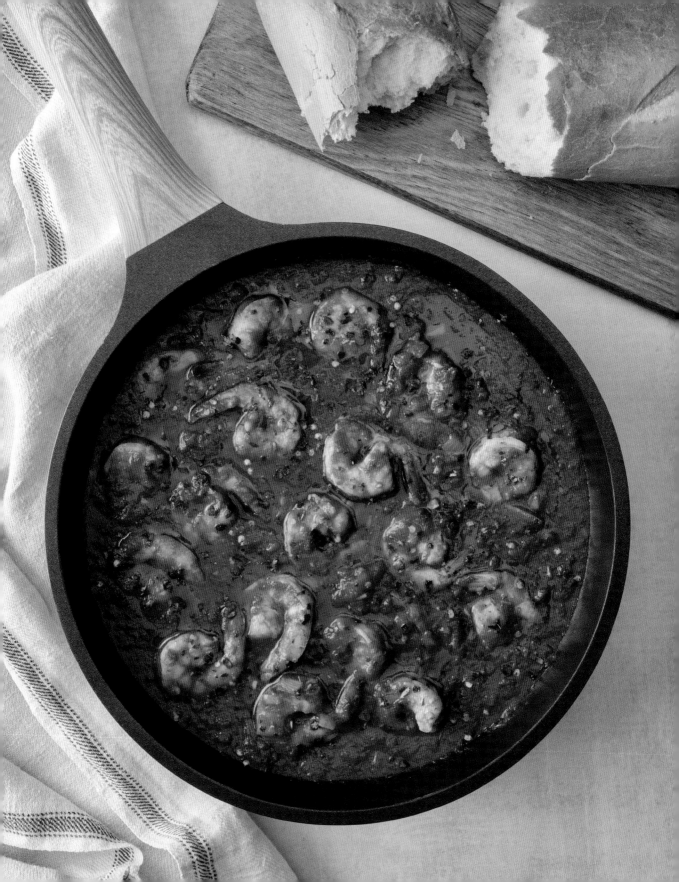

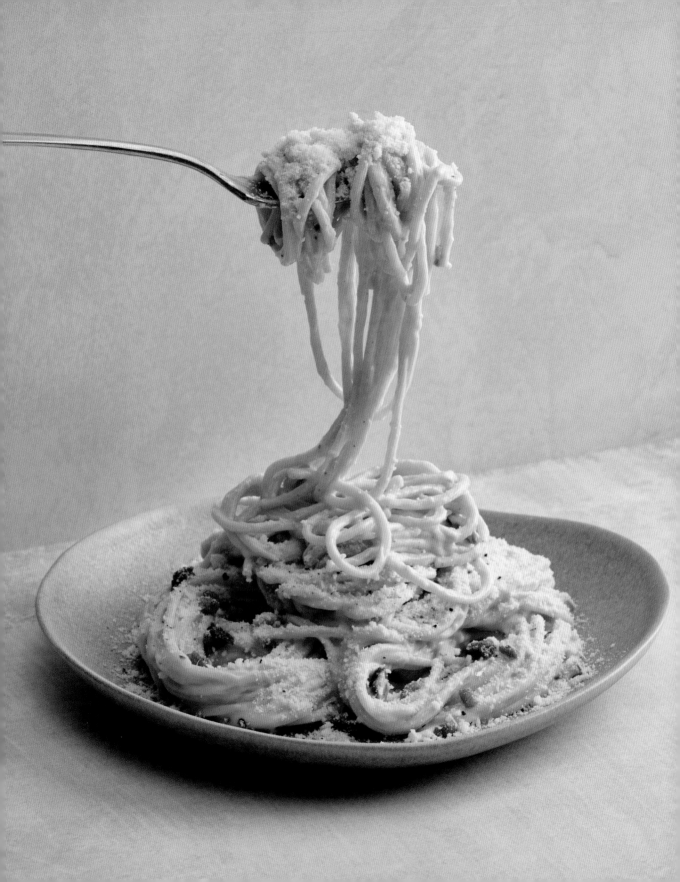

LEILA'S SPAGHETTI CARBONARA

PREP TIME: **10 MINUTES** • COOK TIME: **15 MINUTES**

1 large egg

2 large egg yolks

1 cup finely grated Pecorino Romano cheese, divided

½ teaspoon freshly ground black pepper

Kosher salt

1 pound spaghetti

1 tablespoon olive oil

4 ounces guanciale, diced

You can substitute pancetta or even bacon for the guanciale.

Leave it to the Italians to figure out how to take bacon, eggs, cheese, and pasta and turn it into a sumptuous dinner. The ingredients really matter here. You want to buy the freshest eggs you can get your hands on. Now let's talk cheese. Pecorino comes from *pecora*, the Italian word for ewe. This is a cheese that is made with love and care by farmers whose sheep graze on lush Italian grass. The flavor tends toward the nutty side, which is followed by a zap of saltiness. That salty flavor comes from the farmers hand-rubbing the cheese with salt for several months. That's devotion. Now the pork. *Oh guanciale, come ti amo!* Guanciale is a rich, fatty, cured meat that is made from the cheek of a pig. Again! The Italians! Transforming a pig cheek into a delicacy! When these glorious ingredients are introduced to a high-quality spaghetti, the result is a bowl of pasta with a sparkling golden aura. What we have here is brilliance— breakfast masquerading as dinner.

Whisk the egg, egg yolks, ½ cup of the Pecorino Romano, and the pepper in a small bowl. Set aside.

Bring a large pot of salted water to a boil over high heat. Add the spaghetti and cook until al dente according to the package instructions.

Meanwhile, heat the olive oil in a large skillet over medium heat. Add the guanciale and cook, stirring often, until the fat renders and the guanciale is browned, about 6 minutes. Reduce the heat to medium-low; leave the guanciale in the pan.

When the spaghetti is done, scoop out about 1 cup of the water and reserve, then drain the pasta. Add the pasta to the skillet, then add the egg mixture to the pan, followed by ½ cup of the reserved pasta water. Cook, stirring constantly, until the sauce thickens; add a little more pasta water if necessary.

Remove the pan from the heat and stir in the remaining ½ cup Pecorino Romano. Serve immediately.

ANYTIME CHICKEN THIGHS

2 pounds bone-in, skin-on chicken thighs

1 teaspoon kosher salt

½ teaspoon freshly ground black pepper

½ teaspoon poultry seasoning

2 teaspoons canola oil

Confession: I eat these chicken thighs once a week, but I almost didn't include this recipe in the book because it's just so simple. But last night as I was digging into the satisfying piece of chicken, juicy, flavorful, and with the crispiest skin, I thought, *I am so content right now*, and I knew I had to include it. The chicken practically prepares itself. All it needs is salt and pepper, a hot pan, and a good sear. The leftover fat in the pan makes its own gravy. If you want to be really kind to yourself, toss some baby spinach in that liquid gold while it's still in the pan. You'll be glad you did.

Pat the chicken dry with a paper towel. Toss the chicken with the salt, pepper, and poultry seasoning in a large bowl until evenly coated.

Heat the oil in a large skillet over medium heat. Add the chicken in a single layer, skin side down, and cook undisturbed for about 10 minutes, until the skin is golden brown. Flip the chicken, reduce the heat to medium-low, and continue to cook for about 8 minutes, until browned on the other side and the internal temperature reaches 165°F. Serve right away.

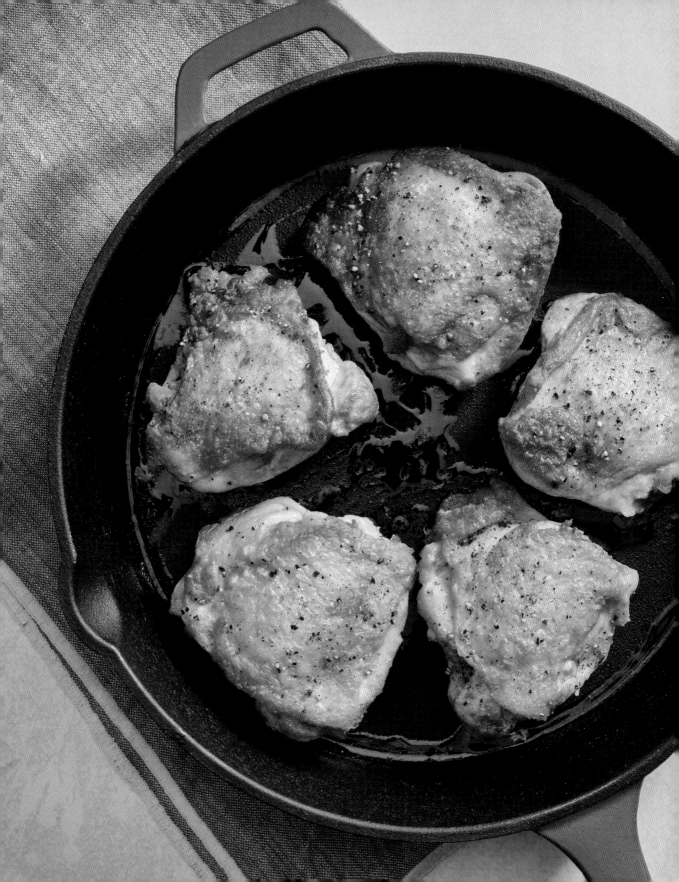

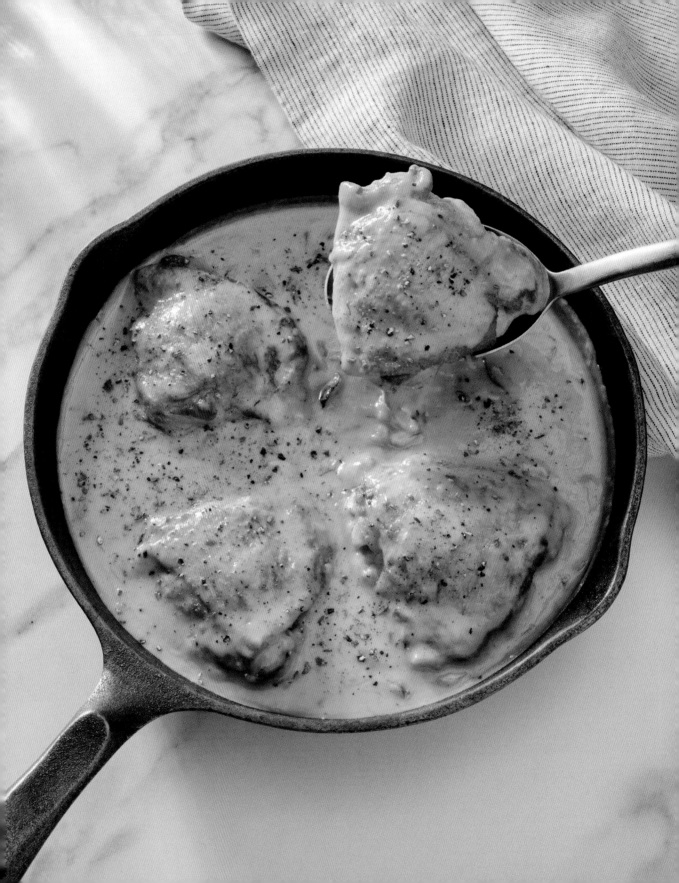

SMOTHERED CHICKEN

2 pounds bone-in, skin-on chicken thighs

1½ teaspoons salt-free poultry seasoning

2 teaspoons kosher salt, divided

½ teaspoon freshly ground black pepper

2 tablespoons plus 1 teaspoon canola oil, divided

1 large yellow onion, sliced ¼ inch thick

6 garlic cloves, chopped

⅓ cup all-purpose flour

2½ cups water

There is only one thing that is better than chicken thighs, and that's chicken thighs with gravy. This Southern classic lands on our table thanks to Deborah, who grew up in the South, where smothered chicken is a well-loved staple. Bone-in chicken thighs are seared in oil (yes, this is another opportunity to whip out the cast-iron pan), along with onions and garlic. Then the only thing you have to do is add water and let the ingredients do their job. The thighs braise along happily while the sauce thickens, smothering the heck out of that chicken.

Don't even think of trying this recipe with chicken breasts: fat equals flavor, and chicken breasts don't have any. Even if you're being health conscious, remember that every bite matters, and those bites should be satisfying.

Season the chicken evenly with the poultry seasoning, 1 teaspoon of the salt, and the pepper.

Heat 2 tablespoons of the oil in a large skillet over medium heat. Add the chicken in a single layer, skin side down. Cook until the skin is golden brown, about 10 minutes. Flip the chicken and continue to cook until browned on the other side, about 5 minutes. Transfer the chicken to a plate.

Add the remaining 1 teaspoon oil, the onion, and the remaining ½ teaspoon salt and cook over medium heat until the onion is slightly softened, about 5 minutes. Add the garlic and cook for 1 minute, stirring constantly. Stir in the flour and cook, stirring constantly, for about 1 minute. Add the water and stir until combined, scraping up the browned bits from the bottom of the pan. Reduce the heat to medium-low, return the chicken to the pan, cover, and cook, stirring occasionally, for about 25 minutes, until the chicken is tender.

Transfer the chicken to a platter and top with the gravy.

CHICKEN SHAWARMA BOWLS

PREP TIME: **20 MINUTES** • COOK TIME: **40 MINUTES**

CHICKEN
2 teaspoons ground cumin

2 teaspoons curry powder

2 teaspoons kosher salt

1 teaspoon ground cardamom

1 teaspoon garlic powder

¼ cup plain Greek yogurt

2 tablespoons olive oil

2 pounds boneless, skinless
chicken thighs

TOMATO-CUCUMBER SALAD
4 Roma tomatoes, diced

1 cucumber, diced

1 small red onion, diced

½ cup crumbled feta cheese

¼ cup finely chopped fresh
parsley

2 tablespoons lemon juice

2 tablespoons olive oil

BOWLS
1½ cups hummus

Warm pita bread, for serving

Lemon wedges, for serving

I'm a plate person. Protein over there, veggie on this side, a starch on the other. Everything has its own area, which means I'm in full control of which foods mingle. But this recipe that my daughter Courtney adores sheds some light on the benefits of a good bowl. The foods in this particular combo get along so well that it doesn't matter what touches what, just so long as it all ends up on your fork.

FOR THE CHICKEN: Preheat the oven to 400°F.

Stir together the cumin, curry powder, salt, cardamom, and garlic powder in a small bowl. Mix the yogurt and olive oil in a large bowl. Add the chicken to the yogurt mixture, sprinkle with the spice mixture, and mix with your hands to thoroughly coat.

Transfer the chicken to a baking sheet and bake for 35 to 40 minutes, until the chicken is golden brown. Remove from the oven and let cool for 10 minutes. Slice the chicken thinly.

MEANWHILE, FOR THE SALAD: Combine the tomatoes, cucumber, onion, feta, and parsley in a large bowl. Add the lemon juice and olive oil and toss to coat well. Set aside.

TO ASSEMBLE THE BOWLS: Divide the hummus among the serving bowls. Top with the salad and sliced chicken and serve with warm pita and lemon weges.

For extra flavor, marinate the chicken in the spices in the refrigerator for 1 to 4 hours before cooking.

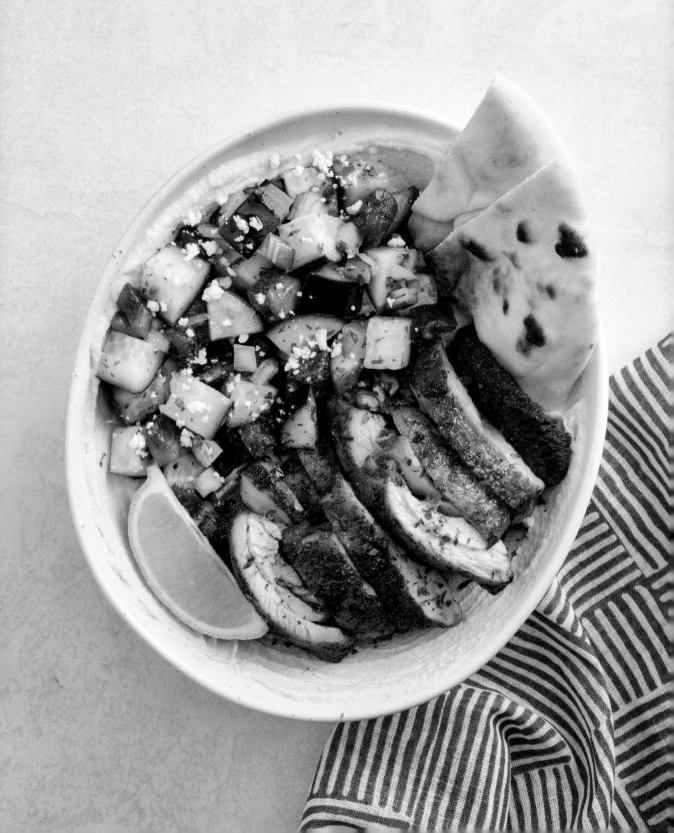

THE BEST ROAST CHICKEN, PERIOD

PREP TIME: **15 MINUTES, PLUS 48 HOURS TO CHILL** • COOK TIME: **1 HOUR 20 MINUTES**

1 (3½- to 4½-pound) chicken

6 rosemary sprigs

6 thyme sprigs

1½ teaspoons kosher salt

¼ teaspoon freshly ground black pepper

1 small head garlic, cut in half horizontally

Every once in a while, you encounter a recipe that makes you sit up and say, *Ohh. Isn't this interesting?* I was immediately intrigued by the preparation of this chicken when I saw it in the *New York Times*. *You put the herbs under the skin? You keep it in the fridge for 48 hours before roasting it?* I had to try it.

Inspired by a recipe from the late Judy Rodgers of Zuni Café in San Francisco, this is The Best Roast Chicken anywhere. For years I've been telling people, "If this isn't the best chicken you've ever had, I will kiss you on the mouth." No one has ever taken me up on this offer (and I let myself assume it's because they love the chicken). I know we all want shortcuts when it comes to getting dinner on the table, but sometimes we need to slow down, plan, and let ourselves relish the results. So yes, this recipe requires planning, but the time you put into the preparation, the time in the refrigerator, and the mid-roast flip will result in the most tender and moist chicken you will ever taste. The photo is on page 152.

Place a wire rack on a baking sheet. Pat the chicken dry inside and out with a paper towel. Gently insert your finger under the skin of the breast on each side and carefully separate the skin from the meat, lifting it slightly to create a "pocket" for the herbs. Insert 1 rosemary sprig and 1 thyme sprig on each side. Then, on the thickest section of each thigh, use your finger to carefully separate the skin from the meat in the same manner. Insert 1 rosemary sprig and 1 thyme sprig as you did with the breasts.

Rub the outside of the chicken with the salt and pepper and place the remaining 2 rosemary sprigs and 2 thyme sprigs and the garlic halves inside the cavity. Place the chicken breast side up on the prepared rack and refrigerate, uncovered, for 48 hours.

About 30 minutes before roasting, remove the chicken from the refrigerator. Place a small roasting pan in the oven and preheat the oven to 475°F.

Pat the chicken dry again with a paper towel and tie the legs together with kitchen twine. Carefully remove the hot pan from the oven and place on the stovetop. Place the chicken in the roasting pan, breast side up.

Place the pan in the center of the oven and roast the chicken until the breast starts to brown, about 30 minutes. Remove the pan from the oven and, using tongs, carefully turn the chicken breast side down. Return the pan to the oven and roast until the back is browned, about 30 minutes. Remove the pan from the oven and carefully flip the chicken so that it is breast side up again. Return the pan to the oven and continue to roast until the skin is golden brown and the internal temperature of the thickest part of the thigh is at least 165°F, about 20 minutes.

Transfer the chicken to a cutting board and let rest, uncovered, for 10 minutes. Carve the chicken and serve, drizzled with the pan juices.

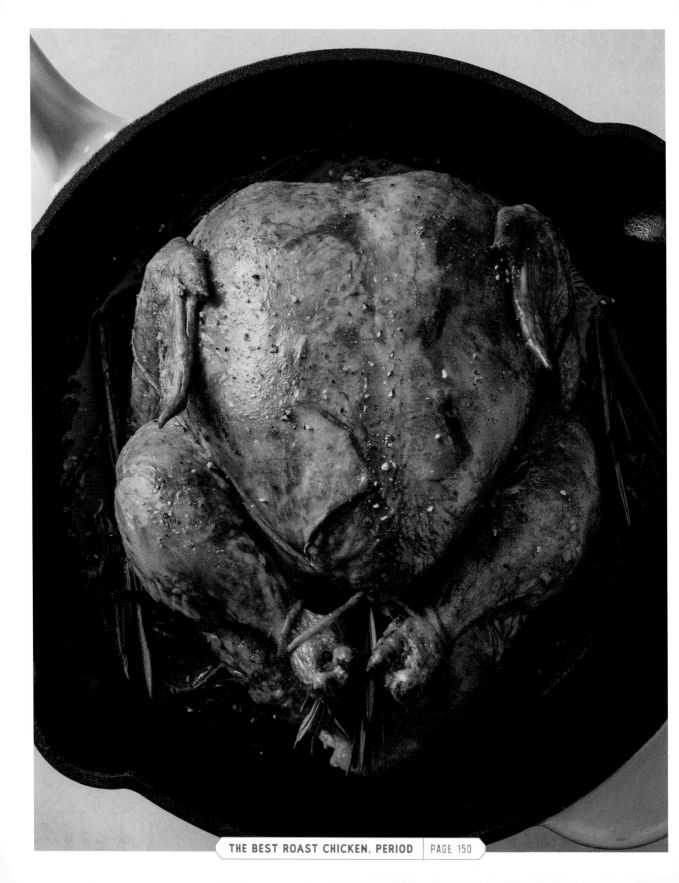

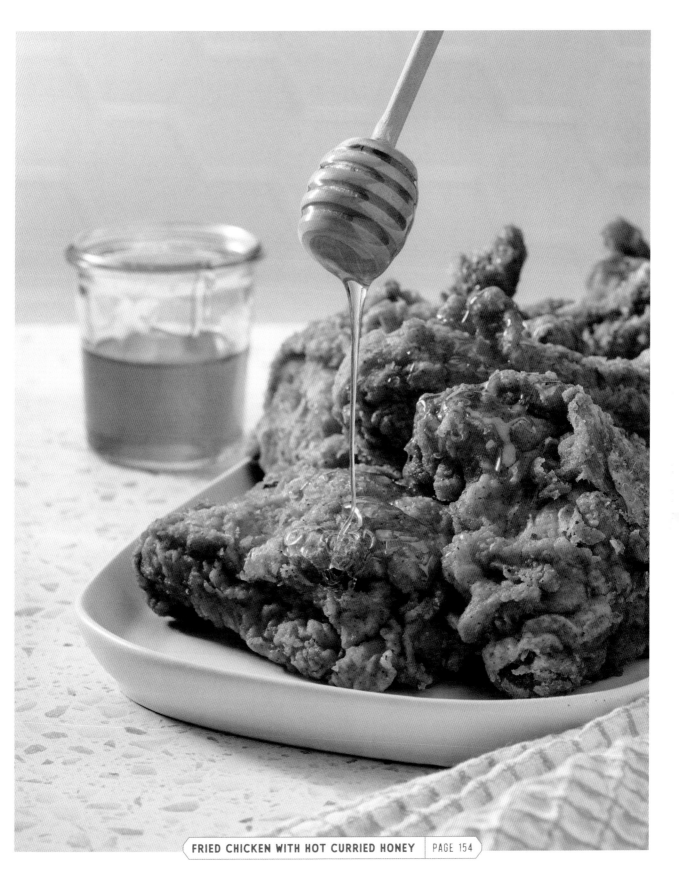

FRIED CHICKEN WITH HOT CURRIED HONEY | PAGE 154

FRIED CHICKEN

WITH HOT CURRIED HONEY

PREP TIME: **30 MINUTES, PLUS 4 HOURS TO MARINATE** • COOK TIME: **35 MINUTES**

CHICKEN

2 cups buttermilk

½ cup dill pickle juice

¼ cup plus ¼ teaspoon sriracha, divided

3½ teaspoons kosher salt, divided

1½ pounds bone-in, skin-on chicken thighs (about 4)

1½ pounds bone-in, skin on chicken drumsticks (about 4)

2 cups all-purpose flour

1 cup panko breadcrumbs

½ cup cornstarch

1 tablespoon garlic powder

1 tablespoon onion powder

1 tablespoon paprika

1 teaspoon ground cumin

1 teaspoon ground coriander

½ teaspoon ground cardamom

8 cups peanut oil

HOT HONEY

1 tablespoon unsalted butter

½ teaspoon curry powder

⅓ cup honey

½ teaspoon red pepper flakes

2 teaspoons sriracha

This recipe comes via the brilliant chef Marcus Samuelsson, and it is as delicious as he is imaginative. Marcus was born in Ethiopia and adopted by Swiss parents, and his food manages to pay tribute to his heritage. He is one of the original fusion chefs, and his ability to merge Swedish and African culinary traditions is a feat. He's turned me on to gravlax and herring, while also making some of the best fried chicken I've ever had. I've had the opportunity to get to know Marcus just a bit, and it's like meeting a culinary Superman— what can't he do? The following recipe is my homage to Marcus and his uniquely prepared fried chicken. I know fried chicken can be intimidating, but this recipe, with its warm curried sweet honey, is great for beginners. The chicken is briefly fried, then finished in the oven, which takes out all the guesswork. You're not going to burn this or end up with undercooked chicken. It's Fried Chicken 101. The photo is on page 153.

FOR THE CHICKEN: Mix the buttermilk, pickle juice, ¼ cup of the sriracha, and 1½ teaspoons of the salt in a large bowl. Add the chicken and turn to coat, cover, and marinate in the refrigerator for at least 4 hours and up to 24 hours.

About 30 minutes before frying time, remove the marinated chicken from the refrigerator. Preheat the oven to 300°F. Place a wire rack on a baking sheet.

Combine the flour, panko, cornstarch, garlic powder, onion powder, paprika, cumin, coriander, cardamom, and the remaining 2 teaspoons salt in a large shallow dish and mix well.

One a time, lift the chicken pieces from the buttermilk, letting any excess drip off, and coat them completely in the seasoned flour. Transfer the chicken to a second baking sheet in a single layer.

Pour the oil into a large, deep pot; it should be at least 4 inches deep. Heat the oil over medium-high heat until it reaches 350°F. If you don't have an instant-read thermometer, toss a bit of

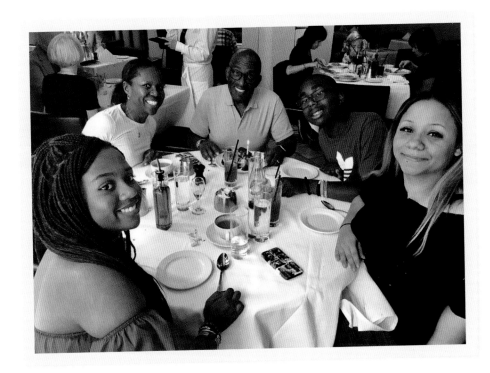

panko into the oil to test if it is ready; the oil should become bubbly around the panko. Working in batches, add half of the chicken to the hot oil and cook, turning occasionally, until crisp and golden brown, about 5 minutes. Transfer the fried chicken to the prepared rack. Cook the remaining chicken in the same way.

Transfer the fried chicken to the oven to finish cooking, about 20 minutes, or until an instant-read thermometer registers 165°F.

MEANWHILE, FOR THE HOT HONEY: Melt the butter in a small saucepan over medium heat. Add the curry powder and cook until fragrant, about 1 minute. Remove from the heat and stir in the honey, red pepper flakes, and sriracha.

Serve the fried chicken on a platter, drizzled with the hot honey.

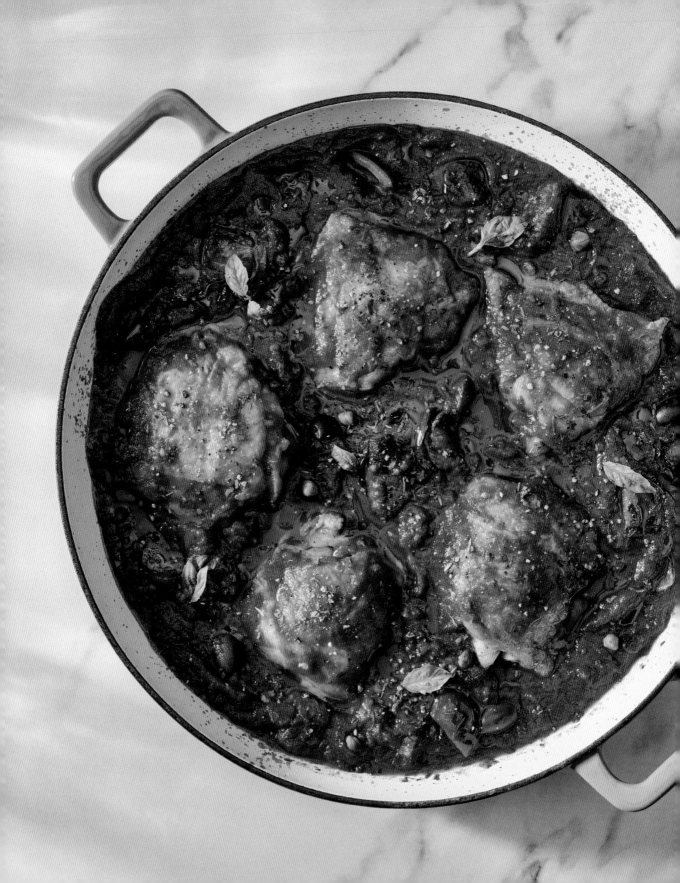

CHICKEN CACCIATORE

PREP TIME: **25 MINUTES** • COOK TIME: **1 HOUR 25 MINUTES**

2 pounds bone-in, skin-on chicken thighs

2 teaspoons kosher salt, divided

1 teaspoon olive oil

1 red bell pepper, diced

1 yellow onion, diced

8 ounces cremini mushrooms, sliced

6 garlic cloves, chopped

1 teaspoon Italian seasoning

1 teaspoon chopped fresh rosemary

⅓ cup sun-dried tomatoes, chopped

1 (14½-ounce) can crushed tomatoes

⅓ cup dry white wine

⅓ cup pitted kalamata olives

¼ cup chopped fresh basil

1 tablespoon drained capers

Warm crusty bread, for serving

If you did a survey of five hundred Italian grandmothers, I suspect you'd get five hundred different recipes. My mother made this regularly, and on chicken cacciatore nights I knew what was for dinner as soon as I walked into the house. The scent of chicken braising in tomatoes and veggies filled the entire house, so mouthwatering it would pull me into the kitchen as if I were in a trance. The spell was broken the second she saw me. "Al, this is about ready. Set the table." The quicker I did it, the sooner I'd get to dig in. I was never sure where my mother's version of the recipe came from—a magazine or a lady at church—but we all loved it and there were never any leftovers. My recipe features a few upgrades from my mother's. The sun-dried tomatoes add depth to the tomato sauce, and olives and capers bring an extra layer of brininess. This is not a recipe I see making the rounds today, and it's too good to be missed.

Preheat the oven to 350°F.

Season the chicken thighs with 1½ teaspoons of the salt. Heat the oil in a large Dutch oven over medium heat. Add the chicken thighs, skin side down, and cook until the skin is golden brown, about 12 minutes. Flip the chicken and cook for about 2 minutes, until the other side is lightly browned. Transfer the thighs to a plate.

Add the bell pepper, onion, and mushrooms to the pan and cook, stirring occasionally, until the vegetables begin to brown, about 8 minutes. Add the garlic, Italian seasoning, rosemary, and remaining ½ teaspoon salt and cook, stirring frequently, until the garlic is fragrant, about 1 minute. Add the sun-dried tomatoes, crushed tomatoes, white wine, olives, basil, and capers and stir to combine. Return the chicken to the pan.

Cover, transfer to the oven, and bake for about 1 hour, until the chicken falls off the bone. Serve with warm crusty bread.

PAN-SEARED DUCK BREAST

PREP TIME: **5 MINUTES** • COOK TIME: **20 MINUTES**

2 (12-ounce) duck breasts

1½ teaspoons kosher salt

½ teaspoon freshly ground black pepper

Why aren't we paying more attention to duck? Don't get me wrong, I'm clearly pro-chicken, but duck breast too often gets forgotten. For crispy, extra juicy meat that will add a wow moment to your weekly meal planning, get the duck! This recipe is all about the duck. It is literally the only ingredient other than salt and pepper because it doesn't need anything else.

Bonus: If you save the rendered duck fat and use it to roast baby potatoes, the skies will part and the sun will shine brighter than ever before, leaving you to wonder, *Where has duck fat been all my life?*

Pat the duck breasts dry with a paper towel.

Using a small knife, lightly score the skin on each duck breast. Season on both sides with the salt and pepper.

Place the duck breasts, skin side down, in a large skillet and heat over medium-low heat. Slowly cook until the fat is rendered and the skin is golden brown, about 15 minutes. Pour out the fat from the pan and save it (see the headnote). Flip the breasts and continue to cook until an instant-read thermometer registers 130°F for medium-rare, about 7 minutes.

Slice the duck breasts and serve.

Some of my favorite sides to serve with this are cooked lentils, roasted cauliflower, or a salad.

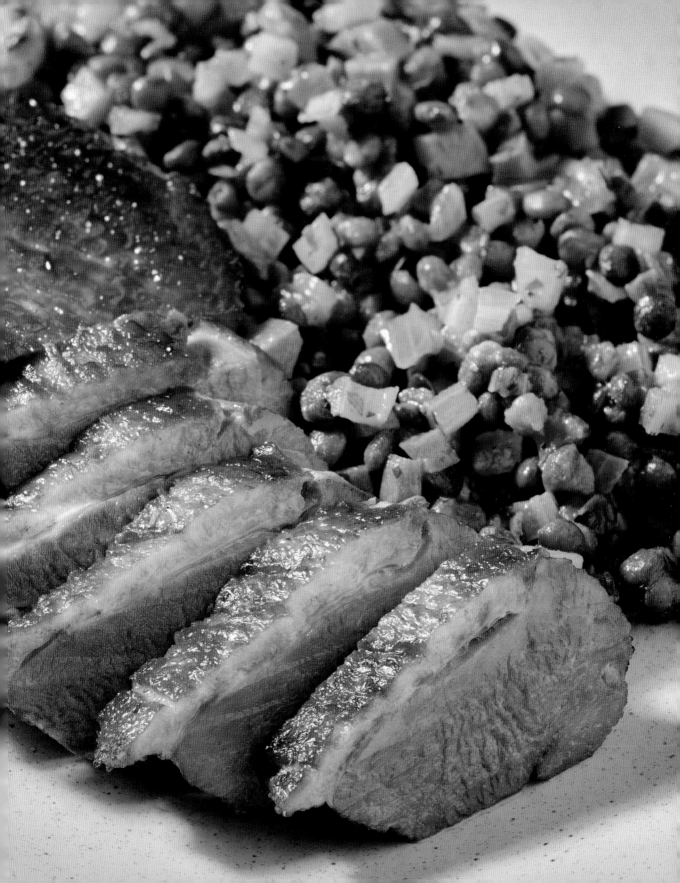

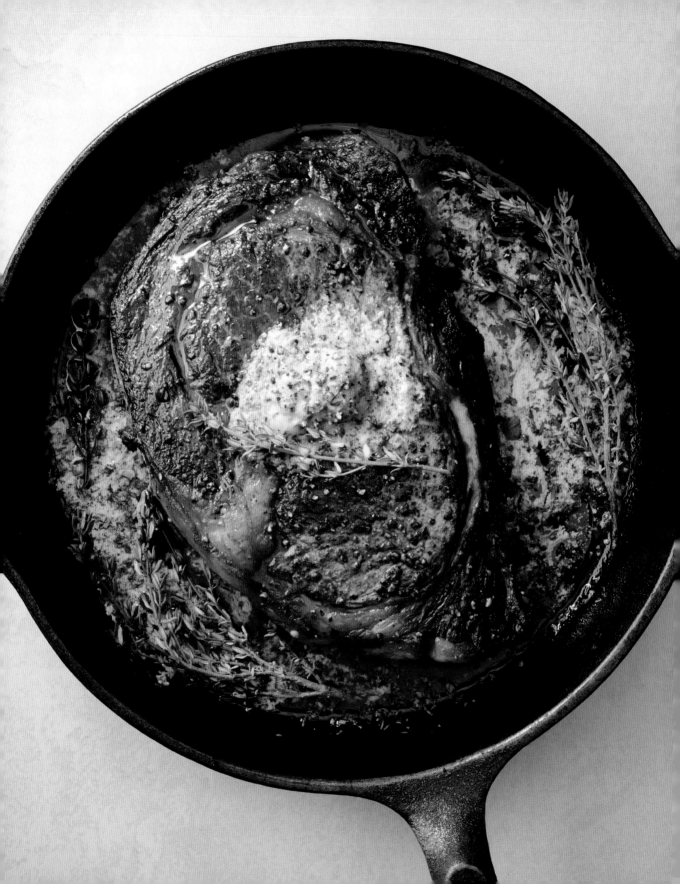

CAST-IRON RIBEYE
WITH DIJON-MUSTARD BUTTER

PREP TIME: **5 MINUTES** • COOK TIME: **20 MINUTES**

4 tablespoons (½ stick) unsalted butter, at room temperature

2 tablespoons chopped fresh parsley

1 tablespoon Dijon mustard

1 (12- to 16-ounce) boneless ribeye steak, about 1½ inches thick

1½ teaspoons kosher salt

½ teaspoon freshly ground black pepper

Thyme sprigs, for garnish (optional)

2 tablespoons canola oil

If you don't own a cast-iron skillet, put this book down immediately and go buy one. I'm serious. Think of the cast-iron pan as the Swiss Army knife of kitchen equipment. It has many uses, and you will come to depend on it more than you could ever imagine. Cast-iron isn't high-tech, delicate, or fussy. It is essentially indestructible, and you will be able to pass it down to the next generation, who can depend on it to fry, roast, bake, or sear for decades to come. And there's nothing quite like the hiss of a good steak hitting a hot cast-iron pan. *Hello!*

Butter is the ideal sauce for a steak, and this classic preparation features a butter–Dijon mustard combo. The mustard adds a bit of bite, lending the dish a wee French feel.

Preheat the oven to 400°F.

Mash the butter, parsley, and mustard together with a fork in a small bowl. Set aside.

Season the steak on both sides with the salt and pepper and strew with thyme sprigs, if using.

Heat the oil in a large cast-iron skillet over high heat until hot, about 3 minutes. Add the steak to the skillet and cook until nicely browned on the bottom, about 3 minutes. Flip the steak and cook until the second side is nicely browned, about 2 minutes.

Transfer the pan to the oven and bake for 12 to 15 minutes, until an instant-read thermometer registers 130°F for medium-rare, or until it's cooked the way you like.

Carefully remove the skillet from the oven and transfer the steak to a cutting board. Let the steak rest for 5 minutes. Slice it against the grain and transfer to plates. Top each portion with Dijon butter and serve.

SPECTACULAR CHILI

PREP TIME: **20 MINUTES** • COOK TIME: **2 HOURS 20 MINUTES**

1½ pounds boneless beef chuck eye steak, cut into 1-inch cubes

1½ teaspoons kosher salt

1 tablespoon canola oil

1 medium Vidalia onion, diced

10 garlic cloves, chopped

1 pound hot Italian sausage, removed from the casings

1 tablespoon ground cumin

1 tablespoon paprika

1 tablespoon ancho chili powder

1 (28-ounce) can crushed tomatoes

1 cup beef stock

1 (15-ounce) can pinto beans, rinsed and drained

1 (15-ounce) can kidney beans, rinsed and drained

1 (15-ounce) can great northern beans, rinsed and drained

Chopped scallions, shredded cheddar cheese, and sour cream, for serving

 Chuck steak is known as poor man's ribeye. Some great substitutes are boneless chuck roast, short ribs, or brisket.

I stand by the bold name of this recipe. There are a couple of challenges with chili we need to address. First, people tend to think their chili is better than it really is. But that's not true here. Mine is really spectacular. Second, chili is personal. Some people want beef chili, others want turkey, and others vegetarian—the variations within those categories are endless. Personally, I think it's beef for the win. This recipe eschews the typical ground beef for beef chunks. If you are using ground beef, you are dancing dangerously close to sloppy joe territory. It's delicious with Grandma's Skillet Cornbread (page 190).

Pat the beef dry with paper towels and season with the salt. Heat the oil in a large Dutch oven over medium-high heat. Add half of the beef and brown well on all sides, about 5 minutes; do not crowd the chunks, as you want the meat to brown, not steam! Transfer to a plate. Add the remaining beef, brown it on all sides, and transfer to the plate.

Turn the heat down to medium-low. Add the onion and garlic and cook until the onion is translucent, about 3 minutes. Add the sausage and cook, breaking up the meat, until it's no longer pink, about 5 minutes. Add the cumin, paprika, and ancho chili powder and cook for 1 minute, stirring constantly. Return the browned chuck to the pan, along with the crushed tomatoes and beef stock and stir. Cover, turn the heat down to low, and simmer for about 1½ hours, until thickened.

Add the pinto beans, kidney beans, and great northern beans, cover, and cook for 30 minutes to heat the beans through and blend the flavors.

Serve the chili with scallions, shredded cheese, and sour cream for topping.

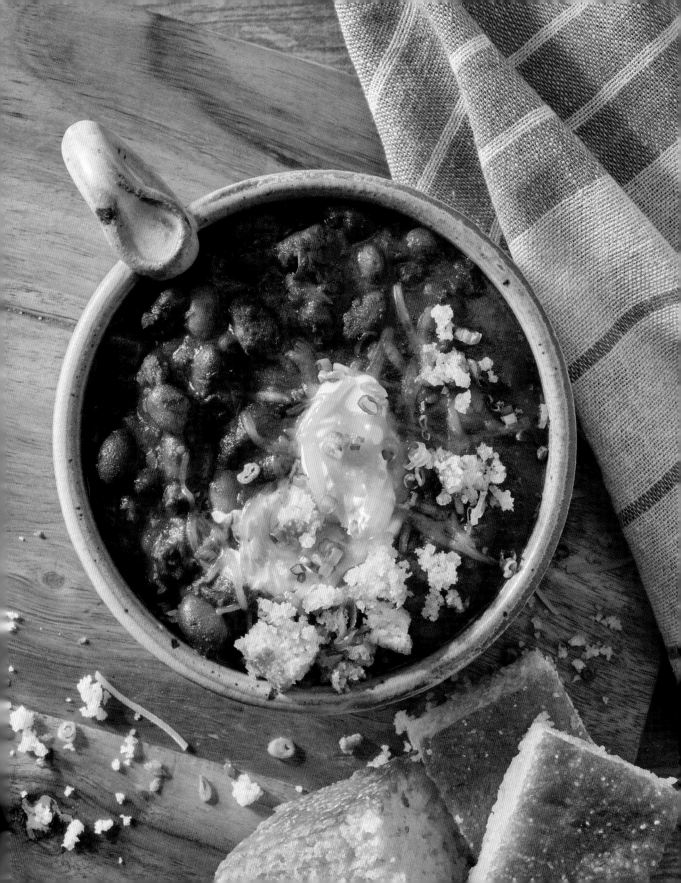

DANIEL BOULUD'S FAMOUS SHORT RIBS

3 (750 mL) bottles dry red wine, such as Pinot Noir

3 pounds bone-in beef short ribs, trimmed of excess fat

2½ teaspoons kosher salt

1 teaspoon freshly ground black pepper

2 tablespoons all-purpose flour

2 tablespoons canola oil

1 medium leek, cleaned and coarsely chopped

1 large carrot, peeled and cut into ½-inch pieces

2 celery stalks, cut into ½-inch pieces

12 garlic cloves, peeled and left whole

1 teaspoon fresh thyme leaves

1 large bay leaf

2 tablespoons tomato paste

2½ cups beef stock

I first met Daniel Boulud years ago while doing a story for *Today*. It was early on in his career, and I was sent to his one-bedroom apartment, where he was busy at work in the kitchen, his newborn baby daughter in his arms. I guess I looked trustworthy, because he took one look at me and thrust the adorable miniature human being right into my arms. I held her the entire time we were talking, and he and I have kept in touch ever since. I've never met anyone as passionate about food, and after years of painstakingly planning my Thanksgiving meals, leaving notes with precise instructions all over the house for Deborah so she could take care of things while I hosted the Thanksgiving parade, he convinced me to try Thanksgiving at Daniel, his namesake restaurant. I was iffy about this. Thanksgiving is meant to be at home. *Eating out? Can we do that?* I finally relented. His dishes are more elevated than what we're used to, but at their core, they emulate home cooking.

This recipe from Daniel is extra meaningful to me. It's the most elaborate thing I make, and it's the first time I served a meal where people looked ecstatic while they were eating it. There is no better compliment for a home cook than *When are you making this again and can I come?* It's the most involved recipe in the book, but don't let that scare you off. It's not especially difficult, it just has many steps. Put in the time to make this and your mouth will be rewarded, I promise. We all need a go-to dish that's a real showstopper, and this one always results in a standing ovation.

The photo is on page 166. Serve with Tuscan Polenta (page 198).

Heat the wine in a large saucepan over medium heat. When the wine is hot, use a long match or a grill lighter to carefully set it aflame to burn off some of the alcohol. Once the flame dies, increase the heat to high and boil the wine until it is reduced by half, about 50 minutes. Remove from the heat.

Preheat the oven to 350°F.

Season the short ribs all over with the salt and pepper and dust them with the flour.

Heat the oil in a large Dutch oven over medium-high heat. Add half of the short ribs and sear for about 4 minutes on each side, until browned. Transfer the browned ribs to a plate and repeat with the remaining short ribs.

Reduce the heat to medium and add the leek, carrot, celery, garlic, thyme, and bay leaf. Lightly brown the vegetables for about 5 minutes, stirring occasionally. Add the tomato paste and cook for 1 minute, stirring.

Return the browned short ribs to the pot, along with the beef stock and reduced wine. Bring to a boil, cover, place in the oven, and braise for about 3 hours, until the short ribs are falling off the bone, skimming the fat from the sauce every hour.

Transfer the short ribs to a plate with a slotted spoon and cover with aluminum foil.

Boil the remaining liquid on the stovetop until it is reduced to about 4 cups, 20 to 25 minutes.

Return the short ribs to the pot and gently toss to coat in the sauce. Remove and discard the bay leaf. Serve the short ribs on a platter, topped with the vegetables and sauce.

NOTE FROM UNCLE AL FROM UNCLE AL

Make sure to properly clean the leeks by chopping them and submerging them in water, then draining them. There is a good amount of sand hiding in the folds of the stalk, especially in the light green parts.

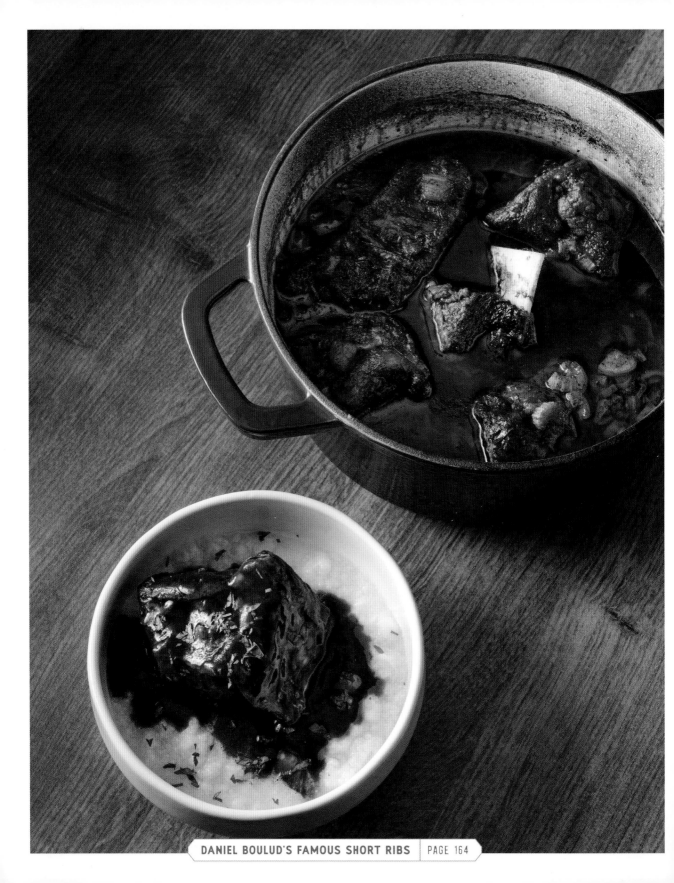

DANIEL BOULUD'S FAMOUS SHORT RIBS | PAGE 164

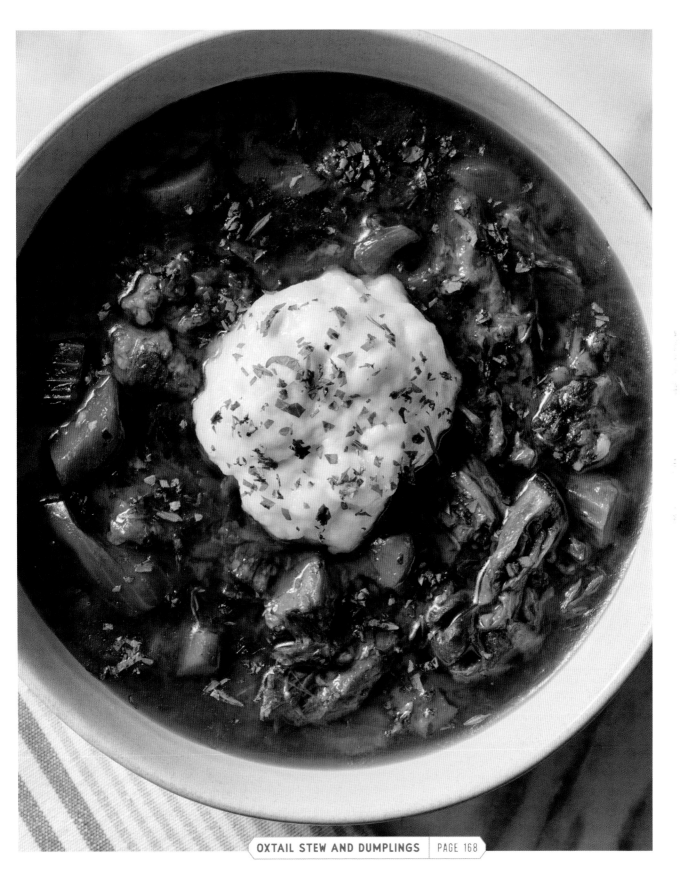

OXTAIL STEW AND DUMPLINGS | PAGE 168

OXTAIL STEW AND DUMPLINGS

PREP TIME: **30 MINUTES** • COOK TIME: **4 HOURS**

OXTAIL STEW

4 pounds oxtails, trimmed of excess fat

1 tablespoon olive oil

3 teaspoons kosher salt, divided

3 tablespoons unsalted butter

1 large yellow onion, chopped

2 celery stalks, chopped

2 medium carrots, peeled and chopped

8 garlic cloves, peeled and left whole

1 tablespoon chopped fresh rosemary

2 teaspoons fresh thyme leaves

1 large bay leaf

2 tablespoons tomato paste

3 cups dry red wine, such as Pinot Noir

2½ cups beef stock

¼ cup chopped fresh parsley

DUMPLINGS

1½ cups all-purpose flour

1 tablespoon baking soda

½ teaspoon kosher salt

¾ cup whole milk, plus more as needed

2 tablespoons unsalted butter, melted

When I was a kid, oxtails were so cheap the butcher practically gave them away. True, there's not a lot of meat on the bones, but when they're braised, you end up with lusciously rich meat that's almost like a ragù (though no one used fancy words like ragù to describe sauce back then). Do yourself a favor and experience what I call the velvet of beef, but know that they can be tricky to find these days. Oxtails are beloved by many other cultures, and they are often snapped up by the cognoscenti. Plus, there's the obvious fact that each beef cattle only comes with one tail. The search is worth it. The photo is on page 167.

FOR THE STEW: Preheat the oven to 425°F.

Place the oxtails on a baking sheet in a single layer. Drizzle with the olive oil and season with 2 teaspoons of the salt. Roast without turning until browned, about 25 minutes. Remove from the oven and reduce the temperature to 325°F.

Melt the butter in a large Dutch oven over medium heat. Add the onion, celery, carrots, garlic, rosemary, thyme, bay leaf, and the remaining 1 teaspoon salt and cook until slightly softened, about 8 minutes. Stir in the tomato paste and cook for 1 minute.

Using tongs, transfer the oxtails to the pot (discard the grease on the baking sheet), along with the wine and beef stock. Bring to a low boil, then cover and transfer to the oven. Bake for 3 to 3½ hours, until the meat is falling off the bone.

With a slotted spoon, transfer the meat and vegetables to a baking sheet to cool. Using a spoon, skim off any fat on top of the sauce. Remove and discard the bay leaf.

When the meat is cool enough to handle, remove the meat from the bones. Return the meat and vegetables to the pot. Keep warm over low heat while you make the dumplings.

Father-son prep moments

NOTE

FROM UNCLE AL FROM UNCLE AL

If you can make the stew (but not the dumplings) the day before, it will be extra flavorful.

FOR THE DUMPLINGS: Combine the flour, baking powder, and salt in a medium bowl. Stir in the milk and butter until just blended (you can add more milk as needed to reach the consistency of drop biscuits).

Right before serving, bring the stew to a simmer over medium-low heat. Drop generous tablespoon-size dollops of the dumpling mixture onto the surface of the stew and cover the pot. Cook for about 10 minutes, until the dumplings have puffed and are cooked through. Sprinkle with the parsley and serve in shallow bowls.

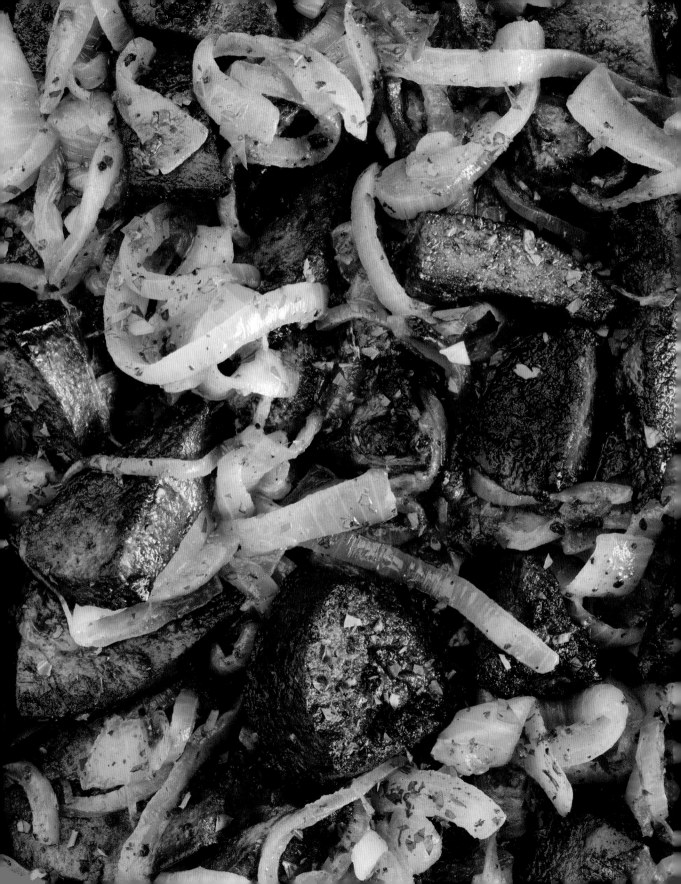

CALF'S LIVER AND SWEET ONIONS

PREP TIME: **10 MINUTES** • COOK TIME: **25 MINUTES**

1 pound calf's liver, cut into
1-inch pieces

1¼ teaspoons kosher salt,
divided

½ teaspoon freshly ground
black pepper

¼ cup all-purpose flour

3 tablespoons unsalted
butter, divided

1 large yellow onion, sliced
¼ inch thick

5 garlic cloves, chopped

1 tablespoon canola oil or
bacon fat

¼ cup chicken stock

During the pandemic, when we were all stuck at home and looking for comfort, I started cooking this simple meal that my mother, Isabel Roker, would often make for us. At first bite I was taken back to her kitchen table, where all the Rokers ate quietly as we let the succulent meat melt in our mouths. The onions are a key part of the dish. When gently sautéed, they add a lovely sweetness to the dish. Listen, if you're thinking, *Calf's liver? I'm not so sure about this one, Roker*, do yourself a favor and try it. I'd be willing to make a wager that this easy dish makes its way into your dinner rotation.

Season the calf's liver with 1 teaspoon of the salt and the pepper, then dust with the flour. Set aside.

Melt 2 tablespoons of the butter in a large skillet over medium heat. Add the onion and cook, stirring occasionally, until softened and lightly browned, about 15 minutes. Add the garlic and the remaining ¼ teaspoon salt and cook, stirring constantly, until fragrant, about 1 minute. Transfer the onion to a plate.

Add the remaining 1 tablespoon butter and the oil to the pan and heat until shimmering. Add the liver and cook, stirring, until it's browned but still slightly pink in the center, about 3 minutes. Return the onion to the pan and heat through, about 1 minute. Pour in the stock and cook until reduced, about 1 minute. Serve hot.

Your typical calf's liver is enormous. It's easier and faster to cut the liver into pieces before cooking.

COFFEE- AND SPICE-RUBBED PORK CHOPS

PREP TIME: **10 MINUTES** • COOK TIME: **15 MINUTES**

2 teaspoons instant coffee

2 teaspoons firmly packed brown sugar

2 teaspoons onion powder

2 teaspoons kosher salt

1½ teaspoons chili powder

1 teaspoon freshly ground black pepper

4 center-cut bone-in pork chops (about 3 pounds), about 1 inch thick

2 tablespoons canola oil

NOTE FROM UNCLE AL

For a long time, people cooked pork nearly to death fearing trichinosis, which, thankfully, we no longer need to worry about. Go forth and enjoy your chops juicy and pink.

What happens in this recipe is dinner magic. We usually don't associate coffee with anything other than coffee, ice coffee, and the heaven that is an affogato (espresso over gelato), but trust me, coffee has more to offer. It adds an earthiness that brings out the flavor in the pork. It's detectable but not screaming for attention. Think of it as one of those "I cannot identify this flavor, but I love it" situations. Before it became socially acceptable to use coffee as a seasoning, there was a trend toward "blackening" pork. I've never understood blackening. It's just a fancy word for burning, and that's only going to set off your smoke detector. Consider coffee seasoning a lively way to season the pork while avoiding a three-alarm fire in your kitchen.

Combine the coffee, brown sugar, onion powder, salt, chili powder, and pepper in a small bowl. Coat the pork chops all over with the spice rub.

Heat the oil in a large skillet over medium-high heat until hot, about 3 minutes. Carefully add the pork chops and sear until nicely browned on the bottom, about 3 minutes. Flip the pork chops and sear the other side, about 2 minutes.

Reduce the heat to medium and continue to cook until an instant-read thermometer inserted in the center reaches 140°F, about 4 minutes. If you don't have a thermometer, poke a hole in the chops with a knife. If the pork is pink but not raw, it's done. (Don't wait till the pork is white, which is overdone, because it will be tough.) Transfer the pork chops to a cutting board, let them rest for 5 minutes, then slice and serve.

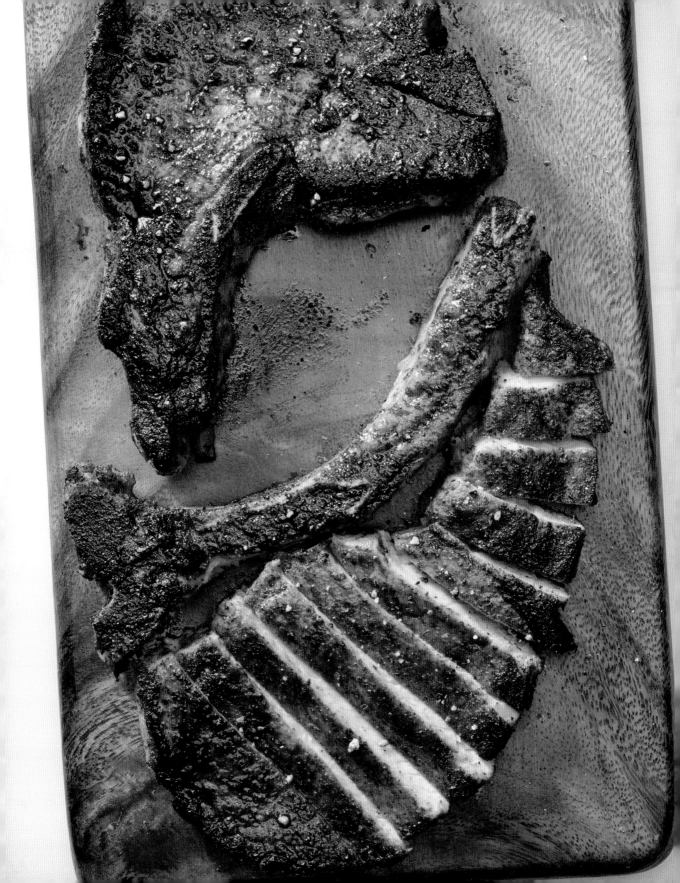

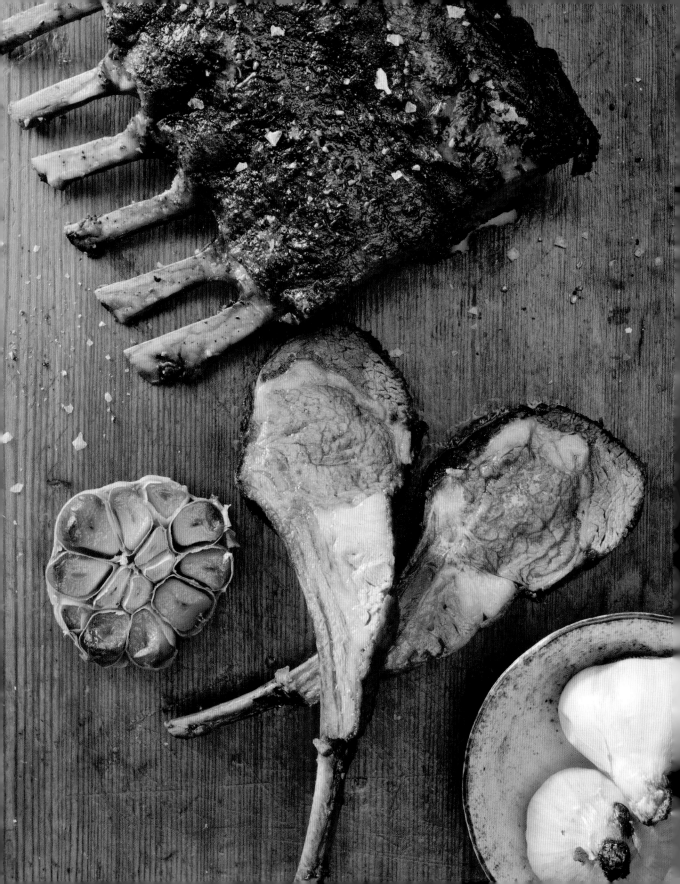

ROAST RACK OF LAMB

PREP TIME: 10 MINUTES • COOK TIME: 30 MINUTES

1 (2-pound) lamb rack, preferably frenched

1 teaspoon kosher salt

½ teaspoon freshly ground black pepper

2 tablespoons olive oil, divided

2 teaspoons garlic paste

2 anchovy fillets in oil, finely minced

NOTE *FROM UNCLE AL · FROM UNCLE AL*

Most lamb racks come "frenched," which means that the tips of the bones are cleaned of cartilage, fat, and excess meat.

You can get garlic paste in the supermarket in the produce or seasoning section. If you substitute minced garlic, be sure to chop it very fine until it's a paste or use a garlic press.

Preparing a great rack of lamb starts with the lamb itself. Courtney and I had the pleasure of meeting Craig Rogers of Border Springs Farm in Virginia at a food charity event. Craig is a retired chemical engineer turned shepherd. He took the time to perfect the grass the animals ate (so much more interesting than perfecting your golf game!), resulting in the best lamb you'll ever eat. While you might not find his lamb at your local supermarket, rack of lamb is a pretty special cut on its own, so it's worth going all out for this recipe. Source your meat from a local butcher and buy American-raised lamb. The flavor of this lamb is elevated by a touch of umami-rich saltiness that comes courtesy of the anchovies.

Remove the lamb from the refrigerator at least 1 hour before cooking.

Preheat the oven to 400°F.

Season the lamb all over with the salt and pepper. In a small bowl, combine 1 tablespoon of the oil, the garlic paste, and the anchovies. Smear the mixture all over the lamb.

Heat the remaining 1 tablespoon oil in a large cast-iron skillet over medium-high heat. Add the lamb rack, fat side down, and sear for about 2 minutes, until browned. Turn the lamb and sear the other side for about 2 minutes, until browned.

Transfer the pan to the oven and roast for 5 minutes. Reduce the oven temperature to 350°F and roast for 15 minutes, or until an instant-read thermometer registers 130°F for medium-rare, or until it's cooked the way you like it.

Remove from the oven and let rest for 10 minutes, so some of the juices get reabsorbed into the meat. Cut into separate chops and serve.

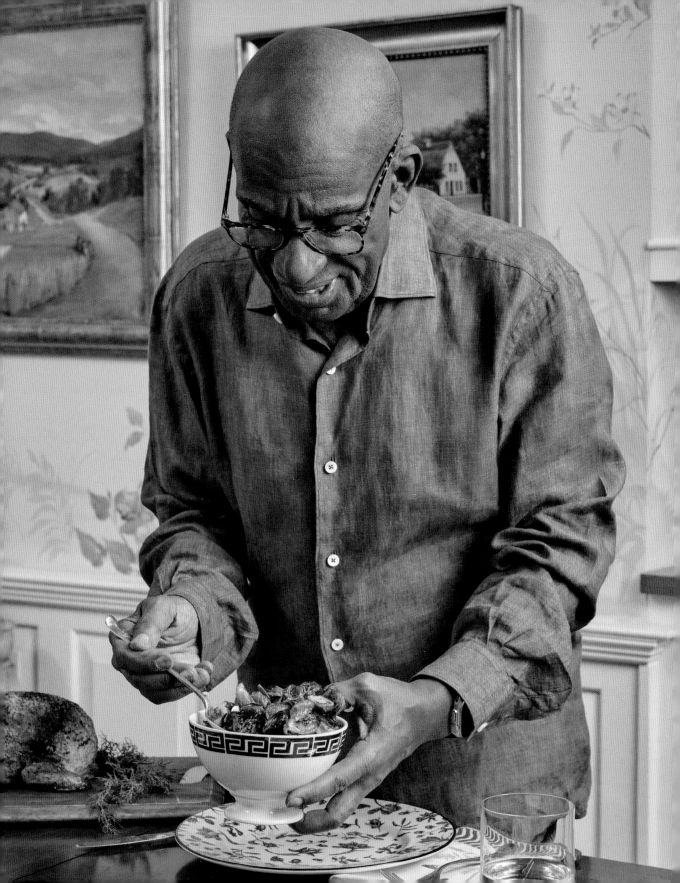

SIDES

TO SHARE, DISHES TO PASS

 YOU KNOW THOSE SCENES IN TELEVISION AND MOVIES where Mom carries the Thanksgiving turkey into the dining room on a platter, placing it on the table to oohs and aahs from the guests? Everyone marvels as if the crown jewels were sitting right there.

Then Dad gets out a gleaming carving knife and slices the turkey with so much reverence you'd think he was performing a mystic ritual.

I do not understand this. I don't believe I'm alone when I say that sides are the real stars of that show. Sure, I enjoy turkey. But if a pack of wild dogs entered the kitchen à la the movie *A Christmas Story*, it's the mashed potatoes I'd protect first. *Godfather*-style situation? "Leave the turkey. Take the stuffing."

When I was growing up, Sunday dinner was all about the sides. Everyone pitched in, and our table was laden with mac and cheese, cornbread, and collard greens. The abundance of those dishes transformed a regular family meal into a feast. True, it's not always feasible to prepare multiple sides—Sunday can't be every day! But adding a few new ones to your repertoire can really liven things up. Make a big batch of Tuscan polenta, plop it on the table, and hand your partner a spoon. Or go one step further and turn a few sides into dinner. There are no rules. You're cooking, it's your meal, and you get to decide who is the star of the show.

Enjoying a Niçoise salad (see page 72) and a rosé at the upstate house

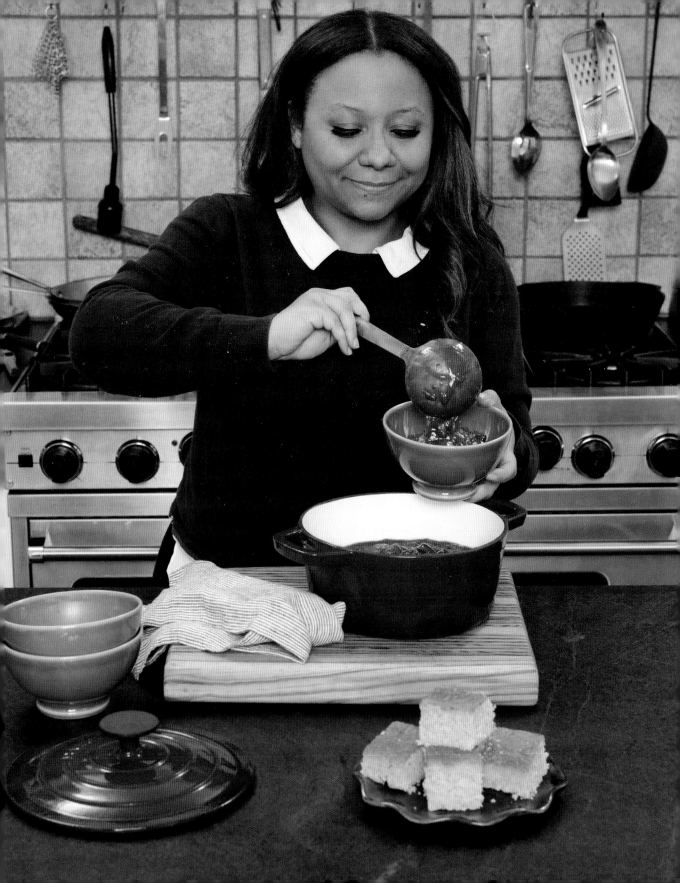

ROASTED BRUSSELS SPROUTS WITH GARLIC

2 pounds Brussels sprouts, trimmed and halved

15 small garlic cloves, halved lengthwise

¼ cup olive oil

1 teaspoon grated lemon zest

1 teaspoon kosher salt

¼ teaspoon freshly ground black pepper

1 tablespoon lemon juice

Brussels sprouts got a well-deserved new lease on life when it became a vegetable that's primarily roasted. Mushy boiled blobs are a thing of the past. Roasted sprouts crisp up beautifully, and plenty of sliced garlic and some sprightly lemon zest lift their flavor into the sparkling present. Now can we please all give Brussels sprouts a chance?

Preheat the oven to 375°F.

Toss together the Brussels sprouts, garlic, olive oil, lemon zest, salt, and pepper in a medium bowl.

Spread the Brussels sprouts and garlic in a single layer on a baking sheet. Roast for 30 to 35 minutes, stirring occasionally, until the Brussels sprouts and garlic are tender and lightly browned.

Transfer to a bowl, toss with the lemon juice, and serve.

NOTE

If you can only find very large Brussels sprouts, make sure to quarter them by cutting them vertically through their stems, so they cook evenly and don't fall apart.

COLLARD GREENS WITH BACON AND BROWN SUGAR

PREP TIME: **15 MINUTES** • COOK TIME: **2 HOURS**

1 teaspoon olive oil

8 ounces smoked bacon, cut into ½-inch pieces

1 medium yellow onion, diced

6 garlic cloves, chopped

1 teaspoon kosher salt

½ teaspoon red pepper flakes

1½ cups low-sodium chicken stock

½ cup apple cider vinegar

¼ cup firmly packed brown sugar

2 pounds collard greens (about 2 large bunches), chopped

Kale gets all the glory, but I'd like to draw your attention to another member of the greens family, collard greens. These meaty, smooth-tasting vegetables are the secret staple of Southern cooking. This preparation comes from Courtney's mother, Alice, and it has been a favorite of Courtney's since she was old enough to chew. The recipe contains a few special touches: smoky bacon, brown sugar, and apple cider vinegar. Collard greens require a long cooking time, but after gently simmering in those ingredients, they taste like a gift. Sweet, sour, and smoky, they are often found on our holiday table, served the Southern way in some of the elixir they've been cooked in. For optimal enjoyment, serve with my grandmother's cornbread (page 190).

Heat the oil in a Dutch oven over medium heat. Add the bacon and cook until the fat renders and the bacon is lightly golden, about 10 minutes.

Add the onion, garlic, salt, and red pepper flakes and cook, stirring frequently, for 3 minutes. Add the chicken stock, vinegar, and brown sugar and stir well to combine. Reduce the heat to medium-low and add the collard greens. Cover and cook until the greens start to wilt, about 10 minutes. Remove the lid and stir the collards into the liquid. Cover, reduce the heat to low, and cook, stirring occasionally, for about 1½ hours, until the collards are tender. Serve in shallow bowls, along with some of the liquid.

Choose bacon with a real smoky flavor; Applegate makes a good one. Mustard greens or turnip greens work well in place of collards—as does kale.

SILKY CAULIFLOWER PUREE

1 (2½- to 3-pound) head cauliflower, cored and cut into 1-inch florets

5 garlic cloves, thinly sliced

1½ cups heavy cream, plus more if needed

3 tablespoons cold unsalted butter, plus more for serving

1 teaspoon kosher salt

¼ teaspoon freshly ground black pepper, plus more for serving

Whether you're avoiding carbs or just want an alternative to your basic mashed potatoes, this puree of the valuable cruciferous vegetable is an easy and healthy substitute. The recipe was born mostly out of curiosity. We had a cauliflower sitting in the refrigerator, and I swear it was taunting me every time I opened the door... *I've been in here for like two weeks—are you going to do something with me already or not?* I wondered if I could transform it into a mashed potato substitute. Game on! Some heavy cream, butter, and a few cloves of garlic later, I whipped this up in the blender and was rewarded with a luscious, buttery puree that could hold its own to mashed potatoes any day. This puree is a perfect accompaniment to Daniel Boulud's short ribs (page 164).

Combine the cauliflower florets, garlic, and cream in a medium saucepan. Bring almost to a boil over medium-high heat. Reduce the heat to low and simmer until the cauliflower is fork-tender, about 12 minutes.

Carefully pour the mixture into a blender, add the butter, salt, and pepper and blend until smooth (or use an immersion blender right in the saucepan). If the mixture is too thick, add a little more cream. Transfer to a bowl and serve topped with more butter.

SPICED DELICATA SQUASH

PREP TIME: **15 MINUTES** • COOK TIME: **25 MINUTES**

1 teaspoon curry powder

1 teaspoon garlic powder

1 teaspoon kosher salt

1 teaspoon ground cumin

½ teaspoon garam masala

2 medium delicata squash, halved lengthwise, seeded, and cut into ½-inch slices

2 tablespoons olive oil

Sheer laziness is the one thing standing between me and many squash dishes because of the unique hell that is peeling the vegetable. Wrestling the knife against its tough rind is just begging for a trip to the ER to get stitches. When I learned that the delicata doesn't need peeling, I knew I had found my squash soulmate. The taste is as delicate as its name. Sweet and nutty, it's a lovely match for the flavor of curry seasonings. It might have taken years for me to discover her, but oh, delicata, I'm so thankful we found each other!

Preheat the oven to 425°F. Lightly grease a baking sheet with nonstick cooking spray.

Combine the curry powder, garlic powder, salt, cumin, and garam masala in a small bowl.

Put the squash in a large bowl and drizzle with the olive oil. Add the spices and toss to coat. Arrange the squash on the prepared baking sheet in a single layer and roast until lightly golden brown, about 25 minutes. Serve.

Like I said, no need to peel the squash, since the skin will be perfectly tender when cooked.

SWEET POTATO POON

PREP TIME: **20 MINUTES** • COOK TIME: **45 MINUTES**

3 pounds sweet potatoes, peeled and cut into 2-inch chunks

8 tablespoons (1 stick) unsalted butter, cut into cubes

1 cup firmly packed dark brown sugar

¾ cup all-purpose flour

2 tablespoons baking powder

1½ teaspoons kosher salt

½ teaspoon ground cinnamon

¼ teaspoon ground nutmeg

¼ teaspoon ground allspice

¾ cups canned crushed pineapple, drained

1 (12-ounce) bag large marshmallows

When I think about my mother and food, this recipe comes to mind. The poon is a bit of a mystery. While it graced our table for every holiday meal and on special Sunday dinners, none of us knows where this beloved side dish came from or why on earth it's called a poon.

Just as the poon was a tradition, so was torturing my mother while she was making it for Thanksgiving dinner. Once we could smell the divine combo of spices wafting from the kitchen, my siblings and I knew it was almost time for her to add the marshmallows and shove it under the broiler. At which point we'd do anything we could to distract her. One of us would be sent to enter the kitchen. "Mom, so where's that, um, big blue bowl?" She'd start rummaging through a cabinet, and before long, black smoke would billow from the oven. Our giggles would have infuriated her if they weren't blocked out by the sound of the fire alarm. But my mother finally figured out how to beat us at our own game. One day after we'd had our fun, she calmly pulled a backup poon out of the refrigerator.

Preheat the oven to 350°F. Grease a 9×13-inch baking dish with nonstick cooking spray.

Bring a large pot of water to a boil over high heat. Add the sweet potatoes and cook until tender, about 12 minutes. Drain and transfer to a large bowl. Add the butter and use a potato masher to mash the butter into the sweet potatoes. Stir in the brown sugar, flour, baking powder, salt, cinnamon, nutmeg, and allspice until well combined. Fold in the crushed pineapple and transfer the mixture to the prepared baking dish.

Bake until the sweet potatoes are lightly browned on top, about 30 minutes. Remove from the oven and preheat the broiler.

Place the marshmallows in a single layer on top of the sweet potatoes. Broil for a minute or two to toast the top of the marshmallows—they brown fast, so don't walk away! Let cool for at least 10 minutes before serving.

GRANDMA'S SKILLET CORNBREAD

PREP TIME: **10 MINUTES** • COOK TIME: **25 MINUTES**

1 cup all-purpose flour

1 cup yellow cornmeal

½ cup granulated sugar

1 tablespoon baking powder

1 teaspoon kosher salt

1 cup whole milk

2 large eggs

¼ cup sour cream

8 tablespoons (1 stick)
 unsalted butter, melted

Salted butter, for serving

Going to my grandmother's house in Queens for dinner meant getting a big hug and eating a big meal, and that always included cornbread. The crispy, golden edges made hers a masterpiece. Now there is only one way to get that crispiness, and that's by making it in the trusty cast-iron skillet. Grandma's cornbread will always be the one for me, and you'll see her recipe calls for sugar. This positions me squarely on the sweet side of the ongoing debate: to add sugar or not to add sugar? To me, cornbread without sugar is like chocolate chip cookies with no chocolate.

Preheat the oven to 350°F. Lightly grease a large cast-iron skillet with nonstick cooking spray.

Whisk together the flour, cornmeal, sugar, baking powder, and salt in a large bowl. Whisk in the milk, eggs, and sour cream, but don't overmix. Add the melted butter and gently stir to combine.

Pour the batter into the prepared skillet and bake for about 25 minutes, until the center is firm and a toothpick inserted into the center comes out clean.

Cool for 10 minutes. Serve with butter.

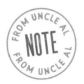

If you don't have a cast-iron skillet, an ovenproof skillet or baking dish will work, though your cornbread may not be as crisp.

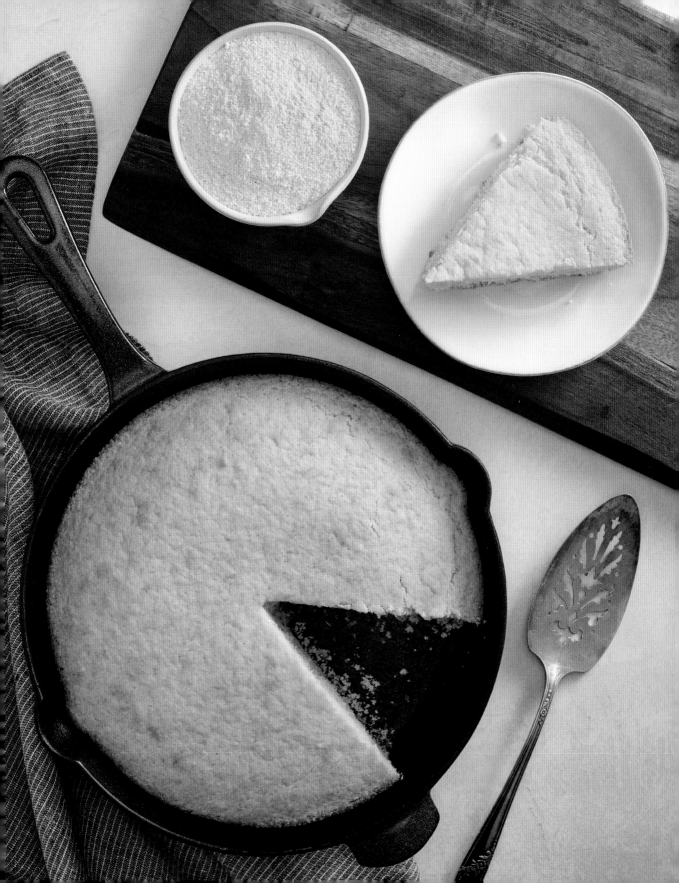

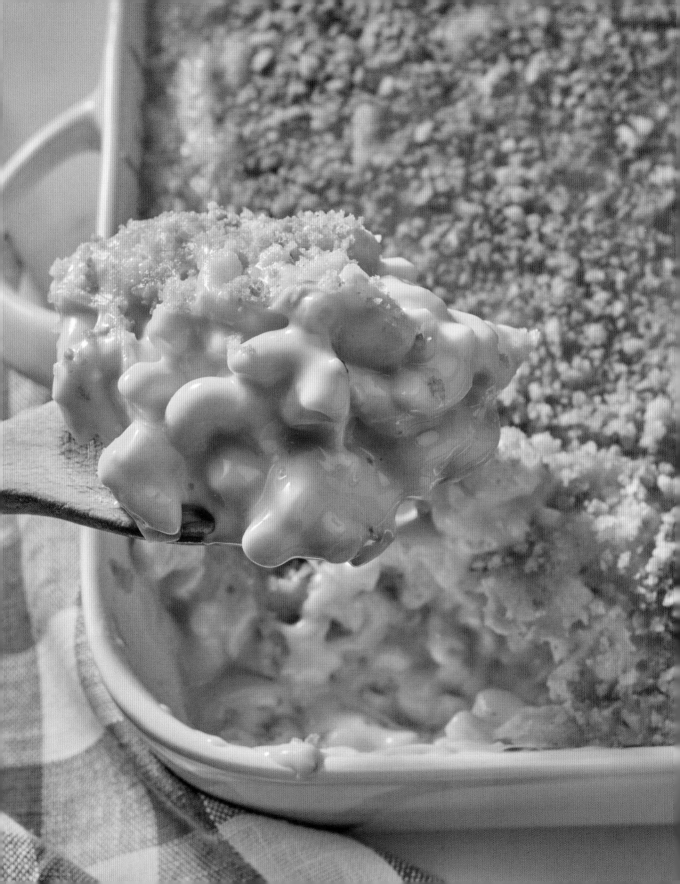

BAKED MAC AND CHEESE

PREP TIME: **20 MINUTES** • COOK TIME: **30 MINUTES**

1 pound elbow macaroni

7 tablespoons unsalted butter, divided

½ cup panko breadcrumbs

3 tablespoons all-purpose flour

1½ cups half-and-half

1½ cups whole milk

5 cups shredded mild cheddar cheese, at room temperature, divided

¼ cup sour cream, at room temperature

1 teaspoon kosher salt

1 teaspoon ground mustard

1 teaspoon garlic powder

1 teaspoon paprika

½ teaspoon freshly ground black pepper

⅛ teaspoon ground nutmeg

The mac and cheese that comes out of a box—runny, overly saucy, and neon orange—is not mac and cheese. If you want to enjoy a gloriously cheesy mac and cheese with a crispy topping, this is the one. It isn't food for a spoon! It's firm enough to stand on its own, so it won't take over your entire plate, running into all your other foods. Some people view mac and cheese as the main attraction, but to me, it is a side dish. It goes perfectly with curried fried chicken with hot honey (page 154) or cornmeal-fried white fish (page 139).

Preheat the oven to 375°F. Lightly grease a 9-inch square baking dish with nonstick cooking spray.

Cook the macaroni according to the package instructions until al dente, about 7 minutes. Drain.

Meanwhile, melt 3 tablespoons of the butter in a small saucepan over low heat. Remove from the heat and stir in the panko. Set aside.

Melt the remaining 4 tablespoons (½ stick) butter in a large saucepan over medium heat. Whisk in the flour and cook, whisking continuously, until bubbly, about 1 minute. Stir in the half-and-half and milk and whisk until incorporated. Reduce the heat to low and cook, whisking occasionally, until slightly thickened, about 5 minutes. Stir in 4 cups of the cheese, the sour cream, salt, mustard, garlic powder, paprika, pepper, and nutmeg and cook, whisking, until the sauce is thick and smooth. Stir in the pasta to coat it with the sauce.

Scrape the pasta into the prepared baking dish and top with the remaining 1 cup cheese and the reserved panko.

Bake until the breadcrumbs are golden brown, about 10 minutes. Serve.

PEAS AND RICE

1 teaspoon canola oil

6 ounces cured salt pork, cut into 4 pieces

1 small yellow onion, finely chopped

6 garlic cloves, chopped

1 small green bell pepper, finely chopped

1 teaspoon thyme leaves

2 cups long-grain white rice

4 cups water

½ teaspoon freshly ground black pepper

2 (15-ounce) cans red kidney beans, rinsed and drained

Kosher salt (optional)

This rice is dressed up for a fun night out, accessorized with salt pork, onions, peppers, and kidney beans (peas and rice does not in fact contain peas, go figure). It was one of my mother's simple but always satisfying dishes that we enjoyed on holidays or alongside a "fancy" Sunday dinner. Whenever I make this Caribbean special for guests, there's always a "Wow, I didn't know rice could taste so good" moment.

Heat the oil in a large pot over medium-high heat. Add the salt pork and cook for about 7 minutes, stirring occasionally, until the pork begins to render its fat. Reduce the heat to medium-low, add the onion, garlic, bell pepper, and thyme and cook, stirring occasionally, until the onion is translucent, about 5 minutes.

Add the rice, water, and pepper and stir to combine. Bring to a boil over high heat, then reduce the heat to low, cover, and simmer for 20 minutes, or until the rice has absorbed the liquid. Occasionally check the pot and stir to make sure the rice is not sticking to the bottom. Stir in the kidney beans and cook over low heat for about 10 minutes, just to heat through.

Remove the salt pork and discard. Fluff the rice with a fork and season with salt, if desired. Stir to combine and serve immediately.

TORTA DI RISO (ITALIAN RICE CAKE)

PREP TIME: **15 MINUTES** • COOK TIME: **30 MINUTES**

2 tablespoons olive oil

¼ cup seasoned Italian breadcrumbs

4 cups cooked white rice (from 2 cups raw)

1 pound package frozen chopped spinach, defrosted and drained

5 large eggs, divided

4 ounces cream cheese, at room temperature

¾ cup grated Parmesan cheese

¼ cup heavy cream

2 teaspoons kosher salt

1 teaspoon freshly ground black pepper

1 teaspoon onion powder

2 tablespoons water

This tasty side dish is brought to us by my son-in-law Wes's great-grandmother Nancy, who grew up in Piedmont, Italy. Wes's family has a copy of this recipe, handwritten by his great-grandmother, which is a treasure in itself. Nancy would make it whenever there was leftover rice or vegetables—spinach and zucchini being her usual choices. This dish hits all the right notes: savory, custardy, smooth, and creamy, and it doesn't surprise me that Courtney's father-in-law grew up loving it. Serve with a nice, big salad, or roasted or grilled vegetables.

Preheat the oven to 350°F, with a rack in the middle. Using a pastry brush, brush the olive oil on the bottom and sides of a 9×13-inch baking dish. Add the breadcrumbs to the pan and shake the pan to coat all sides with the crumbs.

Combine the rice, spinach, 4 of the eggs, the cream cheese, Parmesan cheese, cream, salt, pepper, and onion powder in a large bowl and mix well. Scrape the rice mixture into the pan and spread in an even layer.

In a small bowl, whisk together the remaining egg and water. Brush the egg wash on top of the rice. Bake for about 30 minutes, until the torta is set and the topping is light golden brown. Remove from the oven and let cool for 15 to 30 minutes.

Run a knife around the edges of the torta and invert onto a cutting board. Slice into diamond shapes or squares and serve. Leftovers can be covered and refrigerated for up to 2 days.

The great thing about this dish is it can be made the day before and served warm or at room temperature the next day.

TUSCAN POLENTA

4 cups chicken stock

1½ teaspoons kosher salt

1 cup stone-ground yellow cornmeal

1 cup grated Pecorino Romano cheese, plus more for serving

1 cup crumbled blue cheese, at room temperature

½ cup mascarpone cheese, at room temperature

2 tablespoons unsalted butter, at room temperature

¼ teaspoon freshly ground black pepper

This recipe was inspired by the polenta at Fresco, a midtown New York Italian restaurant that has been serving up Tuscan classics for years. Our family always orders this dish, which I liken to an Italian version of cheesy grits. It's so creamy, thick, and flavorful that after consuming a bowl full of this magical substance, you will feel as content as a sleeping baby.

Combine the stock and salt in a large pot and bring to a boil over high heat. Add the cornmeal slowly, whisking continuously, so it doesn't form lumps. Reduce the heat to low and cook, whisking frequently, until the polenta thickens, about 2 minutes. Cover and cook for 10 to 15 minutes, whisking every 5 minutes, until the polenta is creamy.

Turn off the heat and stir in the pecorino, blue cheese, mascarpone, butter, and pepper. Serve immediately with additional pecorino.

FRESH "FRUIT COCKTAIL" SALAD

PREP TIME: **20 MINUTES** • COOK TIME: **0 MINUTES**

4 ripe peaches, pitted and sliced ¼ inch thick

1 pound strawberries, hulled and sliced

1 pound seedless red grapes, halved

1 pint blueberries

1 cup dark cherries, pitted and halved

1 (15-ounce) can mandarin oranges in light syrup

My mother's "fancy" fruit cocktail salad was front and center on our dinner table on most Sundays, looking so elegant in a crystal bowl. My update gets the job done with fresh fruit and canned mandarin oranges for juiciness and a touch of nostalgia. Can we please keep our wits about us and not stray into Jell-O salad territory? Can we all agree to just say no to transparent food?

Gently mix the peaches, strawberries, grapes, blueberries, cherries, and mandarin oranges, along with the syrup, in a large bowl. Cover with plastic wrap and refrigerate for at least 1 hour. Serve in your best crystal bowl.

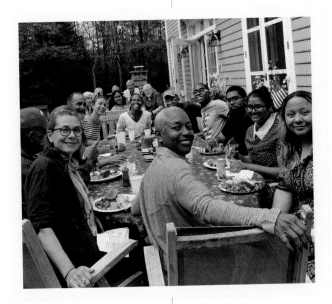

Family and friends for dinner upstate

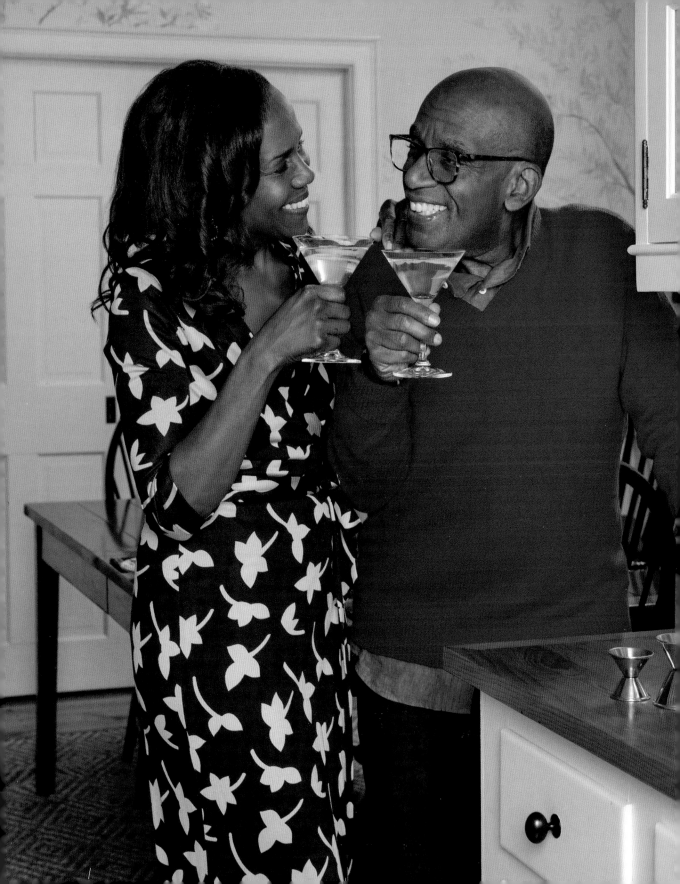

NEXT-LEVEL LIBATIONS:

SPIRITED AND NON-SPIRITED

EVERY YEAR RIGHT AROUND THE HOLIDAYS, DEBORAH and I get dressed in our finest for our favorite annual tradition, a night out at the Café Carlyle to hear music in a classic Manhattan cabaret. The second we enter the hotel, we're transported back in time. Sophisticated people sit at tables sipping on beautifully crafted cocktails. The unmistakable sound of a cocktail shaker is the background music before the show begins. While we've seen some fabulous acts at the Carlyle, the expertly prepared drinks make a night of great music even more special. Everything about the experience is elegant: the etched crystal highball and coupe glasses, the liqueurs and spirits, the perfect garnishes...and then there's the careful mixology.

Looking around at the stylish patrons, I think back on my parents, who always took care to look their best for Friday night dances at our local church. My mother would wear a simple, classic dress, and my father was dashing in his suit and tie, shoes polished to a high sheen, because dressing up to go out meant showing respect for yourself and others. As our server sets down a gorgeous cocktail without spilling a drop, I take a sip and realize I feel about ten times more sophisticated than I actually am. Deborah clinks my glass with her martini, a quick acknowledgment of this special moment at this special place where glamour rules and it's easy to forget that flip-flops, cut-off shorts, and sweatshirts exist.

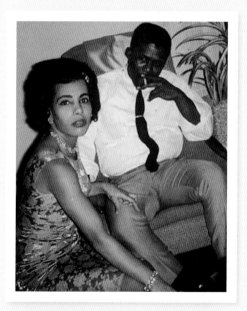

As someone who didn't drink much in college and had never heard of the Aperol Spritz until a couple of summers ago, I've upped my drinks game since Deborah and I started our forays to the Carlyle. It doesn't matter whether a beverage is alcoholic or not;

Ready for a night on the town: my parents, Isabel and Al Roker

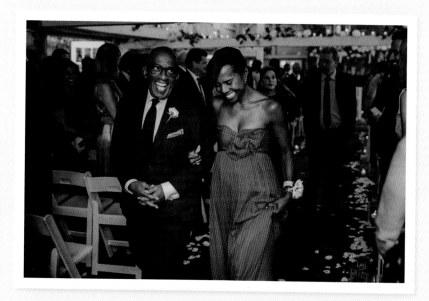

the point is to make an extra effort. There is value to embracing a touch of the cocktail culture—dressing more thoughtfully, putting on some jazzy music, and taking the time to carefully prepare a mojito or a snappy ginger ice tea for yourself and your loved ones.

When my mother was seventy-one, Deborah and I brought her along to see the marvelous Bobby Short. In that unmistakable gravelly voice, he referred to my mom as "an absolutely beautiful creature." My mother *was* beautiful, but I was struck by how easily this former nurse's aid from Queens turned stay-at-home mom fit in with the crowd. Sure, this place had some serious dazzle, but my mother grew up during a time when people tried to look their best all the time.

While I'm glad I don't have to wear a suit every single day, I can't help but wonder what it would be like if we all dressed to show respect for ourselves and everyone else. So get out the cocktail shaker and use the good glasses. This is what they're for!

THE BEST COLD BREW COFFEE (JUST ASK HENRY WINKLER)

PREP TIME: **10 MINUTES, PLUS 12 HOURS TO SOAK** • COOK TIME: **10 MINUTES**

1 pound coarsely ground coffee beans

½ cup ground chicory

5 cups cold water

1 cup Simple Syrup (below)

1 tablespoon vanilla extract

4 (3-inch) cinnamon sticks

Ice cubes

Whole milk, skim milk, or cream, for serving

 NOTE *FROM UNCLE AL* You might need to order the chicory online, as it can be hard to find in stores. Also, you'll need cheesecloth for straining the coffee. Most supermarkets carry it.

Simple Syrup

1 cup granulated sugar

1 cup water

Heat the sugar and water in a small saucepan over medium heat, stirring occasionally, until the sugar dissolves and the liquid is syrupy, about 10 minutes. Cool and transfer to a container with a lid. The syrup will keep in the refrigerator for up to 1 month.

Even though my schedule demands that I get up by 3:45 a.m. on weekdays, I didn't start drinking coffee until fairly recently. I had tried it at my parents' house a few times, but it was too bitter, and I associated it with my father's smoking. I was in Cleveland on assignment when I first encountered "cold brew" in a café, and I became coffee curious. Since the coffee wasn't heated, it wasn't acidic or bitter. Instead, the flavor was smooth and mellow—much like myself. Sweet, but punctuated with just enough bitter chicory to make it interesting.

When I got back to New York, I went into mad scientist mode, mixing up different concoctions with different amounts of vanilla, sugar, and cinnamon until I hit upon The One. I was so pleased with my discovery that I brought batches of it to work for the coffee lovers who work on *Today*. I hadn't been this popular since the days when I brought doughnuts! The recipe makes a big batch because the coffee is so good you'll want it in your life every day, and also, it has to steep for up to a day. When Henry Winkler (aka the Fonz) was a guest host on the third hour, he took a sip and said, "This is the best coffee I have ever had in my life."

For the coffee concentrate, combine the coffee beans, chicory, and water in a large pitcher or bowl. Mix to combine and let sit at room temperature for at least 12 and up to 24 hours. Strain through a fine-mesh strainer lined with cheesecloth into a container with a lid. Refrigerate for up to 2 weeks.

Put the simple syrup, vanilla, and cinnamon sticks in a small saucepan and heat to a simmer. Remove from the heat and let the cinnamon sticks sit in the syrup for about 10 minutes, then discard the sticks.

For each drink, pour ½ cup of the coffee concentrate and the desired amount of simple syrup into a tall glass. Add ice and milk or cream to taste. Stir to combine and serve.

GINGER-LEMON ICED TEA

2 black tea bags

1 lemon, sliced, plus more for garnish

4 cups water

1 (3-inch) piece fresh ginger, peeled and cut into ½-inch pieces

¼ cup honey

Ice cubes

I love ginger. I'm convinced my appreciation of the root, with its cheeky and spicy flavor, comes via my father's Caribbean heritage. I like iced tea as much as the next person, but can we all agree it can be a little bland? And unsweetened iced tea? That's an invention of the devil—totally unpalatable. Serve this at a party and watch your guests' expressions go from bored to *Wait a minute, what is happening here?* It's like a gentle little slap saying *Wake up, it's a beautiful day!*

Put the tea bags and lemon slices in a large pitcher. Set aside.

Put the water and ginger in a medium saucepan and bring to a boil over high heat. Reduce the heat to medium and gently boil for about 10 minutes, until the ginger softens slightly.

Strain the ginger water over the tea bags and lemons. Let steep for 2 minutes, then discard the tea bags. Stir in the honey. Refrigerate until cold, about 30 minutes.

Serve in tall glasses over ice, garnished with additional lemon slices.

BASIL-WATERMELON LEMONADE

PREP TIME: **15 MINUTES, PLUS 30 MINUTES TO CHILL** • COOK TIME: **5 MINUTES**

1 cup Simple Syrup (page 207)

½ cup packed fresh basil leaves, plus small sprigs for serving

3 cups cold water

1 pound seedless watermelon, cubed (about 3 cups)

½ cup lemon juice

Ice cubes

This is your all-American summer beverage, but with a couple of exciting additions. And before you get second thoughts about digging out your blender from the back of the cabinet, know this: it is worth it! A few blitzes with that blender and you won't just have a delicious beverage; you'll have a cooling solution that will fix you right up on the hottest and most humid days of summer.

Combine the simple syrup and basil in a small saucepan and heat to a simmer. Remove from the heat and let the basil leaves sit in the syrup for about 5 minutes. Fish out and discard the leaves and let the syrup cool for 5 minutes.

Transfer the cooled syrup to a blender, add the cold water, watermelon, and lemon juice, and blend until smooth. Strain through a fine-mesh strainer into a pitcher and refrigerate until cold, about 30 minutes. Pour into tall glasses over ice, garnish with basil sprigs, and serve.

Courtney and her husband, Wesley Laga

CUCUMBER REFRESHER

1 English cucumber, cut into ¼-inch pieces

1½ ounces gin

Ice cubes

2 tablespoons Simple Syrup (page 207)

Tonic water

Mint sprigs, for garnish

A subtler, slightly more grown-up version of a gin and tonic, this drink is summer in a lowball glass. The recipe comes from Deborah's lifelong best friend, Agenia Clark, and is as light as a summer breeze. We usually serve these drinks when we're relaxing outside at our lake house upstate. With each sip, I revert to a ten-year-old who just wishes summer never had to end.

Combine the cucumber and gin in a pitcher. Using a muddler or a wooden spoon, mash the cucumber to release most of its liquid.

Strain the liquid into a large measuring cup. Pour equal amounts into two lowball glasses. Add ice. Pour 1 tablespoon simple syrup into each glass and top with tonic water. Use a long cocktail spoon to stir, garnish each glass with a sprig of mint, and serve.

 You can substitute vodka for the gin.

BLOOD ORANGE APEROL SPRITZ

Simple Syrup (page 207)

¼ cup blood orange juice

Ice cubes

3 ounces Aperol

4 ounces dry prosecco

2 ounces club soda

I was sitting in a French bistro with Deborah, Nick, and Leila when a waiter passed our table carrying a tray full of intriguing orange-hued drinks. I looked around. Many of the patrons were enjoying this mysterious beverage, even though it was barely noon. I immediately asked the waiter to bring me what everyone else was having. Where had this tasty cocktail been all my life? My family was ready to do some sightseeing, but I couldn't imagine anything better than indulging in a bit of café life while sipping the nectar of the gods. *Au revoir* and *à bientôt*, dear family! I ordered a second (and a third) and settled back into a perfect Parisian afternoon.

Combine the simple syrup and orange juice in a medium nonreactive saucepan and heat until simmering. Remove from the heat and cool to room temperature. The orange syrup will keep, covered and refrigerated, for 1 month.

Fill a wine glass halfway with ice. Add the Aperol, 1 ounce of the orange syrup, and the prosecco. Top with the club soda, stir, and enjoy.

MOJITO

4 ounces lime juice, plus lime wedges for garnish

10 fresh mint leaves, plus more for garnish

4 ounces Simple Syrup (page 207)

Ice cubes

3 ounces white rum

Soda water

The mojito is a party in a glass, and it is a classy party. Imagine seersucker suits, sundresses, and chatting with friends on a summer evening. With its mint, rum, soda water, and light sweetness, the mojito is so much more sophisticated than the margarita, with its never-ending list of gaudy flavors. Fresh, festive, refined, it adds a dash of posh to any gathering.

Combine the lime juice and mint leaves in a large measuring cup and lightly crush with a muddler or wooden spoon until the mixture is aromatic and the mint leaves look bruised. Add the simple syrup and mix.

Fill two glasses with ice cubes. Using a small fine-mesh strainer, strain the mint syrup equally into the glasses. Add 1½ ounces rum to each glass. Top with soda water and stir. Garnish with lime wedges and additional mint leaves and serve.

BATCH MARTINIS

PREP TIME: **5 MINUTES, PLUS 1 HOUR TO CHILL** • COOK TIME: **0 MINUTES**

8 ounces vermouth

8 ounces gin

4 ounces water

Pimiento-stuffed green
 olives, for garnish

Lemon twists, for garnish
 (optional)

Deborah is partial to a crisp, cold martini, a drink that's timeless, chic, no-nonsense, and strong—just like she is. The queen of efficiency, she's developed a method for serving icy martinis to a group of people without having to mix one at a time.

A heads-up: You'll want to make the batch at least an hour ahead or preferably the night before so it can chill. Serving warm martinis is no way to treat friends.

Combine the vermouth, gin, and water in a large mason jar or similar container. Cover and store in the refrigerator or freezer for at least 1 hour and up to overnight.

Chill five martini glasses. Pour 4 ounces of the martini mix into each glass. Add an olive or two to each glass and garnish the rim with a lemon twist, if you like.

 You can substitute vodka for the gin.

LEILA'S SANGRIA

PREP TIME: **20 MINUTES, PLUS 4 HOURS TO CHILL** • COOK TIME: **0 MINUTES**

1 (750 mL) bottle Spanish red wine, such as Rioja or Garnacha

1 (750 mL) bottle dry white wine, such as Pinot Grigio

1 (1 L) bottle fruit punch, such as Minute Maid

4 ounces white rum

½ cup Simple Syrup (page 207)

1 star anise pod

3 (3-inch) cinnamon sticks

2 apples, cored and sliced

2 lemons, sliced

1 orange, sliced

Sparkling water (optional)

You're never quite sure how to feel when you realize your twenty-something daughter knows her way around a bar pretty well. The first time Leila made this sangria, I thought, *This is so much better than the sangria of my college years!* And also, *Just how many batches of these has she made to reach this level of perfection?*

As I watched my daughter pour in two full bottles of wine and rum, I realized the one-dollar pitchers of my SUNY Oswego days were more of a juice-meets-fruit-salad situation—with just a touch of cheap wine. But at a dollar per pitcher, who could complain? You will receive zero complaints with Leila's recipe.

Combine the red wine, white wine, fruit punch, rum, simple syrup, star anise, cinnamon sticks, and apple, lemon, and orange slices in a large pitcher and stir. Refrigerate for at least 4 hours and up to 12 hours before serving. (The longer the drink sits, the more the fruit will absorb the wine and rum.)

When you're ready to serve, top with sparkling water, if desired.

BOURBON APPLE PIE MILKSHAKES

PREP TIME: **5 MINUTES** • COOK TIME: **0 MINUTES**

1 pint vanilla ice cream

½ cup canned apple pie filling

⅔ cup whole milk, plus more if needed

1½ ounces bourbon

6 whole vanilla wafers, plus ¼ cup crushed wafers

Store-bought caramel sauce, for topping

Do you know what happens when you take a beloved dessert and introduce it to bourbon? We all fall in love. This boozy milkshake is the ultimate dessert indulgence, so it must be slowly savored. I was so smitten at my first sip that I decided the BAPM would be the only dessert-booze combo in my life. Sure, I was curious to conduct further experiments, but I knew I had to draw the line somewhere.

Combine the ice cream, pie filling, milk, bourbon, and whole vanilla wafers in a blender and blend until smooth. (Alternatively, you can use an immersion blender in a sturdy quart-size container.) If the mixture is too thick, add a dash more milk.

Pour into two chilled glasses, top each with half of the crushed vanilla wafers, and drizzle with caramel sauce. Serve with a tall spoon or a straw.

THE FINALE

3½ cups softened Belgian chocolate ice cream

2 cups softened chocolate chip ice cream

8 ounces chocolate syrup

8 ounces chocolate liqueur, such as Godiva

4 ounces coffee liqueur

This chocoholic's dream in a champagne flute is brought to us by my new son-in-law, Wesley Laga. It was the signature after-dinner drink-dessert of Wesley's grandmother Elsa (aka Nonna), a chef and caterer. When you merge families, you merge recipes, and there is nothing better than chocolate on chocolate to bring people together.

Combine the chocolate ice cream, chocolate chip ice cream, chocolate syrup, chocolate liqueur, and coffee liqueur in a blender and blend until smooth.

Pour into individual champagne flutes and serve immediately.

The key to this drink is using Belgian chocolate ice cream, which is creamy and decadent.

MEMORY-MAKING
DESSERTS

DESSERT HAS ALWAYS MANAGED TO FIND _ME_. MY VERY first after-school job was at a company that supplied the goodies to vending machines in offices all across New York City. Any packages that appeared broken were mine for the eating, and that is how I fell in love with Lorna Doone, the crumbly, golden shortbread cookie. Packages of pulverized pretzels and potato chips I could do without, but Lorna Doone, with her just-sweet-enough buttery richness, was as good to me crushed as she was whole. I've since moved on from broken Lorna Doones, but the shortbread cookies earn an extra-special place in our banana pudding recipe. It took some convincing to get Courtney to swap out the tried-and-true Nilla Wafers for them, but what can I say? _Father knows best_.

When I was a kid, there was no better way to end a week than being handed a slice of my mother's pineapple upside-down cake at the end of Sunday dinner. These days, seeing Leila's lemon meringue pie cooling on the counter is what gets me beaming, because it means she is visiting from France. My girl is home! And also... I get to eat pie.

Making desserts is not where I excel in the food-prep arena, so I leave that to the capable women in my family. (Cliché, but true.) In fact, I believe the best desserts are those someone else has made. Show up at my house hankering for dessert, and you have a couple of options: (1) Pass me the ice cream scooper. I'm a regular soda jerk when it comes to milkshakes. (2) Wait for Courtney or Leila to visit, because I am not getting out the stand mixer and no way am I fussing with pastry. However, I do know a magnificent dessert when I taste one, and I suggest you beg, bribe, or do whatever it takes to get someone to make the ones in this chapter for you.

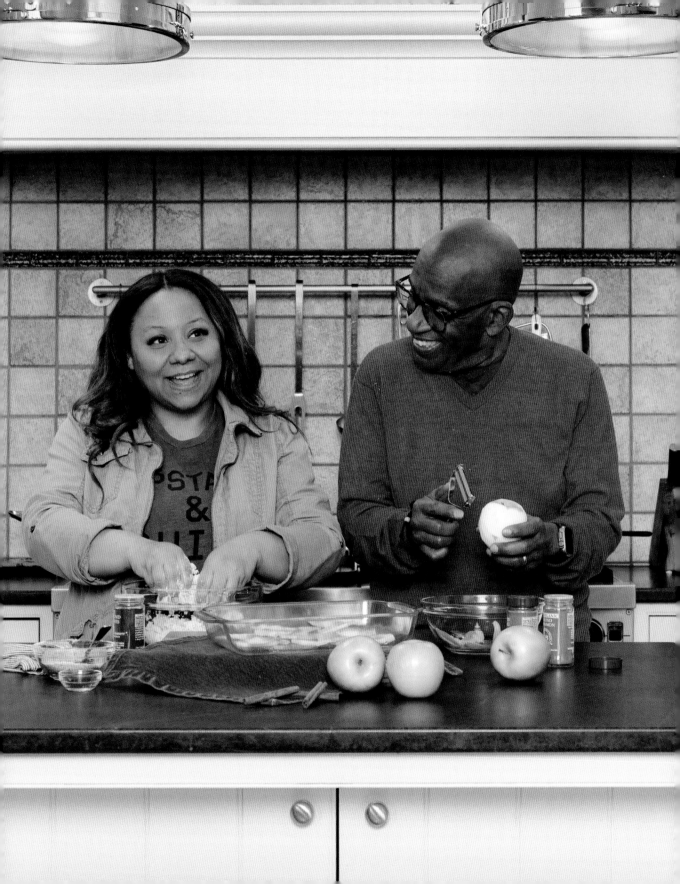

STRAWBERRY SHORTCAKES
WITH LEMON-CURD WHIPPED CREAM

PREP TIME: **30 MINUTES** • COOK TIME: **15 MINUTES**

STRAWBERRIES

1 pound strawberries, hulled

6 tablespoons granulated sugar

SHORTCAKES

2 cups all-purpose flour, plus more for dusting

2 tablespoons granulated sugar, plus 1 teaspoon for sprinkling

2 teaspoons baking powder

1 teaspoon kosher salt

8 tablespoons (1 stick) cold unsalted butter, cut into cubes

½ cup whole milk

1 large egg

1 large egg white

LEMON-CURD WHIPPED CREAM

1 cup heavy cream

3 tablespoons jarred lemon curd

1 teaspoon vanilla extract

1 teaspoon grated lemon zest

A dessert with a biscuit as its base is sure to be a winner. Who doesn't love biscuits? Add fresh sweet strawberries and whipped cream to the slightly sweet biscuit and behold—you have perfection on a plate. Depending on how many you're feeding, you could end up with leftover biscuits...so, *Hello, breakfast sandwich!* That's like hitting two buttery birds with one stone. The photo is on page 232.

Preheat the oven to 400°F, with a rack in the middle. Lightly grease a baking sheet or line it with parchment paper.

FOR THE STRAWBERRIES: Mash half the strawberries in a medium bowl. Slice the remaining strawberries and add them to the mashed strawberries. Stir in the sugar and refrigerate.

FOR THE SHORTCAKES: Put the flour, sugar, baking powder, and salt in a food processor. Pulse 3 or 4 times to mix. Add the butter and pulse 5 or 6 times, until it is pea-sized. In a small bowl, whisk together the milk and whole egg.

Transfer the flour mixture to a large bowl. Pour in the milk mixture and mix with your hands to form a dough. Transfer the dough to a floured work surface and gently knead just until it comes together, about 1 minute. Roll out the dough to a ¾-inch thickness. Cut out 4 biscuits with a 3-inch-wide biscuit cutter or the rim of a glass.

Place the biscuits 1 ½ inches apart on the prepared baking sheet. Brush the tops with the egg white and sprinkle with the 1 teaspoon sugar.

Bake for about 15 minutes, until the biscuits are golden brown. Transfer to a rack to cool.

FOR THE WHIPPED CREAM: Whip the cream in the bowl of a stand mixer or in a large bowl with a hand mixer until stiff peaks form. Using a silicone spatula, gently fold in the lemon curd, vanilla, and lemon zest.

TO ASSEMBLE: Cut each biscuit in half, spoon some strawberries on the bottom half, and top with a large dollop of whipped cream. Set the top of the biscuits on the whipped cream, top with more whipped cream and strawberries, and serve immediately.

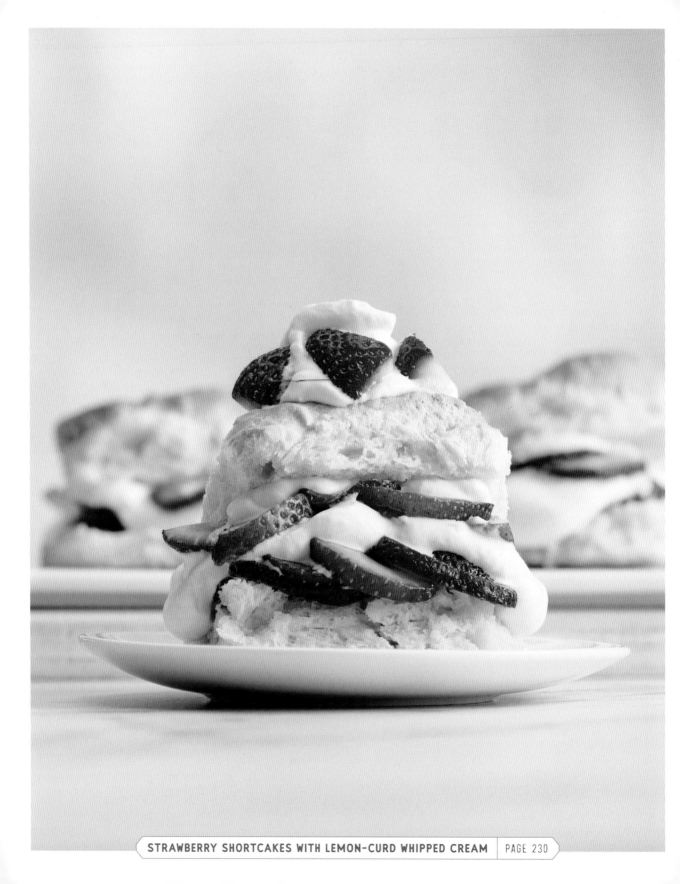

STRAWBERRY SHORTCAKES WITH LEMON-CURD WHIPPED CREAM | PAGE 230

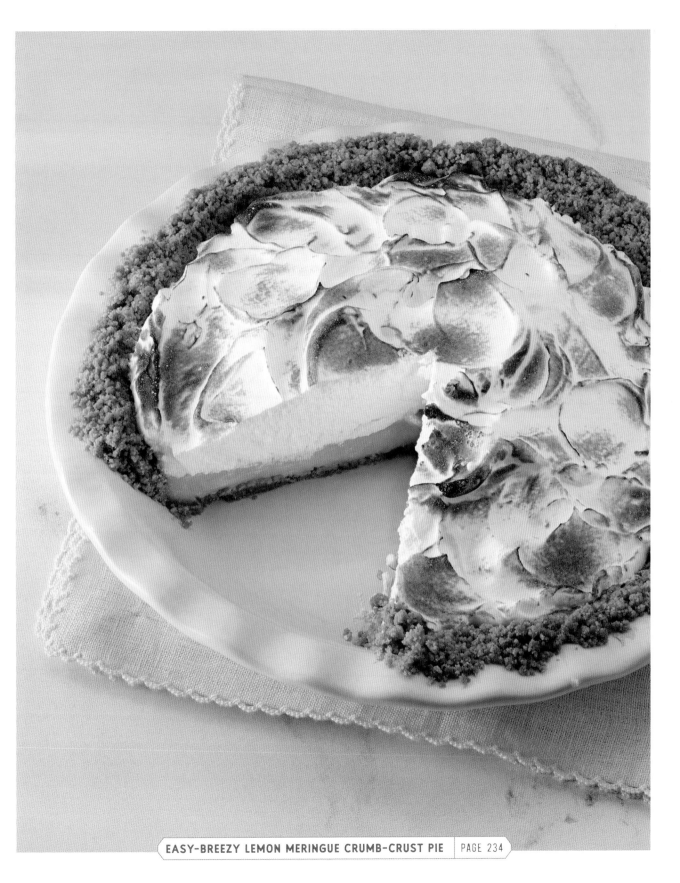

EASY-BREEZY LEMON MERINGUE CRUMB-CRUST PIE | PAGE 234

EASY-BREEZY LEMON MERINGUE CRUMB-CRUST PIE

PREP TIME: **25 MINUTES, PLUS 3 HOURS TO CHILL** • COOK TIME: **30 MINUTES**

CRUMB CRUST

1½ cups finely ground graham cracker crumbs

8 tablespoons (1 stick) salted butter, melted

1 tablespoon granulated sugar

FILLING

1 (14-ounce) can sweetened condensed milk

5 large egg yolks

2 teaspoons grated lemon zest

6 tablespoons lemon juice

1 teaspoon vanilla extract

MERINGUE

4 large egg whites, at room temperature

¼ teaspoon kosher salt

½ cup granulated sugar

⅓ cup water

Some people see the word *pie* and panic. To those who fall into this category, I say face your fear—because it's worth it! Lemon pie is one of the true joys life brings us, and my daughter Leila brings me joy in abundance every time she makes it. It's light and refreshingly sweet, and whoever invented the graham cracker crust should be nominated for a Nobel Prize. It's so much easier to make than fussy pastry, and it shows just how divine the humble cracker of our kindergarten years can be. As for the meringue, are you going to let that stop you? It's just frothing, when you get down to it! The photo is on page 233.

FOR THE CRUST: Preheat the oven to 350°F, with a rack in the middle.

Combine the graham cracker crumbs, melted butter, and sugar in a medium bowl. With your hands or the bottom of a drinking glass, press the crumbs firmly into the bottom and up the sides of a 9-inch pie pan. Bake for 10 minutes, or until lightly browned. Remove the crust from the oven and reduce the temperature to 300°F.

MEANWHILE, FOR THE FILLING: Whisk together the condensed milk, egg yolks, lemon zest, lemon juice, and vanilla in a medium bowl. Pour the mixture into the warm pie crust. Return the pie to the oven and bake for about 15 minutes, or until the filling is set. Remove from the oven and refrigerate for about 1 hour, until the pie is thoroughly chilled.

FOR THE MERINGUE: Beat the egg whites in the bowl of a stand mixer on medium speed or in a large bowl with a hand mixer until frothy. Add the salt and continue to beat until soft peaks form. Turn off the mixer. Heat the sugar and water in a small

Visiting Leila in Paris

Room-temperature egg whites whip faster than cold egg whites. And make sure there is no egg yolk in your egg whites.

If you own a kitchen torch, use it to brown the meringue instead of the broiler.

saucepan over medium-high heat for about 3 minutes, stirring until it's syrupy and registers 240°F to 250°F on an instant-read thermometer; the syrup will bubble. Turn the mixer to high and slowly pour the syrup into the egg whites, beating until the meringue has cooled and stiff peaks form, about 5 minutes.

Preheat the oven to broil and adjust the rack 5 inches from the broiler.

Spread the meringue on the pie and swirl decoratively. Broil for a minute or two, watching carefully so it doesn't burn, until the meringue is nicely toasted.

Remove from the oven and allow to cool to room temperature for about 30 minutes.

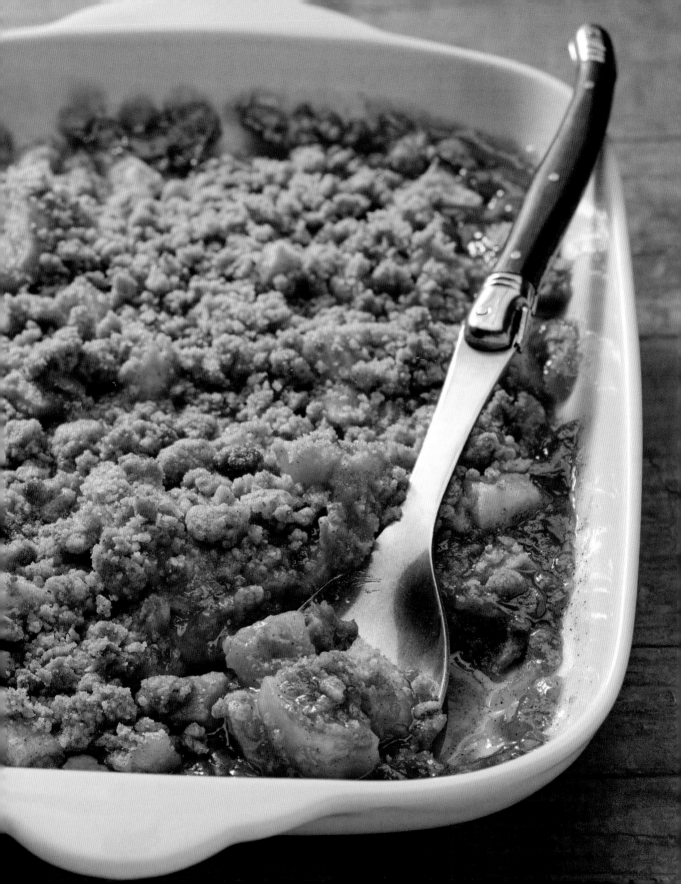

APPLE-PICKING APPLE CRUMBLE

PREP TIME: **25 MINUTES** • COOK TIME: **40 MINUTES**

APPLES

2 pounds Granny Smith apples (about 4 large), peeled, cored, and cut into ¾-inch pieces

2 pounds Honeycrisp apples (about 4 large), peeled, cored, and cut into ¾-inch pieces

6 tablespoons granulated sugar

2 teaspoons Chinese five-spice powder

1 teaspoon ground ginger

1 teaspoon ground cinnamon

½ teaspoon ground nutmeg

2 tablespoons unsalted butter

¼ cup apple cider

2 teaspoons lemon juice

1 teaspoon vanilla extract

½ teaspoon cornstarch

CRUMBLE

1¼ cups all-purpose flour

½ cup firmly packed dark brown sugar

½ teaspoon ground cinnamon

½ teaspoon kosher salt

8 tablespoons (1 stick) unsalted butter, at room temperature, cut into 8 pieces

Vanilla ice cream, for serving (optional)

Apple picking on Columbus Day weekend is a treasured family tradition—think sweater weather, lovely countryside, fresh air, and a hayride pulled by an actual farmer driving a tractor. The entire experience is about as American as apple crumble. The custom is still going strong, and every year we buy more apples than any family could reasonably consume. Let the Rokers loose in an orchard and we become apple-picking fiends, stuffing Granny Smith, McIntosh, Honeycrisp, Golden Delicious, and Macoun into our bags like they are the last apples on earth. When life gives you lots of apples…make crumble.

Preheat the oven to 350°F, with a rack in the middle.

FOR THE APPLES: Toss the apples in a large bowl with the granulated sugar, five-spice powder, ginger, cinnamon, and nutmeg until all the pieces are coated.

Melt the butter in a large skillet over medium-low heat. Add the apples and stir. Cover and cook, stirring occasionally, until the apples release juices and soften, about 10 minutes. Add the cider, lemon juice, vanilla, and cornstarch and stir. Simmer, uncovered, until the juices have slightly thickened, about 2 minutes. Transfer to a 9×13-inch baking dish.

FOR THE CRUMBLE: Mix the flour, brown sugar, cinnamon, and salt in a medium bowl. Add the butter and work into the flour with your fingers until the mixture is crumbly, breaking any larger clumps into smaller pieces. Sprinkle the crumble mixture over the apples, pressing it lightly into the apples.

Bake for 25 minutes, or until the topping is lightly browned and crispy. Cool for 10 minutes. Serve with vanilla ice cream, if desired.

PINEAPPLE UPSIDE-DOWN CAKE

PINEAPPLE

4 tablespoons (½ stick) unsalted butter

½ cup firmly packed light brown sugar

1 (20-ounce) can pineapple rings in juice, drained (juice reserved)

Maraschino cherries, drained and stems removed

CAKE

1½ cups all-purpose flour

¾ cup granulated sugar

1 teaspoon baking powder

1 teaspoon baking soda

½ teaspoon kosher salt

1 cup whole milk

8 tablespoons (1 stick) unsalted butter, melted

2 large eggs

2 teaspoons vanilla extract

"Mesmerizing" isn't often used to describe a dessert, but it's an apt description for this cake, a signature Isabel Roker recipe. I remember my siblings and me staring at it, thinking, *Wow, it's upside down!* All the gorgeous sugary syrup soaks into the cake, adding an extra layer of wow. I guarantee your guests will be impressed with your wizardry when you set this on the table.

Preheat the oven to 350°F, with a rack in the middle.

FOR THE PINEAPPLE: Melt the butter in a large (11- to 12-inch) cast-iron skillet over medium-low heat. Remove from the heat and sprinkle the brown sugar over the butter.

Place the pineapple rings in an even layer on top of the brown sugar. Put a cherry in the middle of each ring.

FOR THE CAKE: Whisk together the flour, granulated sugar, baking powder, baking soda, and salt in a large bowl. Whisk the milk, melted butter, eggs, vanilla, and ⅓ cup of the reserved pineapple juice in a medium bowl. Pour the wet ingredients into the dry and whisk until you have a smooth batter.

Pour the batter over the pineapple rings. Bake for 40 minutes, or until the cake is golden brown and a toothpick inserted in the middle comes out clean.

Remove the skillet from the oven and cool on a rack for 10 minutes. Run a small knife around the edges of the cake, place a large plate over the skillet, and carefully invert the cake onto the plate. Serve warm or at room temperature.

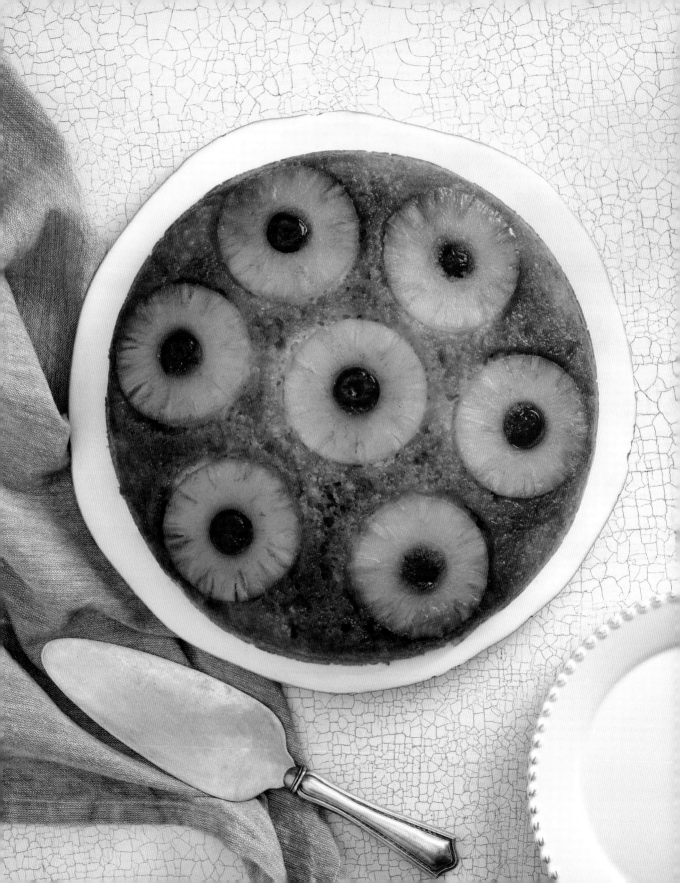

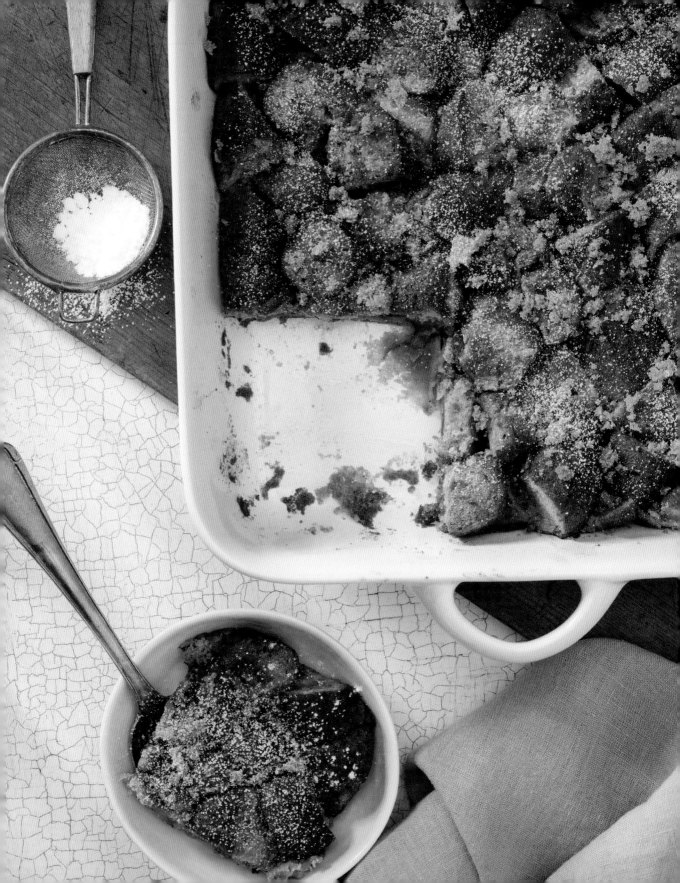

APPLE-CIDER DOUGHNUT BREAD PUDDING

PREP TIME: **20 MINUTES** • COOK TIME: **35 MINUTES**

2 cups heavy cream

1 cup whole milk

3 large eggs

½ cup granulated sugar

½ teaspoon ground cinnamon

½ teaspoon vanilla extract

10 apple-cider doughnuts, preferably 1 to 2 days old, cut into 1-inch pieces

⅓ cup firmly packed light brown sugar

2 tablespoons powdered sugar

After the Rokers have stripped an orchard of all the apples, we take our greed over to the apple-cider doughnut stand, where I order a dozen. "No, wait, two. Three. Yes, three dozen please." Freshly baked, warm apple-cider doughnuts are like White Castle burgers: when they're fresh and hot, they're about the greatest thing going on, but once they cool, they sink a couple of notches to meh. What to do with all the extra doughnuts? Bread pudding! Douse those babies in custard and bake, and you've given the doughnuts a second chance to shine and yourself a reason to overbuy next year.

Preheat the oven to 350°F, with a rack in the middle. Lightly grease a 9-inch square baking dish with nonstick cooking spray.

Whisk together the cream, milk, eggs, granulated sugar, cinnamon, and vanilla in a large bowl.

Scatter the doughnut pieces in the prepared baking dish. Pour the custard mixture over them, pressing the doughnuts down so they soak up the custard. Let sit for 15 minutes, or until the doughnuts absorb the custard.

Sprinkle the top with the brown sugar, cover with aluminum foil, and bake for 20 minutes. Remove the foil and continue to bake for 15 minutes, or until the top is golden brown and the filling is set. Remove from the oven and let cool, about 10 minutes.

Top with the powdered sugar and serve warm.

If you can't get apple-cider doughnuts, you can substitute plain cake doughnuts.

SHORTBREAD BANANA PUDDING

PREP TIME: **30 MINUTES, PLUS 4 HOURS TO CHILL** • COOK TIME: **0 MINUTES**

4 ounces cream cheese, at room temperature

1 (14-ounce) can sweetened condensed milk

1 (5-ounce) box instant vanilla pudding

2 cups half-and-half

1½ cups heavy cream

3 tablespoons powdered sugar

2 teaspoons vanilla extract

2 (10-ounce) packages shortbread cookies, such as Lorna Doone

4 bananas, peeled and sliced

You can use graham crackers instead of shortbread cookies, which will make this pudding taste like a banana cream pie.

I like to imagine that you can open any refrigerator below the Mason-Dixon line and find a banana pudding. While I've never encountered a version that wasn't spoon-licking worthy, mine has a secret weapon. One day as I was getting ready to put together a banana pudding, I thought, *What would happen if I used shortbread cookies instead of the traditional Nilla Wafers?* Unlike the wafers, shortbread doesn't soak up the pudding but stays crisp. Thrilled by my discovery, I've been making it this way ever since.

In the bowl of a stand mixer fitted with the whisk attachment or in a large bowl with a hand mixer, mix the cream cheese and condensed milk until combined. Add the pudding mix and half-and-half and mix until smooth and creamy. If using a stand mixer, transfer to a large bowl and set aside; wash and dry the mixer bowl.

In the cleaned stand mixer bowl or in another large bowl with a hand mixer, beat the cream on medium-high speed until soft peaks form, about 1 minute. Add the powdered sugar and vanilla and mix until stiff peaks form. Add 1 cup of the whipped cream and gently fold it in. Cover and refrigerate the remaining whipped cream.

Place 4 cookies in a zipper-lock bag and crush them with a rolling pin. Set aside. Place half of the remaining cookies in a single layer in a 9×13-inch baking dish, followed by half of the sliced bananas. Spoon half of the pudding mixture on top, making sure to spread it to the edges of the dish. Add the remaining cookies, then the remaining sliced bananas, and then the remaining pudding. Spread the reserved whipped cream on top and sprinkle with the reserved crushed cookies.

Tightly cover with plastic wrap and refrigerate for at least 4 hours and preferably overnight.

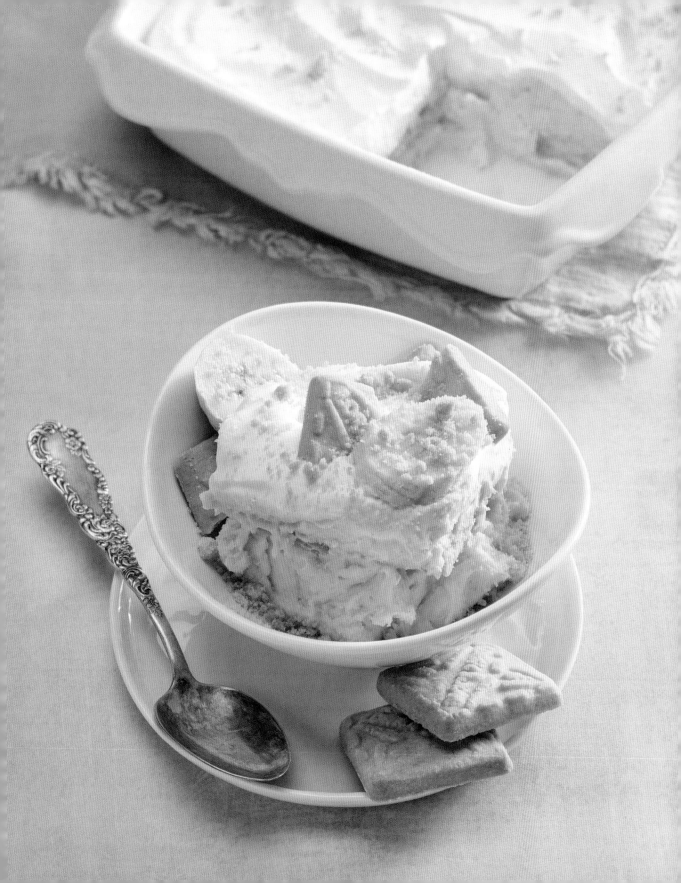

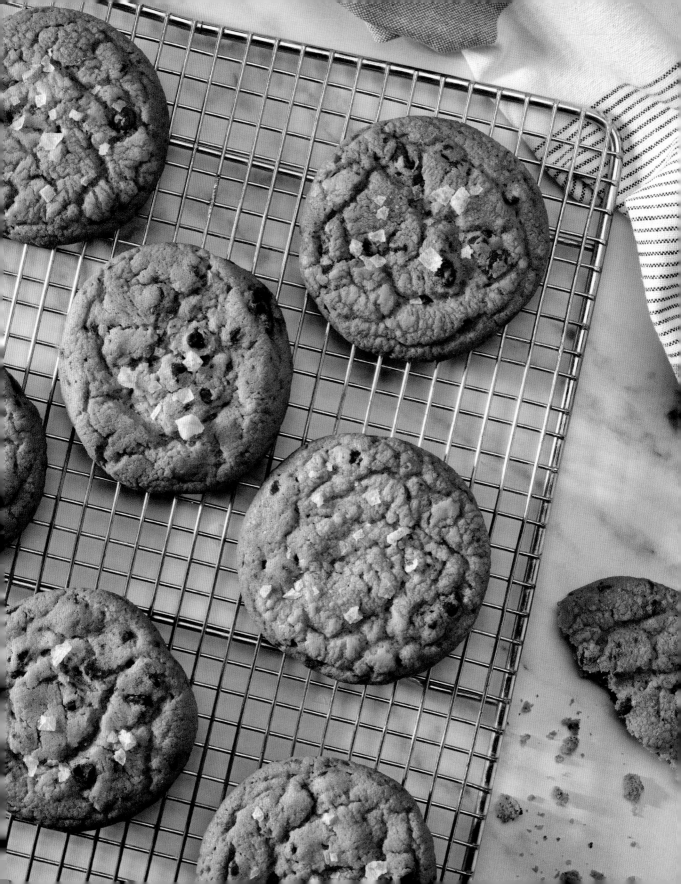

THE WORLD'S GREATEST CHOCOLATE CHIP COOKIES

PREP TIME: **20 MINUTES** • COOK TIME: **20 MINUTES**

1 cup all-purpose flour

1 teaspoon baking soda

8 tablespoons (1 stick) salted butter, at room temperature

½ cup firmly packed light brown sugar

¼ cup granulated sugar

1 large egg, at room temperature

1 teaspoon vanilla extract

1 (12-ounce) bag semisweet chocolate chips

1 teaspoon Maldon or other flaky sea salt

In January 2019, the daughter of a dear family friend came to stay with us. Haley Clark was starting her first job and ready to take New York City by storm. Enter the pandemic and, instead of exploring, making new friends, and painting the town red, she was cooped up working virtually and seeing no one other than Deborah and me. Her loss turned out to be our gain when she made it her mission to produce the world's greatest chocolate chip cookie, and I'm pleased to report she accomplished her goal. The cookies have a high density of chocolate chips, and they're hefty. The tiny touch of salt is a nice little surprise.

Preheat the oven to 350°F, with a rack in the middle. Line a baking sheet with parchment paper.

Whisk together the flour and baking soda in a medium bowl. Set aside.

In the bowl of a stand mixer fitted with the paddle attachment or in a large bowl with a hand mixer, beat the butter, brown sugar, and granulated sugar on medium speed for 1 minute, or until combined. Add the egg and vanilla and mix until light and fluffy, about 2 minutes. Reduce the speed to low and add half of the flour mixture. Once it is incorporated, add the remaining flour mixture and mix just to incorporate, a minute or two. Add the chocolate chips and mix just until they are evenly distributed.

Using a 2½-tablespoon cookie scoop, scoop the dough onto the prepared baking sheet, making sure the cookies are at least 1 inch apart. Bake for about 18 minutes, until the edges are golden brown.

Remove the cookies from the oven and immediately sprinkle with the sea salt flakes. Cool on a rack for at least 5 minutes, then serve. The cookies will keep in an airtight container at room temperature for up to 4 days.

NO-CHURN MINT COOKIES-AND-CREAM ICE CREAM

PREP TIME: **10 MINUTES, PLUS 3 HOURS TO FREEZE** • COOK TIME: **0**

15 to 20 Oreo cookies

1 (14-ounce) can sweetened condensed milk

4 ounces cream cheese, at room temperature

1 teaspoon vanilla extract

1 teaspoon mint extract

1½ cups heavy cream

1 drop green food coloring

Oreos and mint ice cream: think SpongeBob and Patrick, Mario and Luigi, and Batman and Robin. Sure, they're great on their own, but put them together and *pow!* You've got an unbeatable combination. This easy, ultra-minty homemade ice cream is smoother than silk, thanks to the cream cheese.

Put the cookies in a zipper-lock bag and crush using a rolling pin or the bottom of a saucepan. Set aside.

Whisk together the condensed milk, cream cheese, and vanilla and mint extracts in a medium bowl until combined.

Beat the heavy cream in a stand mixer fitted with the whisk attachment or in a large bowl with a hand mixer until stiff peaks form. Add the food coloring and the cream cheese mixture and gently fold them in with a silicone spatula. Fold in the crushed Oreos.

Scrape the ice cream mixture into a 9×5-inch loaf pan and smooth the top. Freeze for at least 3 hours, until very firm.

About 5 minutes before serving, remove the ice cream from the freezer and let soften slightly.

For mint chocolate chip ice cream, replace the cookies with 1 cup semisweet chocolate chips.

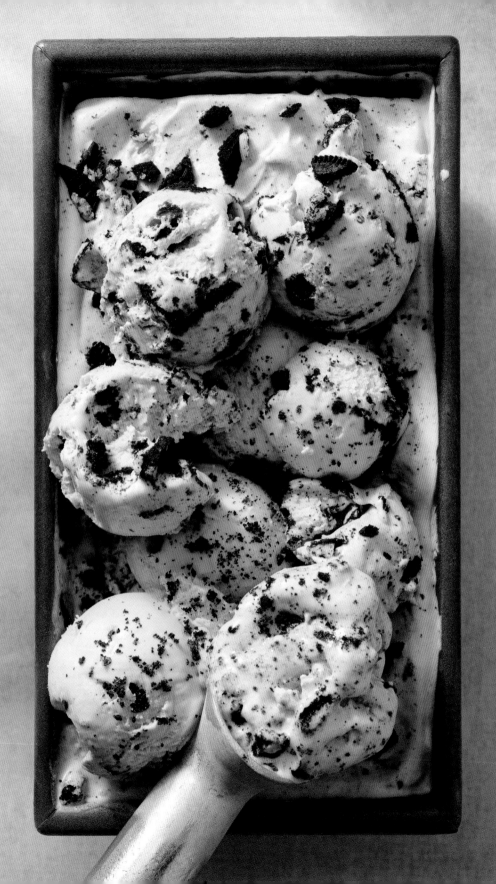

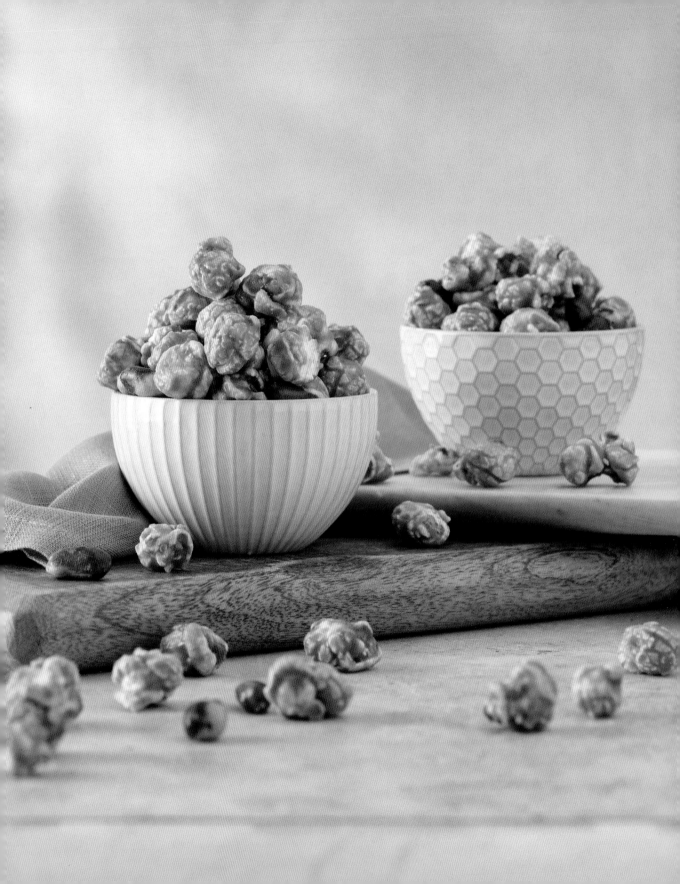

SPICY CRACKER JACKS

PREP TIME: **15 MINUTES** • COOK TIME: **50 MINUTES**

1 (3-ounce bag) microwave popcorn with butter

1 cup unsalted roasted peanuts

8 tablespoons (1 stick) unsalted butter

1 cup firmly packed dark brown sugar

¼ cup dark corn syrup

½ teaspoon kosher salt

1 teaspoon vanilla extract

½ teaspoon baking soda

½ teaspoon ground cayenne pepper

NOTE FROM UNCLE AL

You'll need a candy thermometer or an instant-read thermometer for this one. Also, you need to work fast after you make the caramel and immediately pour it onto the popcorn. If it cools, it will solidify in the pan.

When I was a kid, my dad, Uncle Champ (my mother's brother), and I took the subway up to Yankee Stadium for baseball games. I'd settle in my seat and make preparations for the game. That entailed getting myself a hot dog, a Coke, and finally Cracker Jack—the only snack food that came with a prize. Looking at the food piled in my lap, my uncle asked, "Did you come here to watch baseball or to eat?"

Stupid question! No one peddles Cracker Jack when I'm watching the Yankees on TV. I'm here for the snacks! This version is just a bit grown-up, thanks to a dash of cayenne.

Preheat the oven to 250°F, with a rack in the middle. Line a baking sheet with parchment paper.

Microwave the popcorn according to the package directions. Stir together the popcorn and peanuts in a large bowl.

Melt the butter in a medium saucepan over medium heat. Add the brown sugar, corn syrup, and salt and stir until melted. Bring to a boil and cook, stirring occasionally, until the mixture becomes a dark caramel color and the temperature reads 250°F on a candy thermometer, 5 to 6 minutes. Watch carefully!

Remove the pan from the heat and carefully add the vanilla and baking soda, stirring constantly (the mixture will spatter). Stir in the cayenne. Immediately pour the caramel mixture over the popcorn and peanuts and gently toss with a wooden spoon or silicone spatula until the popcorn is coated.

Transfer the mixture to the prepared baking sheet and, using a silicone spatula, gently press the mixture into an even layer. Bake for about 45 minutes, stirring halfway through, until the caramel has hardened.

Let cool on the baking sheet for about 15 minutes before serving. Store in an airtight container at room temperature for up to 1 week.

ACKNOWLEDGMENTS

There are many people in my life who have inspired my love of food and have helped shape this book.

We can't write a book about family recipes without acknowledging our family. My sibs, Alisa Smith, Desireé Bomman, Christopher Roker, and our late sister, Patricia Cummins, were all around our family table and added to the fun and flavor of our meals.

Cooking for family is a love language like no other. And I love my kids who helped me expand what and how I cook. I wouldn't be the cook I am today if it wasn't for Leila, who helped me explore the fun of vegetarianism, and Nick, who loves good food and plenty of it.

Of course, my oldest, Courtney, is the one who did *all* of the heavy lifting for this book, and, as a real chef, brought it to life. Thanks, sweetie, for all the hard work and pushing your old man to get stuff done for the book. You helped give birth to this book, and you gave birth to the human being who gave me the will to live when I also was in heaven's waiting room, my little Sky Clara.

I wouldn't have the life and family I have if it weren't for my wife, Deborah Roberts. Deborah, you try to keep me and my cooking healthy. I thank you for never giving up. I don't listen, but you never give up.

To Debbie Kosofsky, who runs *Today Food*, thanks for always being open to my crazy ideas; and to Katie Stilo, our *Today Food* stylist, I appreciate your keeping me up on what's new and next.

I'm grateful to everyone at Legacy Lit for helping this idea become a reality. Thank you to Tara Kennedy, publicity director; Maya Lewis, marketing manager; and Amina Iro. And to Krishan Trotman, publisher of Legacy Lit, thank you for allowing me to share my favorite foods and more of my crazy stories with the world.

Thank you, Rux Martin, for sharing your wisdom and expertise as we put this together. This book would be a random scrapbook of recipes without your keen eye and zest for words (and food).

Paula B. Vitale tells as many wild stories as I do, so working with her is like a hurricane of crazy. And I like it.

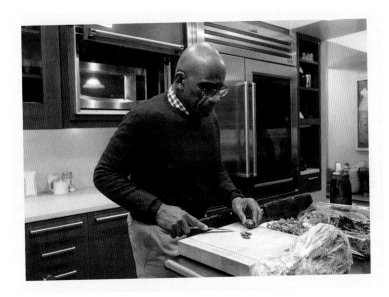

How fitting is it that my WME literary agent's name is Mel Burger? Well, it's actually Mel Berger, but for this book, it's Burger, and he is the best. Speaking of cheeseburgers, I am so fortunate to have Le Grande Fromage at WME in my corner, Jon Rosen. That the guy who is responsible for almost every big name in food on TV is my agent is a dream come true.

And thanks to Briana Watson, who has the unenviable job of keeping me on track and on deadline. Her side job is herding feral cats.

The main reason we read cookbooks is to drool over the pictures of the finished recipes.

Amy Roth took the drool-worthy photos, while Christina Nuzzo and her studio gave us a place to shoot said photos.

And no matter how good the food is, there must be folks who style that food to make it look better. Shanna Sooknanan, Mark Vasquez, and Joshua Gruenberg are three of the best. Of course, all that food sits on tables, plates, platters, glasses, and more. They call those props, and we called Deborah Ruggieri to supply 'em.

Whoever I forgot to thank, please chalk it up to over-indexing on York Peppermint Patties as the deadline approached, and old age.

INDEX

ABOUT THE AUTHORS

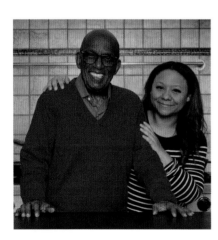

Al Roker is a co-anchor of NBC's *TODAY*, an Emmy Award–winning journalist, and a *New York Times* bestselling author. He lives in New York with his family.

Courtney Roker Laga is a recipe developer and trained chef who has worked in two Michelin-starred restaurants. She lives in New Jersey with her husband and young daughter.